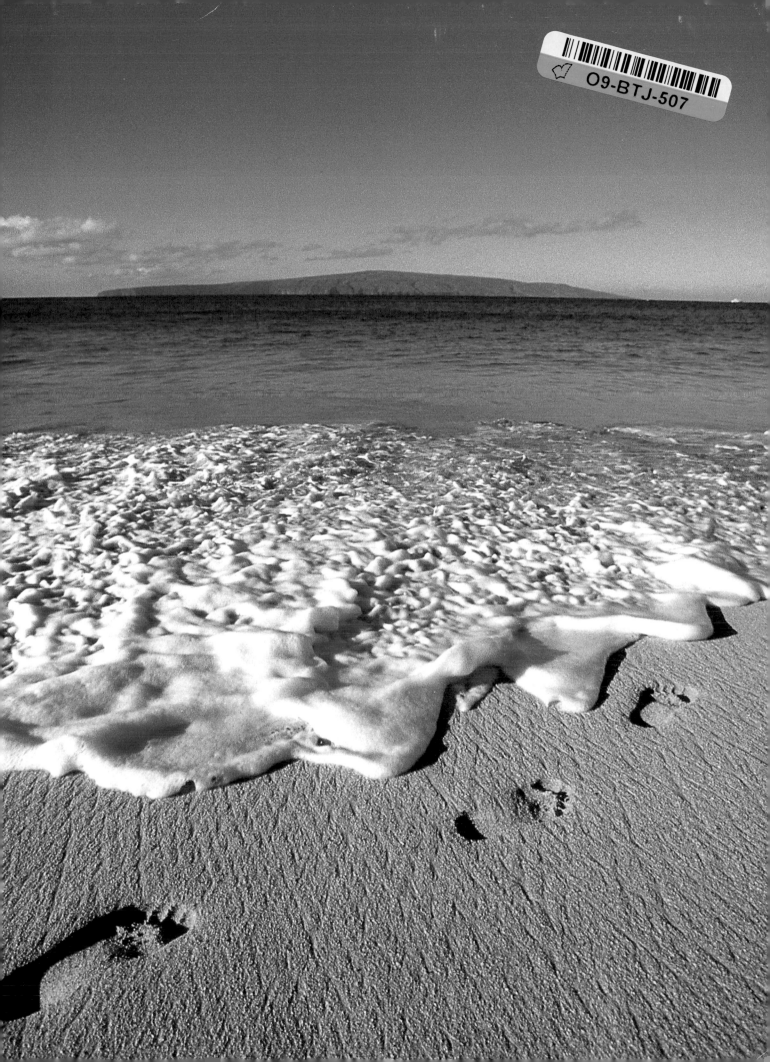

UNDERSTANDING Exposure

REVISED EDITION

*How to Shoot Great Photographs
with a Film or Digital Camera*

BRYAN PETERSON

AMPHOTO BOOKS

An imprint of Watson-Guptill Publications

Acknowledgments

My career would not be where it is today without the generous help and support of the wonderful people at *Popular Photography* magazine, past and present, namely Steve Pollack, Arthur Goldsmith, Monica Cipnic, and Mason Resnick; as well as Steve Werner at *Outdoor Photographer* magazine. In addition, I want to thank the more than one hundred thousand fellow shooters who bought the first edition of *Understanding Exposure* over these past ten years. And thanks again to my friends at Amphoto Books: Victoria Craven, Sharon Kaplan, and Bob Ferro. Your belief in me has meant so much! And finally, this book would not be what it is without the best editor I have ever worked with at Amphoto, Alisa Palazzo, and without the best designer I have ever worked with at Amphoto, Bob Fillie.

Fourth published in 2005 by Amphoto Books
an imprint of Watson-Guptill Publications
a division of VNU Business Media, Inc.
770 Broadway
New York, NY 10003
www.wgpub.com
www.amphotobooks.com

Senior Acquisitions Editor: Victoria Craven
Senior Developmental Editor: Alisa Palazzo
Designer: Bob Fillie, Graphiti Design, Inc.
Senior Production Manager: Ellen Greene

Text and illustrations copyright © 2004 Bryan Peterson

Library of Congress Cataloging-in-Publication Data
Peterson, Bryan F.
 Understanding exposure : how to shoot great photographs with a film or
 digital camera / Bryan Peterson.— Rev. ed.
 p. cm.
 ISBN 0-8174-6300-3 (pbk.)
 1. Photography—Exposure. I. Title.

TR591.P48 2004
771—dc22

 2003023838

Printed in China

4 5 6 7 8 / 11 10 09 08 07 06 05

*To my beautiful wife, Kathy, the greatest gift I have
ever been given and with whom I will forever be in love,
and to the two greatest gifts she has ever given me,
our beautiful daughters, Chloe and Sophie*

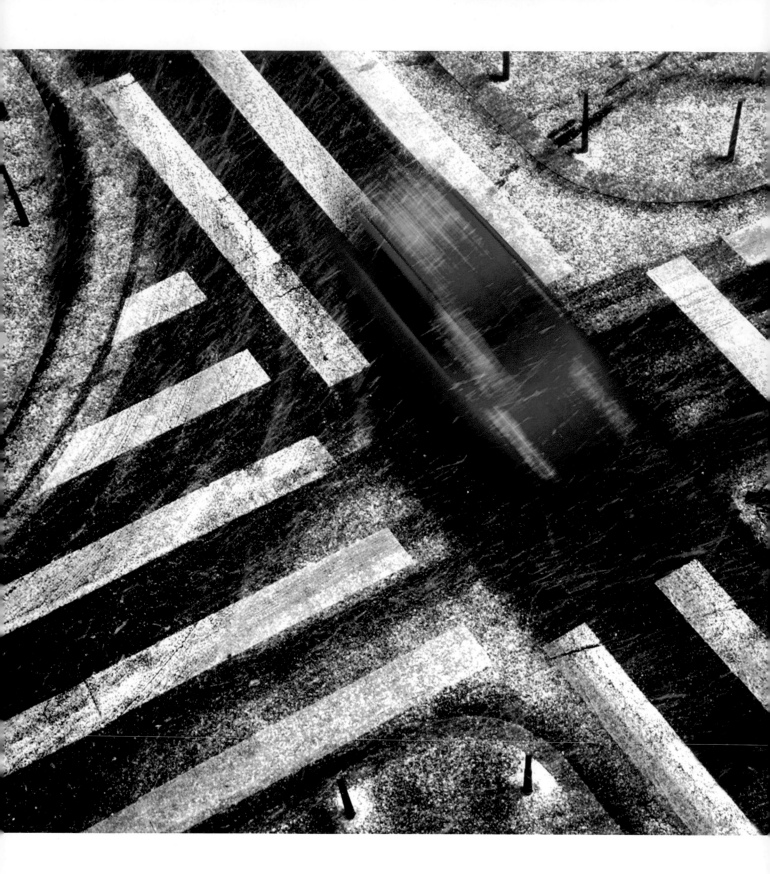

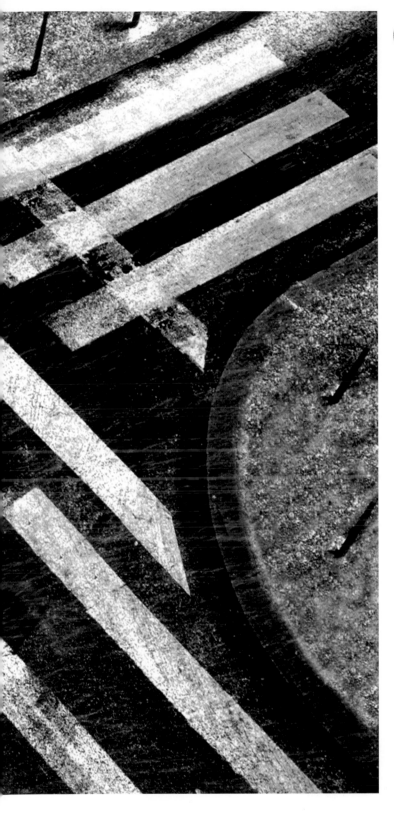

CONTENTS

INTRODUCTION

Several years ago, at one of my workshops, I responded with a surprising answer to the often-asked question "Bryan how long have you been shooting?" Perhaps it was because I had been without sleep for several days, and oftentimes I think clearer without much sleep, but I answered, *I would estimate that I've been shooting a little less than two weeks, most.* Needless to say, my reply got more than just a puzzled look and even a few giggles. I went on to explain that there's no doubt I've had a camera slung over my shoulder for some thirty-plus years, but when it comes down to actual shooting time—actually pressing the shutter release to record an exposure—it has indeed been minimal. If, on average, I've made all of my exposures at 1/2 sec. over the course of a year and have averaged 10,000 exposures in that time, then in one year I've spent a grand total of 5,000 seconds literally shooting. That's roughly eight hours and thirty minutes. Multiplied by exactly thirty-three years, that's roughly eleven days and five hours!

While this might not have been the intended meaning behind the original question, it is an interesting consideration. By my interpretation of how long one has been "shooting," professional sports photographers—who make most of their exposures at 1/500 sec.—are mere "babies" in terms of shooting time. The same goes for fashion photographers, who more often than not are stuck at a flash synchronization speed of 1/250 sec.

So, this just goes to prove what I've always known to be true: photographers who spend the bulk of their shooting time in the great outdoors (away from sports and fashion) have the greatest amount of "shooting" time behind the camera and are, therefore, the best qualified to speak about the joy of photography. I hope you've enjoyed the way I played with these numbers, because playing with numbers—and the way numbers relate to one another—is what exposure is all about.

The numbers that I am talking about are the very numbers that have, perhaps, confused you for far too long: shutter speed (from 1/8000 sec. down to several minutes), aperture (from $f/2.8$ to $f/32$), and ISO (film speed). No wonder understanding exposure can make you feel like you need a slide rule and a degree in calculus. Fourteen years ago, when *Understanding Exposure* was first published, I made it my mission to dispel the myth that understanding exposure was hard. It doesn't have to be hard at all! And now, I'm revising the book to update and expand upon that information.

My own love affair with photography began in 1970, fresh out of high school, when my oldest brother, Bill, proposed I use his Nikon F and 50mm lens to photograph the beautiful country in Willamette Valley, Oregon, rather than making the pen-and-ink drawings of it that I was doing at the time. With minimal instruction, I headed off and shot two rolls of black-and-white film over the next three days. A day later, with my brother's help in his home darkroom, I was absolutely mesmerized by the immediacy of the photographic print, and I was hooked.

I bought more film and shot everything I could for the next eight months when I made what proved to be one of the best mistakes of my life. Reaching into a basket on the film counter of a local camera store, I bought three rolls of "outdated" Agfachrome 35mm film. I spent the weekend photographing, and when I showed up at my brother's darkroom, he pointed out that the film was not black and white, but rather color slide film. I wasn't thrilled to have to make the trip to the camera store to have the film processed, but my brother convinced me that I should, because "you never know. You might like the colors." So, just how happy was I with the colors? Let's just say that over the course of these past thirty-two years, I've shot 99 percent of everything in living color!

Color film motivated me so much that it was then that I started writing everything down—aperture, shutter speed, and even time of day—for each exposure. I was soon adding notes on lens choice. I devoured photography books at the local library, and it wasn't long before I began to develop a much better understanding—and appreciation—of apertures and shutter speeds, along

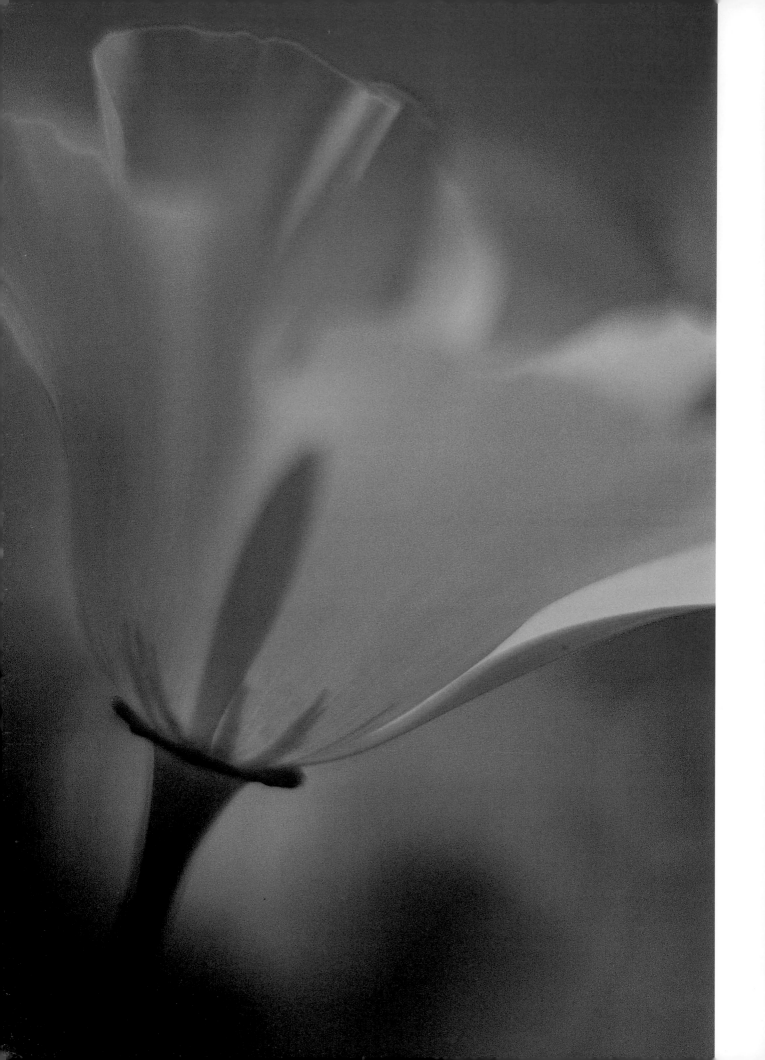

with the impact of ISO on various combinations of the two. And, as I tried different color films, with their different grain structures and color biases, I was better able to match a given film to a particular subject. Although it seemed a long time coming, I felt I'd finally reached the point where the concept of exposure became far more than just recording a correct exposure; with the *right* aperture, *right* shutter speed, and *right* film, I could consistently record *creative* exposures—exposures that resulted in greater depth of field, or that rendered only one flower out of an entire field in focus, or that conveyed the motion of a galloping horse.

Throughout this book, I discuss the interrelationship between aperture, shutter speed, and film that is—and has always been—at the heart of every exposure. Together, these three elements make up what I affectionately call *the photographic triangle*. Familiarizing yourself with these relationships and the triangle will, first and foremost, enable you to make correct exposures far more consistently. This, in turn, will free you to learn the art of recording *creatively correct* exposures under many different lighting situations. In addition, at the heart of the photographic triangle is the exposure meter; without it, making a correct exposure would require the written charts of a bygone era and a careful eye in determining light's value. And, you need to know *where* to take your meter reading to get successful exposures. I'll address these primary issues so that you can move beyond simply recording correct exposures to learning the art of making creatively correct exposures.

The mere mention of the word *exposure* can strike fear in the hearts of many photographers. Over the years, I have witnessed these anxiety attacks, and they *are* often warranted; but the good news is that *these* anxiety attacks are the easiest to quell. Every amateur photographer shares a common ground: the inability to consistently make "correct" exposures. It's my hope that, after reading this book and putting into practice the basic principles on exposure, you'll have a knowledge of exposure that will permanently alter your approach to every picture-taking situation. Your anxiety will be replaced by a level of confidence you thought you might never achieve.

So much has changed in the world of photography since the first edition of *Understanding Exposure*, not the least of which is the advent of the digital age, yet it needs to be said, the more things change, the more they stay the same. Every camera is still nothing more than a light-proof box with a lens at one end and a light-sensitive device (be it film or a digital chip) at the other. The process of light entering through the lens to record an image (be it on film or digital media) is still the same. And the recorded image is still called an exposure.

Whether you shoot film or digital, we can all agree on one thing: there's always photo-imaging software to help us out when we blow it, right? Yes, but *please* make it your goal to use photo-imaging software only as your *last resort*! Do you really enjoy spending all of your leisure time at the computer correcting bad exposures? Learning how to make the correct exposure *in-camera* will save you lots of time, and who couldn't use more time?

For many readers, the material in this book will be brand new territory, while for others, the material may serve as an affirmation of what is already known. Whether you try several or all of the suggestions, the material will have a profound effect on your ability to say with certainty that you *do know* what your exposure will be.

Defining Exposure

What Is Meant by "Exposure"?

As I mentioned in the introduction, just as it was 100 years ago and just as it was in 1970 when I made my first exposure, today every camera—be it film or digital—is nothing more than a lightproof box with a lens at one end and light sensitive film or a digital card at the other end. The same light enters the lens (the aperture), and after a certain amount of time (determined by shutter speed) an image will be recorded (on film or digital media). This recorded image has been called—since day one—an *exposure*, and it still is.

Sometimes, the word *exposure* refers to a finished slide or print: "Wow, that's a nice exposure!" At other times, it refers to the film or digital card: "I've only got a few exposures left." But more often than not, the word exposure refers to the amount, and act, of light falling on photosensitive material (either the film or digital card). And in this context, it comes up most often as part of a question—a question I've heard more often than any other: "Hey Bryan, what should my exposure be?" (In other words, how much light should hit the film/digital media and for how long?) And my answer is always the same: "Your exposure should be correct!"

Although my answer appears to be flippant, it really is *the* answer. A correct exposure really is what every amateur and professional alike hopes to accomplish with either his or her camera.

Up until about 1975, before many autoexposure cameras arrived on the scene, every photographer had to choose both an aperture and shutter speed that, when correct, would record a correct exposure. The choices in aperture and shutter speed were directly influenced by the film's ISO (speed or sensitivity to light). Most photographers' exposures would be based on the available natural light. And when the available light wasn't enough, they'd resort to using flash or a tripod.

Today, most cameras, either film or digital, are equipped with so much automation they promise to do it all for you, allowing photographers to concentrate solely on what they wish to shoot. "Just keep this dial here set to P and fire away! The camera will do everything else," says the enthusiastic salesman at the camera shop. Oh, if that were only true! Obviously, most—if not all—of you who bought this book have a do-it-all-for-you camera, yet you still find yourself befuddled, confused, and frustrated by exposure. Why is that? It's because your do-it-all-for-you camera *is not* living up to that promise, and/or you have finally reached the point at which you want to consistently record correct photographic exposures.

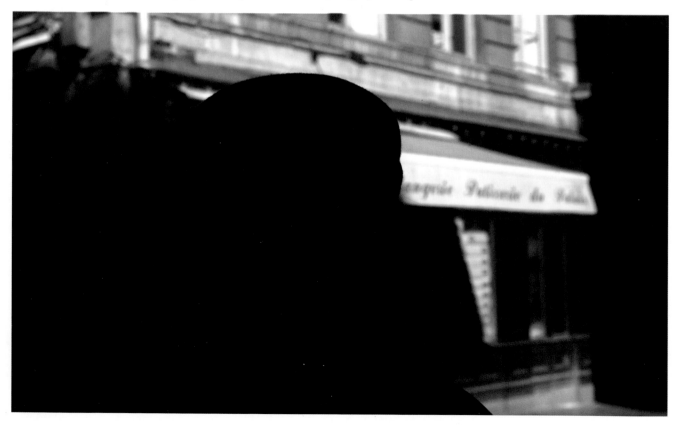

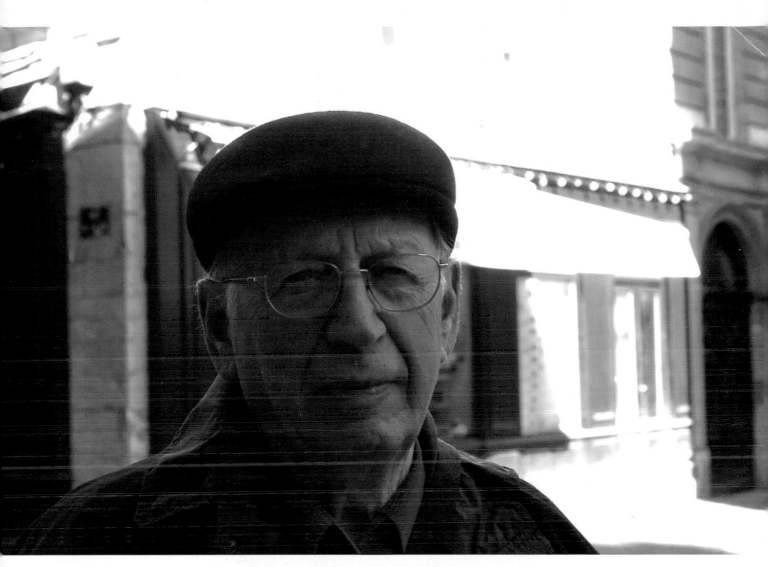

The do-it-all camera often falls short of its promise, yielding disappointing results (opposite). Use your camera's manual settings (this page), or at the very least, know how light and dark interact on film or digital media so that you can be assured of getting it right even when you are in auto-exposure mode. (Note: To determine the successful exposure, I moved in close to the subject and took a meter reading off his face; I then backed up to reframe and make the exposure.)

[Both photos: 35–70mm lens at 35mm. Opposite: f/5.6 for 1/500 sec. in program mode. This page: f/5.6 for 1/90 sec. in manual mode]

Setting and Using Your Camera on Manual Exposure

I know of no other way to consistently make correct exposures than to learn how to shoot a fully manual exposure. Once you've learned how to shoot in manual exposure mode (it's really terribly easy), you'll better understand the outcome of your exposures when you choose to shoot in semi- or full autoexposure mode.

With your camera and lens in front of you, set your camera dial to M for manual. (If you're unsure on how to set your camera to manual exposure mode, read the manual!) Get someone to use as your subject and go to a shady part of your yard or a neighboorhood park, or if it's an overcast day, anywhere in the yard or park will do. Regardless of your camera, and regardless of what lens you're using, set your lens opening to the number 5.6 (f/5.6). Place your subject up against the house or some six- to eight-foot shrubbery. Now, look through the viewfinder and focus on your subject. Adjust your shutter speed until the camera's light meter indicates a "correct" exposure in your viewfinder and take the photograph. You've just made a manual correct exposure!

Operating in manual exposure mode is empowering, so make a note of this memorable day.

The Photographic Triangle

The last thing I want you to do is forever leave your camera's aperture at *f/5.6* and simply adjust your shutter speed for the light falling on your subject until the viewfinder indicates a correct exposure. Before you forge ahead with your newfound ease in setting a manual exposure, you need to learn some basic concepts about exposure.

A correct exposure is a simple combination of three important factors: aperture, shutter speed, and ISO. Since the beginning of photography, these same three factors have always been at the heart of every exposure, whether that exposure was correct or not, and they still are today—even if you're using a digital camera. I refer to them as *the photographic triangle*.

Locate the button, wheel, or dial on your camera or lens that controls the aperture. If you're using an older camera and lens, the aperture control is a ring that you turn on the lens itself. Whether you push buttons, turn a wheel, or rotate a ring on the lens, you'll see a series of numbers coming up in the viewfinder or on the lens itself. Of all of the numbers you'll see, take note of 4, 5.6, 8, 11, 16, and maybe even a 22. (If you're shooting with

a fixed-zoom-lens digital camera, you may find that your apertures don't go past 8 or maybe 11.) Each one of these numbers corresponds to a specific opening in your lens and these openings are called *f*-stops. So in photographic terms, the 4 is called *f*/4, the 5.6 is *f*/5.6, and so on. The primary function of these lens openings is to control the volume of light that reaches the film or digital media during an exposure. The *smaller* the *f*-stop number, the *larger* the lens opening; the *larger* the *f*-stop, the *smaller* the lens opening.

For the technical minded out there, an *f*-stop is a fraction that indicates the diameter of the aperture. The *f* stands for the focal length of the lens, the slash (/) means *divided by*, and the number represents the stop in use. For example, if you were shooting with a 50mm lens set at an aperture of *f*/1.4, the diameter of the actual lens opening would be 35.7mm. Here, 50 (lens focal length) divided by 1.4 (stop) equals 35.7 (diameter of lens opening). Whew! It makes my head spin just thinking about all that. Thank goodness this has very little, if anything, to do with achieving a correct exposure.

Interestingly enough, each time you descend from one aperture opening to the next, or *stop down*, such as from *f*/4 to *f*/5.6, the volume of light entering the lens is cut in half. Likewise, if you change from an aperture opening of *f*/11 to *f*/8, the volume of light entering the lens doubles. Each halving or doubling of light is referred to as a full stop. This is important to note since many cameras today offer not only full stops, but also the ability to set the aperture to one-third stops, i.e. *f*/4, *f*/4.5, *f*/5, *f*/5.6, *f*/6.3,

While teaching a photo workshop in Dubai, I photographed the daughter of one of my students. Since depth of field was not a big concern for this composition, I chose a "Who cares?" aperture of *f*/11 (see page 56 for more on this type of aperture). Handholding my camera, I adjusted the shutter speed until the camera's light meter indicated 1/250 sec. as the correct exposure.

[80–200mm lens, *f*/5.6 for 1/250 sec.]

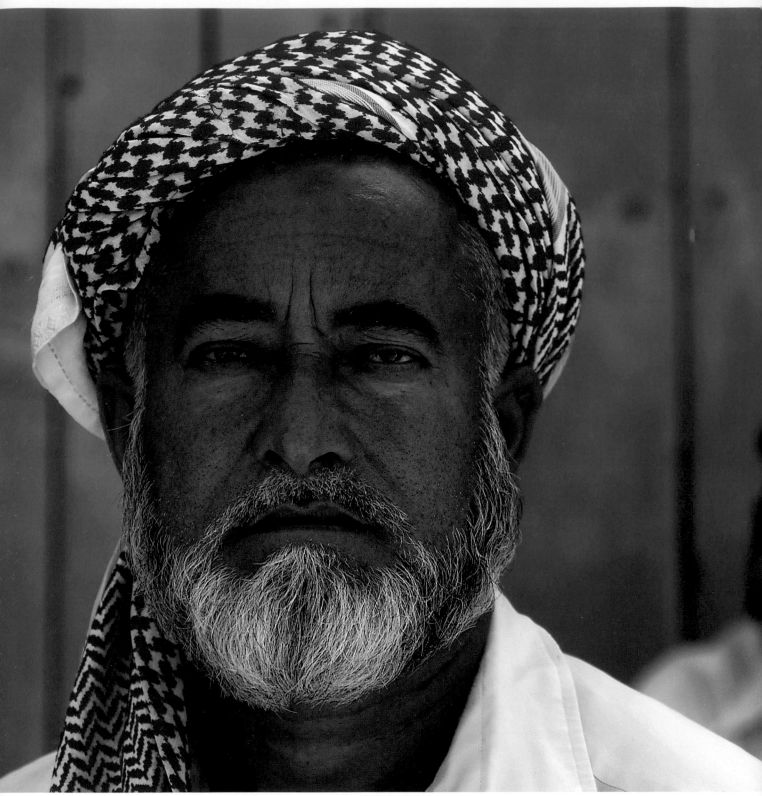

Outside the town of Charja in the United Arab Emirates, I came upon several men engaged in a card game. Although the game itself proved interesting to photograph, I wanted, more than anything, to make a portrait of this particular gentleman. With an aperture of f/4, I knew I'd be able to get a "selectively focused" image of just him while the man in the background remained an out-of-focus—yet important—compositional element. As I framed the image, I adjusted the shutter speed until 1/250 sec. was indicated as the correct exposure.

[80–200mm lens, f/4 for 1/250 sec.]

f/7.1, *f*/8, *f*/9, *f*/10, *f*/11, and so on. (The underlined numbers represent the original, basic stops while the others are the newer one-third options sometimes available.)

Now let's turn to shutter speed. Depending on the make and model, your camera may offer shutter speeds from a blazingly fast 1/8000 sec. all the way down to 30 seconds. The shutter speed controls the amount of time that the volume of light coming through the lens (determined by the aperture) is allowed to stay on the film or digital media in the camera. The same halving and doubling principle that applies to aperture also applies to shutter speed.

Let me explain. Set the shutter speed control on your camera to 500. This number denotes a fraction—500 represents 1/500 sec. Now change from 500 to 250; again, this represents 1/250 sec. From 1/250 sec. you go to 1/125, 1/60, 1/30, 1/15, and so on. Whether you change from 1/30 sec. to 1/60 sec. (decreasing the time the light stays on the film/digital media) or from 1/60 sec. to 1/30 sec. (increasing the time the light stays on the film/digital media), you've shifted a full stop. Again this is important to note since many cameras today also offer the ability to set the shutter speed to one-third stops: 1/500 sec., 1/400 sec., 1/320 sec., 1/250 sec., 1/200 sec., 1/160 sec., 1/125 sec., 1/100 sec., 1/80 sec., 1/60 sec., and so on. (Again, the underlined numbers represent the original, basic stops while the others are the newer one-third options sometimes available.) Cameras that offer one-third stops reflect the camera industry's attempts to make it easier for you to achieve "perfect" exposures. But as you'll learn later on, it's rare that one always wants a perfect exposure.

The final leg of the triangle is ISO. Whether you shoot with film or use a digital camera, your choice of ISO has a direct impact on the combination of apertures and shutter speeds you can use. It's so important that it warrants its own discussion and exercise, so take a look at the next page.

EXERCISE: Understanding the Effect of ISO on Exposure

To better understand the effect of ISO on exposure, think of the ISO as a worker bee. If my camera is set for ISO 100, I have, in effect, 100 worker bees; and if your camera is set for ISO 200, you have 200 worker bees. The job of these worker bees is to gather the light that comes through the lens and make an image. If both of us set our lenses at the same aperture of f/5.6—meaning that the same volume of light will be coming through our lenses—who will record the image the quickest, you or me? You will,

since you have twice as many worker bees at ISO 200 than I do at ISO 100.

How does this relate to shutter speed? Let's assume the photo in question is of a lone flower taken on an overcast day. Remember that your camera is set to ISO 200 and mine to ISO 100, both with an aperture of f/5.6. So, when you adjust your shutter speed for a correct exposure, 1/250 sec. is indicated as "correct," but when I adjust my shutter speed for a correct exposure, 1/125 sec.—a longer exposure—is indicated. This is

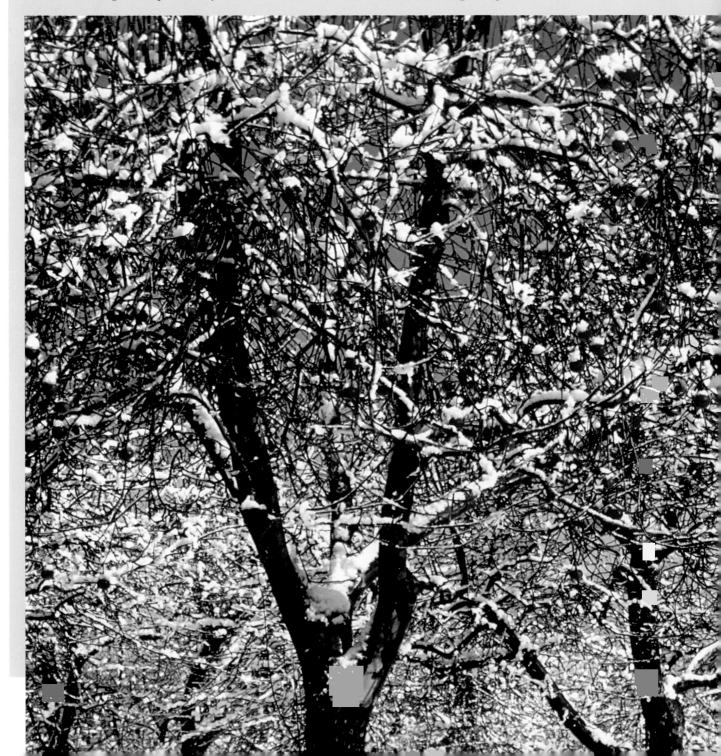

because your 200 worker bees need only half as much time as my 100 worker bees to make the image.

Since this is such an important part of understanding exposure, I want you to put the book down for a moment and get out your camera, as well as a pen and paper. Set the film speed dial to ISO 200; do this even if you have a roll of film in your film camera that is *not* ISO 200. (Don't forget to set the ISO back to the correct number when we're done here.) Now, set your aperture opening to *f*/8, and with the camera pointed at something that's well illuminated, adjust your shutter speed until a correct exposure is indicated in the viewfinder.

(If you want, you can leave the camera in the automatic aperture-priority mode for this exercise, too). Write down that shutter speed. Then, change your film speed again, this time to ISO 400, leaving the aperture at *f*/8, and once again point the camera at the same subject. Whether you're in manual mode or auto-aperture-priority mode, you'll see that your light meter is indicating a different shutter speed for a correct exposure. Once again, write down this shutter speed. And finally, change the ISO to 800, and repeat the steps above.

What have you noticed? When you change from ISO 100 to ISO 200 your shutter speed changed: from 1/125 sec. to 1/250 sec. or perhaps something like from 1/160 sec. to 1/320 sec.. These shutter speeds are examples, of course, and not knowing what your subject was, it's difficult at best to determine your actual shutter speeds, but one thing is certain: each shutter speed is close to if not exactly half as much as the one before it.

When you increase the number of worker bees (the ISO) from 100 to 200, you cut the time necessary to get the job done in half. (If only the real world worked like that!) This is what your shutter speed was telling you: Going from 1/125 sec. to 1/250 sec. is half as long an exposure time. When you set the ISO to 400, you went from 1/125 sec.—passing by 1/250 sec.—and ended up at 1/500 sec. Just as each halving of the shutter speed is called 1 stop, each change from ISO 100 to ISO 200 to ISO 400 is considered a *1-stop* increase (an increase of worker bees).

You can do this same exercise just as easily by leaving the shutter speed constant, for instance at 1/125 sec., and adjusting the aperture until a correct exposure is indicated in the viewfinder; or, if you choose to stay in autoexposure mode, select shutter-priority, set a shutter speed of 1/125 sec., and the camera will set the correct aperture for you.

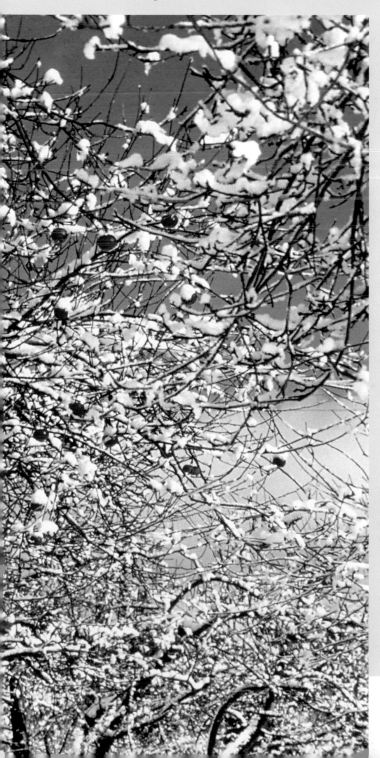

To record exacting sharpness from front to back, I used a small lens opening. I metered off the blue sky, which indicated a 1/15 sec. exposure, and then recomposed.

[135mm lens, *f*/32 for 1/15 sec.]

The Heart of the Triangle: The Light Meter

Now it's time to introduce you to what I call the heart of the photographic triangle: the light meter. At the heart of every exposure is your camera's light meter, which is a pre-calibrated device designed to react to any light source no matter how bright or dim that light source may be.

Based on the example on the previous page, the camera's light meter knew that the aperture was set to $f/5.6$, and it also knew that the ISO was set to 200. As a result, it reacted and directed you to adjust the shutter speed, and then it indicated in the viewfinder that you had reached the correct shutter speed. It's the light meter that is ultimately behind the calculations of every correct photographic exposure.

To set this idea in stone, let me offer this final illustration: Imagine your lens opening, again say $f/5.6$, is the same diameter as your kitchen faucet opening. Now imagine that your faucet handle is your shutter speed dial and that waiting in the sink below are 200 worker bees, each with their own empty bucket. The water coming through the faucet will be the light. It's the job of the camera's light meter to indicate how long the faucet stays open in order to fill up all the buckets of the waiting worker bees below. The light meter knows that there are 200 worker bees and that the opening of the faucet is $f/5.6$. So with this information, the camera's light meter can now tell you *how long* to leave the faucet open, and assuming you turn on the faucet for this correctly indicated amount of time, you will record a correct exposure. In effect, each worker bee's bucket is filled with the exact amount of water necessary to record a correct photographic exposure.

Crossing the bridge leaving the harbor in Hamburg, Germany, I spotted this great shot in my rearview mirror. I immediately pulled off to the side of the highway and set up my tripod. Since I knew I wanted to exploit the motion of the traffic flowing across the bridge, I chose a shutter speed of 8 seconds. With my camera pointed to the sunset sky, I adjusted my aperture until the camera's light meter indicated $f/11$ as a correct exposure and then recomposed the scene. I was so pleased with the result that I forgot my previous anger at receiving a ticket for "parking along a highway when there clearly was no emergency." The $85 fine was well worth it, since this image has earned more than $4,000 in stock photo sales over the past several years.

[300mm lens, $f/11$ for 8 seconds]

What happens if the water (the light) is allowed to flow longer than the light meter says? The buckets become overfilled with water (too much light). In photographic terms, this is called an *overexposure*. If you've ever taken an overexposed image, you've undoubtedly commented that the colors look "washed out." Conversely, what happens if the water (the light) coming through the faucet is *not* allowed to flow as long as the light meter says? The buckets get but a few drops (not enough light). In photographic terms, this is an *underexposure*. If you've ever taken an underexposed photo, you've found yourself saying, "It's hard to see what's there since its so dark."

Having now learned how simple the basic concept of exposure is, is it safe to say you can record perfect exposures every time? Not quite, but you're closer than you were when you started reading this book. You can certainly say that you understand how an exposure is made. And, you now understand the relationship between *f*-stops, shutter speeds, and ISOs. However, most picture-taking opportunities rely on the *one* best aperture choice or the *one* best shutter speed choice. What's *the one* best aperture? *The one* best shutter speed? Learning to "see" the multitude of *creative* exposures that exist is a giant leap toward photographic maturity.

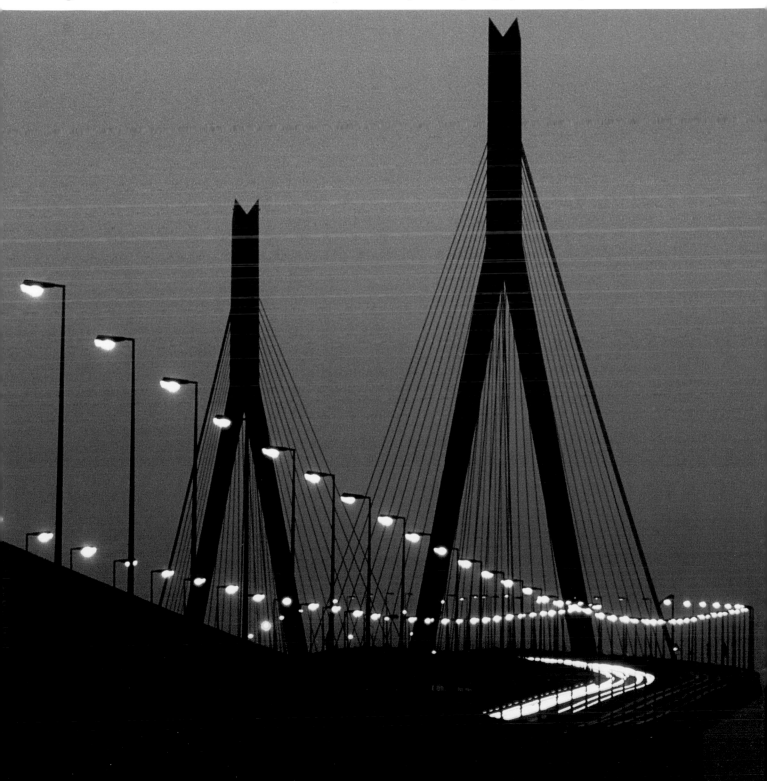

Six Correct Exposures vs. One Creatively Correct One

It's not uncommon to hear at least one student in my on-location workshops say to me, "What difference does it make which combination of aperture and shutter speed I use? If my light meter indicates a correct exposure, I'm taking the shot!" Perhaps you are like this, too. Whether you shoot in program mode, shutter-priority mode, aperture-priority mode, or even manual mode, you may think that as long as the light meter indicates that everything's okay, then it must be okay to shoot.

The trouble is that this kind of logic makes about as much sense as deer hunters who fire off their rifles at anything that moves. They may eventually get a deer, but at what cost? If you want to shoot only "correct" exposures of anything and everything, be my guest. Eventually, you might even record a creatively correct exposure. But I'm assuming that most of you who bought this book are tired of the shotgun approach and want to learn how to *consistently record creatively correct exposures every time.*

Most picture-taking situations have at least six possible combinations of *f*-stops and shutters speeds that will *all* result in a correct exposure. Yet, normally, *just one of* these combinations of *f*-stops and shutter speeds is the creatively correct exposure.

As we've already learned, every correct exposure is nothing more than the quantitative value of an aperture and shutter speed working together within the confines of a predetermined ISO. But a creatively correct exposure *always* relies on *the one f-stop* or *the one shutter speed* that will produce the desired exposure.

Let's pretend for a moment that you're at the beach taking pictures of the powerful surf crashing against the rocks. You're using a film speed of ISO 100 and an aperture of *f*/4. After adjusting your shutter speed, you get a correct exposure (indicated in the viewfinder) of 1/500 sec. This is just one of your exposure options! There are other combinations of apertures (*f*-stops) and shutter speeds you can use and still record a correct exposure. If you cut the lens opening in half with an aperture of *f*/5.6 (*f*/4 to *f*/5.6), you'll need to increase the shutter speed a full stop (to 1/250 sec.) to record a correct exposure. If you use an aperture of *f*/8, again cutting the lens opening in half, you'll need to increase the shutter speed again by a full stop (to 1/125 sec.). Continuing in this manner would also produce the following pairings of apertures and shutter speeds to achieve a correct exposure: *f*/11 at 1/60 sec., *f*/16 at 1/30 sec., and finally *f*/22 at 1/15 sec. That's six possible correct exposures for the scene—six possible combinations of aperture and shutter speed that will all result in exactly the same exposure. And I want to stress the word same here means the "same" in terms of quantitative value only! Clearly, a picture of crashing surf taken using *f*/4 at 1/500 sec. would capture action-stopping detail of the surf as it hits the rocks; a correct exposure of that surf using *f*/22 at 1/15 sec., on the other hand, would capture less action-stopping detail and show the surf as a far more fluid and wispy, somewhat angelic element.

This creative approach toward exposure will reap countless rewards *if* you get in the habit of looking at a scene and determining what combination of aperture and shutter speed will render the most dynamic and creative exposure for that subject. The choice in exposure is always yours, so why not make it the most creative exposure possible?

Shooting a Ferris wheel at dusk presents an opportunity to show the vast difference between three quantitatively identical exposures (opposite and on the following two pages)—the difference is in their *creative* exposure value. I made all three of these photographs on Kodak E100S slide film with my 20mm lens and Nikon F5 mounted on a tripod. The top image was taken at f/8 for 1/4 sec., the one below was shot at f/11 for 1/2 sec., and the one on page 26 was at f/16 for 1 second.

[Opposite, top: 20mm lens, f/8 for 1/4 sec. Opposite, bottom: 20mm lens, f/11 for 1/2 sec.]

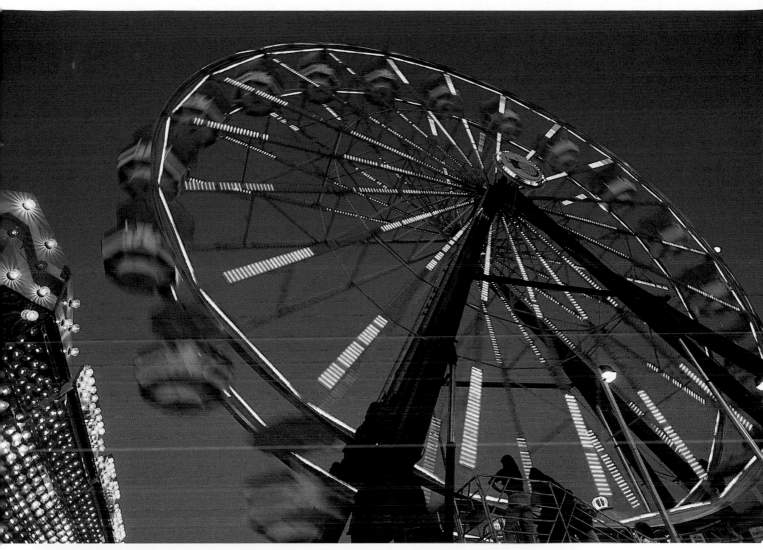
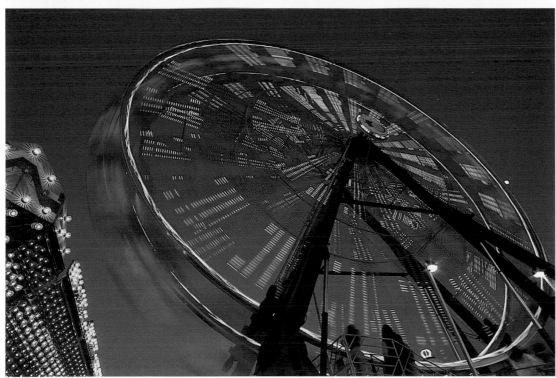

An exercise such as this is truly eye-opening. The next time you head out to the amusement park you probably won't hesitate to use the slower shutter speeds, since as this example shows, of the three "identical" exposures, the one with the slowest shutter speed is the most creative and interesting.

[20mm lens, f/16 for 1 second]

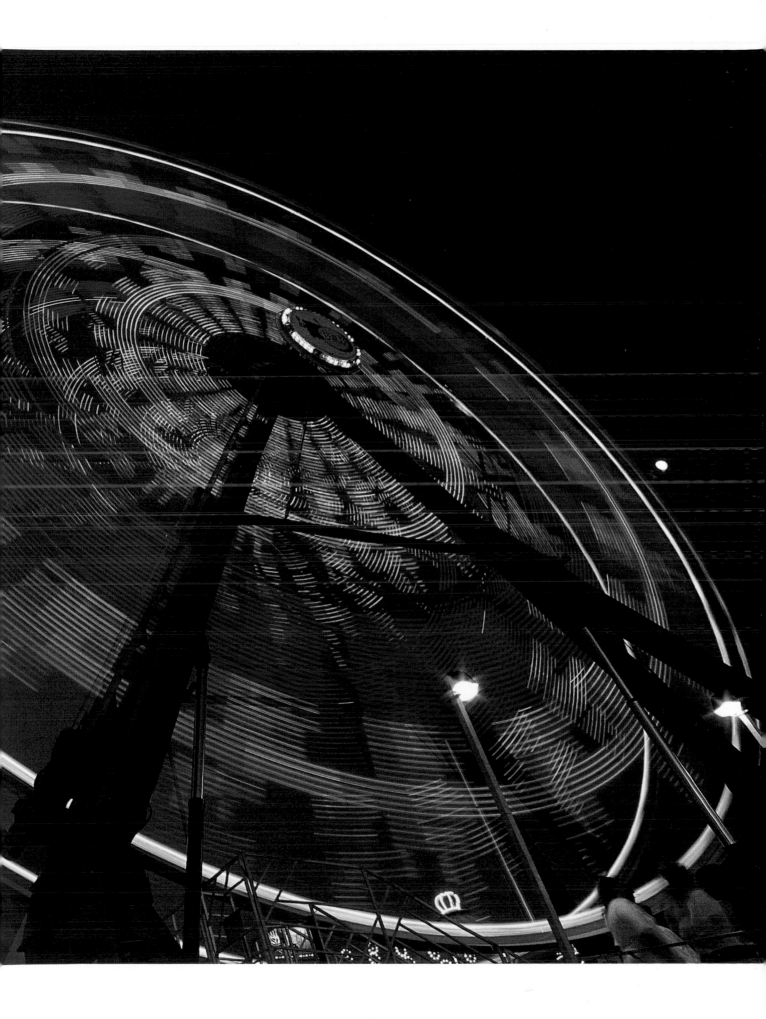

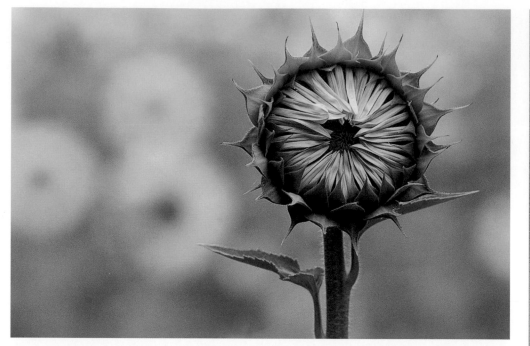

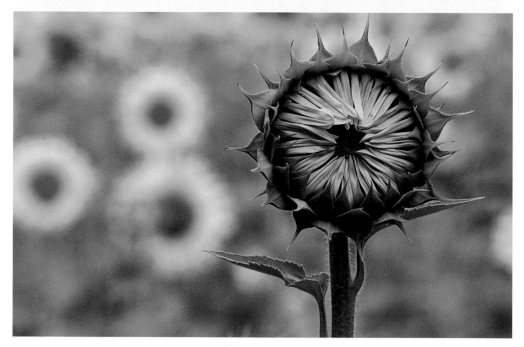

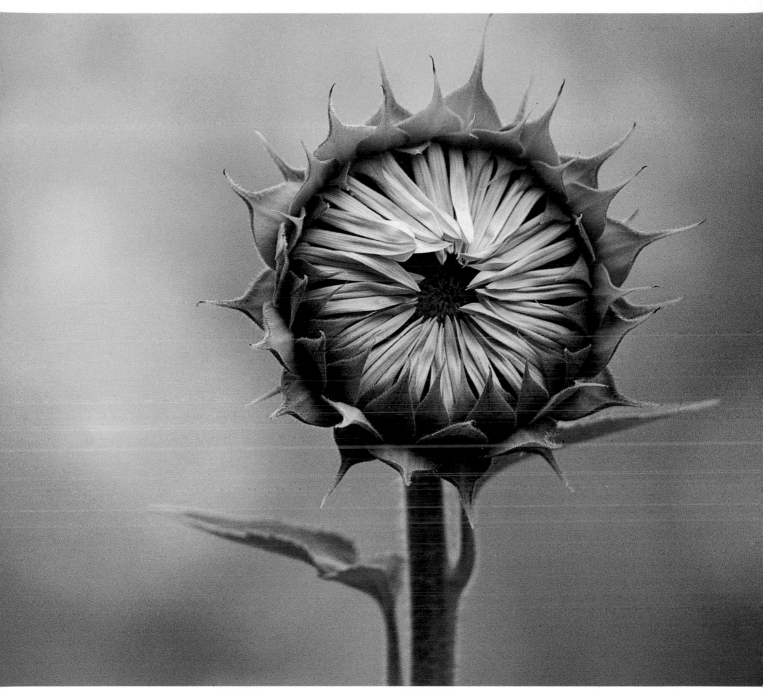

With my camera and Nikkor 80–400mm zoom lens mounted on a tripod and the lens set to 300mm, I shot the first image at f/4 for 1/1000 sec. The second image was f/8 for 1/250 sec., and the third was f/16 for 1/60 sec.

All three exposures are exactly the same in terms of quantitative value, but quite different in the arena of "creative" exposure. Note how at the wide open aperture of f/4, the sunflower is isolated—in effect, it's all alone—but at f/16, due to the

increase in depth of field, it has quite a bit of company.

[All photos: 80–400mm zoom lens at 300mm. Above: f/4 for 1/1000 sec. Opposite, top: f/8 for 1/250 sec. Opposite, bottom: f/16 for 1/60 sec.]

EXERCISE: Seeing the Creatively Correct Exposure

One of the best lessons I know is very revealing. Not surprisingly, it will lead you further into the world of creatively correct exposures. Choose a stationary subject, such as a flower, or have a friend stand for a portrait. Also choose a moving subject, such as a waterfall or a child on a swing. If possible photograph on an overcast day and choose compositions that crop out the sky so that it is not part of the scene.

With your camera and lens mounted on a tripod, set the camera to manual exposure mode. Get used to being in manual mode as this is where you'll now be spending all of your "quality time." Now set your aperture wide open—that will be the smallest number on your lens, such as *f*/2, *f*/2.8, *f*/3.5, or *f*/4. Do your best to fill the frame with your subject—be it the flower or the portrait—adjust your shutter speed until a correct exposure is indicated (in the viewfinder), and then shoot one frame.

Now change your aperture one stop (for example, from *f*/4 to *f*/5.6), readjust your shutter speed one stop

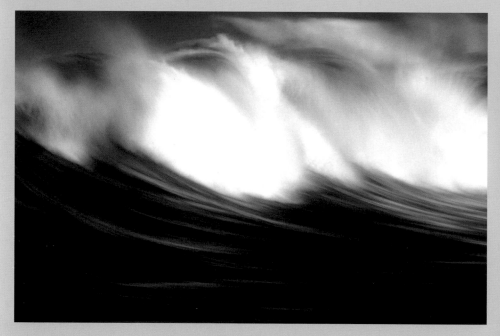

Two waves, different effect—all because of a change in exposure. The camera and lens were the same for both images, but for the image at right I chose a shutter speed of 1/500 sec. to freeze the action of the wave. In doing so, I knew I'd end up with a large lens opening, namely because I was using ISO 50. Sure enough, as I adjusted my aperture while taking a meter reading off the distant horizon and blue sky, I got *f*/4 as a correct exposure. I then recomposed and took the shot.

For the image above, I wanted the angry surf to have a softer and more surreal quality. So, I set the aperture to *f*/32, knowing that this would force me to use a much slower shutter speed (1/8 sec.) since the aperture opening had been reduced considerably.

[Both photos: 80–200mm lens at 200mm. Right: *f*/4 for 1/500 sec. Above: *f*/32 for 1/8 sec.]

to maintain a correct exposure, and shoot one frame. Then change the aperture from *f*/5.6 to *f*/8 and so on, each time remembering to change the shutter speed in order to keep the exposure correct. For each exposure, write down the aperture and shutter speed used. Depending on your lens, you will have no less than six different aperture/shutter speed combinations, and even though each and every exposure is exactly the same in terms of its quantitative value, you should certainly notice a difference in the overall definition and sharpness of the image! A once lone flower is really only "alone" in a few frames; it gets lost in a sea of background when you use apertures of *f*/16 and *f*/22.

(See the images on pages 28 and 29.) A portrait picks up some distracting elements in the background, too, when you use those bigger *f*-stop numbers.

And what about that waterfall shot, for example? That blurred cotton-candy effect doesn't appear until you use apertures of *f*/16 or *f*/22. And isn't that motion-filled photograph of your child on a swing really something? It's funny how at the faster shutter speeds, motion is "frozen"; but at the slower shutter speeds, figures in motion look ghostlike. Look at your notes and decide which combination of aperture and shutter speed resulted in the most *creatively correct* exposure for you.

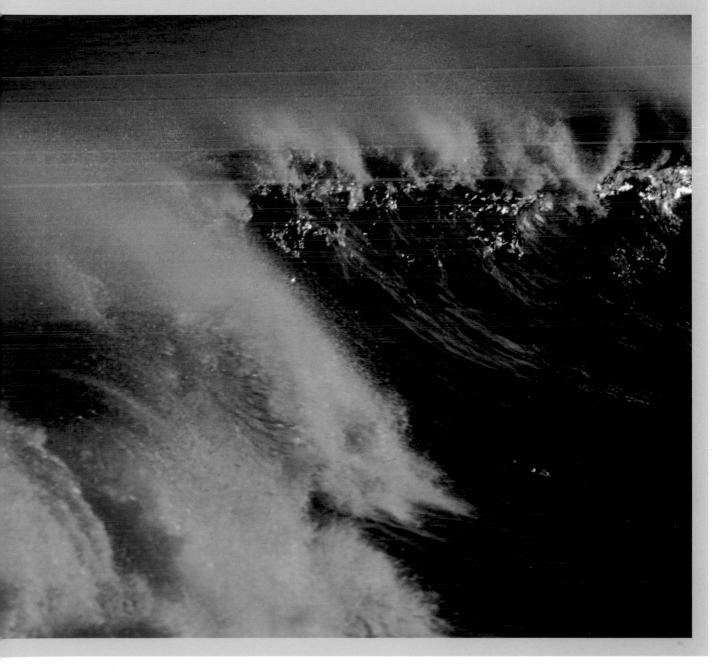

Seven Creative Exposure Options

Since every picture-taking opportunity allows for no less than six possible aperture and shutter speed combinations, how do you determine which combination is the best? You must decide, first and foremost, if you want to simply make an exposure or if you want to make a creative exposure. As we just saw, you can make many different exposures of a given scene, but only one or maybe two are the creative exposures.

You can break down the three components of exposure—film speed, shutter speed, and aperture—to get seven different types of exposures, and since, of these components, it's either the aperture or the shutter speed that's most often behind the success of a creative exposure, I'll start there: Small apertures (*f*/16, *f*/22, and *f*/32) are the creative force behind what I call *storytelling* exposures [option 1]—images that show great depth of field (see pages 36–47 for a thorough discussion of depth of field). Large apertures (*f*/2.8, *f*/4, and *f*/5.6) are the creative force behind what I call *singular-theme* or *isolation* exposures [option 2]—images that show shallow depth of field. The middle-of-the-road apertures (*f*/8 and *f*/11) are what I call *"Who cares?"* exposures [option 3]— those in which depth of field is of no concern. Aperture is also the element in *close-up*, or *macro*, photography that showcases specular highlights, those out-of-focus circular or hexagonal shapes [option 4].

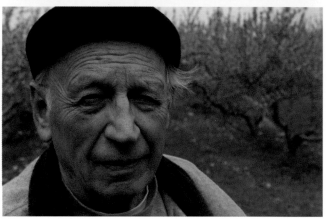

Fast shutter speeds (1/250 sec., 1/500 sec., and 1/1000 sec.) are the creative force behind exposures that *freeze action* [option 5], while slow shutter speeds (1/60 sec., 1/30 sec., and 1/15 sec.) are the creative force behind *panning* [option 6]. The superslow shutter speeds (1/4 sec., 1/2 sec., and 1 second) are the creative force behind exposures that *imply motion* [option 7]. These factors make up a total of seven creative exposure tools to call upon when reaching for your goal of achieving the one most creative exposure. The next two chapters take a closer look at aperture and shutter speed, respectively, as they pertain to all seven of these situations.

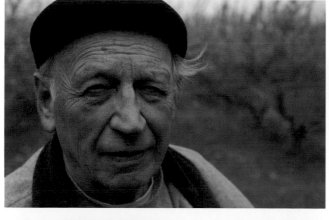

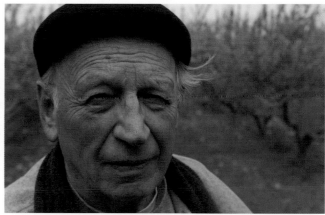

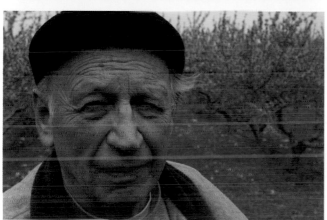

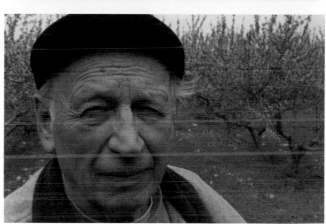

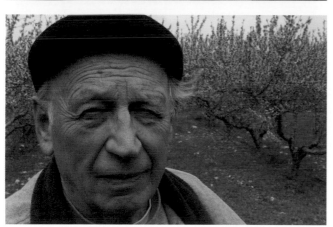

Glancing quickly at these seven images of my father, it may not register that each is a bit different from the previous one. But note the difference in the background, which becomes gradually more defined in each one—eventually creating a striking difference between the first image and the last one.

Each of these images is the same in "quantitative value," but each one is different in terms of its overall depth of field. The type of background you want—out of focus or clearly defined—will ultimately determine which of these seven images is the "correct" one for you.

[All photos: 35–70mm lens at 35mm. First row, left to right: f/2.8 for 1/1000 sec., f/4 for 1/500 sec., f/5.6 for 1/250 sec. Second row, left to right: f/8 for 1/125 sec., f/11 for 1/60 sec., f/16 for 1/30 sec. Left: f/22 for 1/15 sec.]

Aperture

Aperture and Depth of Field

The aperture is a "hole" located inside the lens. Also known as the diaphragm, this hole is formed by a series of six overlapping metal blades. Depending on your camera, you either make aperture adjustments on the lens, or you push buttons or turn dials on your camera. As you do this, the size of the hole in the lens either decreases or increases. This, in turn, allows more light or less light to pass through the lens and onto the film (or digital media).

For all lenses, the smallest aperture number—either 1.4, 2, 2.8, or 4 depending on the lens—reflects the widest opening and will always admit the greatest amount of light. Whenever you set a lens at its smallest numbered aperture (or *f*-stop), you are shooting "wide open." When you shift from a small aperture number to a larger one, you are reducing the size of the opening and "stopping the lens down."

The largest aperture numbers are usually 16, 22, or 32 (or 8 or 11 with a fixed-lens digital camera).

Why would you want to be able to change the size of the lens opening? Well, for years, the common school of thought has been that since light levels vary from bright to dark, you want to control the flow of light reaching the film. And, of course, the way to do this is simply by making the hole (the aperture) smaller or larger. This logic suggests that when you're shooting on a sunny day on the white sandy beaches of the Caribbean, you should stop the lens down, making the hole very small. Doing so would ensure that the brightness of the sand didn't "burn a hole" in the film. This same logic also implies that when you're in a dimly lit fourteenth-century cathedral, you should set the aperture wide open so that as much light as possible can pass through the lens and onto the film/digital media.

Although these recommendations are well-intentioned, I could not disagree with them more. They set up the unsuspecting photographer for inconsistent results. Why? Because they give no consideration to a far more important function of aperture: its ability to determine depth of field.

So, just what is depth of field? It's the area of sharpness (from near to far) within a photograph. As you've undoubtedly noticed when looking at magazines, calendars, greeting cards, or large picture books, some photographs contain a great deal of sharpness. You might be mystified by the "technique" professional photographers use to record extreme sharpness throughout an image—for example, from the flowers in the immediate foreground to the distant mountains beyond. When you try to achieve overall sharpness in a composition like this, you may find that when you focus on the foreground flowers, the background mountains go out of focus; and when you focus on the mountains, the flowers go out of focus. I've had more than one student say to me over the years, "I wish I had one of those 'professional' cameras that would allow me to get exacting sharpness from front to back." They can't believe it when I tell them that they already do! They just

The choice in backgrounds can *always* be yours, *if* you know how to control the area of sharpness. This is especially true when using a telephoto lens. I made the image at left at *f*/32, assuring not only that the branch would be in sharp focus, but that the backgound would also be more defined than it is opposite due to the added depth of field that small lens openings provide. I much prefer the less defined background.

[Both photos: 80–400mm lens at 400mm. Left: *f*/32 for 1/30 sec. Opposite: *f*/5.6 for 1/1000 sec.]

have to use depth of field to their advantage. Likewise, exposures of a lone flower against a background of out-of-focus colors and shapes (like the one on page 29) are the direct result of creative use of depth of field.

What exactly influences depth of field? Several factors come into play: the focal length of the lens, the distance between you and the subject you want to focus on, and the aperture you select. I feel strongly that of these three elements, aperture is the most important.

In theory, a lens is able to focus on only one object at a time; as for all the other objects in your composition, the farther away they are from the in-focus subject—whether it be in front of or behind it—the more out of focus they will be. Since this theory is based on viewing a given scene through the largest lens opening, it's vital that you appreciate the importance of understanding aperture selection. Of course, the light reflecting off a subject makes an image on film (or digital media), but the chosen aperture dictates how well this image is "formed" on film. Optical law states that the smaller the opening of any given lens (large *f*-stop numbers—16, 22, or 32), the greater the area of sharpness or detail in the photo. When using apertures at or near wide open (smaller *f*-stop numbers—2.8, 4, or 5.6), only the light that falls on the focused subject will be rendered on film as "sharp"; all the other light in the scene—the out-of-focus light—will "splatter" across the film or sensor. In effect, this unfocused light records as out-of-focus blobs, blurs, and blips.

Conversely, when this same object is photographed at a very small lens opening, such as *f*/22, the blast of light entering the lens is reduced considerably. The resulting image contains a greater area of sharpness and detail because the light didn't "splatter" across the film plane (or sensor) but instead was confined to a smaller opening as it passed through the lens. Imagine using a funnel with a very small opening and pouring a one-gallon can of paint though it into an empty bucket. Compare this process to pouring a one-gallon can of paint into the same empty bucket without the aid of the funnel. Without the funnel, the paint gets into the bucket quicker, but it also splatters up on the bucket sides, as well. With a funnel, the transfer of paint to the bucket is cleaner and more contained.

Keeping this in mind, you can see that when light is allowed to pass through small openings in a lens, a larger area of sharpness and detail always results. Does this mean that you should always strive to shoot "neat" pictures instead of "messy and splattered-filled" ones? Definitely not! The subject matter and the depth of the area of sharpness you want to record will determine which aperture choice to use—and it differs from image to image.

Storytelling Apertures

There are three picture-taking situations for which your attention to aperture choice is paramount. The first is what I call a *storytelling* composition. This is simply an image that, like the name implies, tells a story. And like any good story, there's a beginning (the foreground subject), a middle (the middle ground subject), and an end (the background subject). Such an image might contain stalks of wheat (the foreground/beginning) that serve to introduce a farmhouse fifty to a hundred feet away (the main subject in the middle ground/middle), which stands against a backdrop of white puffy clouds and blue sky (the backgound/end).

Experienced amateurs and professionals call most often upon the wide-angle zoom lenses—such as the 35mm, 28mm, 24mm, and 20mm focal lengths—to shoot their storytelling compositions. One of the primary reasons wide-angle zooms have become so popular is that they often encompass 100 percent of the range of focal lengths that a photographer would use when shooting storytelling imagery, i.e. 17–35mm.

It sometimes happens that a storytelling composition needs to be shot with a moderate telephoto (75–120mm) or with the "normal" focal lengths (45–60mm), but regardless of the lens choice, there is one constant when making a storytelling composition: a small lens opening (the biggest *f*-stop numbers) is the rule!

Once you start focusing your attention on storytelling compositions, you may find yourself asking a perplexing question: where the heck do you focus? When you focus on the foreground stalks of wheat, for example, the red barn and sky go out of focus; and when you focus on the red barn and sky, the foreground wheat stalks go out of focus. The solution to this common dilemma is simple:

The Auto-Depth-of-Field Scale

NOTE: Some of you may own one of those new SLR (single-lens-reflex) or fixed-lens digital cameras that offer an *auto-depth-of-field scale* setup; Canon is one example. With these cameras, you can autofocus your foreground, autofocus the background, and the camera will then beep *only* if your range of depth of field is greater than the aperture choice can offer. Wow! Now that's what I call a very, very cool invention! If the camera should beep, chances are good that you're focusing on too close of a foreground, so move back a bit and focus again.

you don't focus the lens at all, but rather preset the focus via the distance settings.

There was a time when most photographers used single-focal-length lenses instead of zooms simply because they were sharper. Additionally, all single-focal-length lenses had—and still do have—what is called a depth-of-field scale. This depth-of-field scale makes it very easy to preset your focus for a given scene before you, and it offers tremendous assurance that you'll get the area of sharpness that you desire in your image. But with the proliferation of high-quality zoom lenses, most photographers have abandoned single-focal-length lenses in favor of zoom lenses. The trade-off, of course, is that we are then running around with lenses that don't have depth-of-field scales.

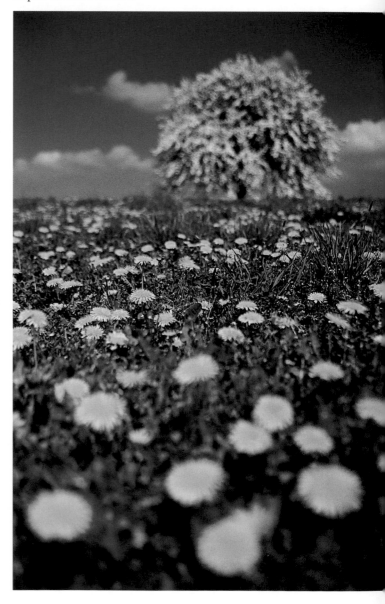

But, what we do have are *distance settings*. The distance settings are similar to the depth-of-field scale in that they allow you to preset the depth of field *before* you take your shot. And, since every storytelling composition relies on the maximum depth of field, you would first choose to set your aperture to *f/22* and then align the distance above your distance-setting mark on the lens. Your focal length will determine which distance you choose.

When I photograph a scene like this, I know I need to use great depth of field to achieve sharpness throughout. I also call upon my wide-angle-lens, in this case my 20–35mm zoom. I set my aperture to f/22 for maximum depth of field and preset my focus so that the distance of two feet is aligned directly above the center mark near the front of the lens. And as I learned long ago, when I look through the viewfinder, the scene before me is anything but sharp. This is because the viewfinders of all modern-day cameras allow for wide open viewing, meaning that even though my aperture is f/22, the image in my viewfinder is showing me the scene at a wide open aperture (opposite), in this case f/2.8. The lens won't stop down to the picture-taking aperture of f/22 *until I press the shutter release*. At that point, the sharpness will record on film (right). I obtained the desired depth of field not by refocusing the lens, but by combining a storytelling wide-angle lens with a storytelling aperture and with the focus preset via the distance scale.

[Both photos: 20–35mm lens at 20mm, f/22 for 1/30 sec.]

From foreground flowers to background mountains, the depth of field in this image is extreme. I was setting up my camera and lens to get a storytelling image of flowers and mountains, and had already shot several frames, when my daughter Sophie came running up from the hill below me. It was a photo op I couldn't pass up. With my aperture set to f/16 and my focus already preset for maximum depth of field, I shot this frontlit scene in aperture-priority exposure mode, firing off several frames.

[35–70mm lens at 35mm, f/16 for 1/60 sec.]

I was in Portland, Maine, to speak to a photography group several years ago when I made this image. My schedule was such that I had some time in the early morning to get in some shooting, and high on my list was the Portland Head Lighthouse. With a temperature of -14 degrees, it's easy to understand why I had to muster all the courage I could to leave my warm bed and go shoot. On arriving at the lighthouse, I wasn't at all surprised to see that I was the only "idiot" out and about with his camera.

As the sunrise came over the horizon, I quickly decided to use the foreground fence to create depth and scale, as well as to frame the distant lighthouse. With my lens and camera mounted on a tripod, I set the aperture to f/22 and preset the focus via the depth-of-field scale. Of course, this image appeared a bit fuzzy when I looked through the viewfinder, but I reminded myself that I was looking through the viewfinder at a wide open aperture and that once I pressed the shutter release, the lens would stop down to f/22, transforming the fuzziness to sharpness. I then adjusted my shutter speed until a correct exposure was indicated in the viewfinder. (*Note:* To take my meter reading, I first tilted the camera down to exclude the distant sunrise, and then I adjusted my shutter speed until 1/60 sec. was indicated as the correct exposure for the very, very low light cascading across the snow. I then recomposed the scene as it is here and fired away.)

[20mm lens, f/22 for 1/60 sec.]

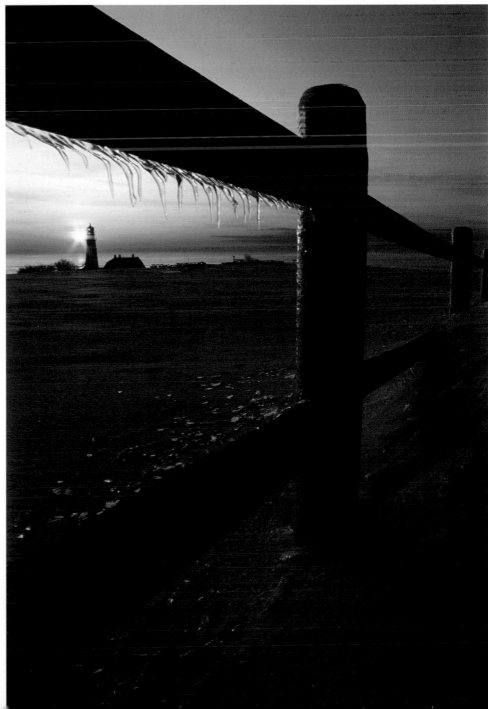

Are storytelling compositions limited to the use of wide-angle lenses? Absolutely not, but the wide-angle focal lengths are most often called upon because of their ability to encompass the wide and sweeping landscapes—and, of course, for their ability to render great depth of field.

There are certainly other compositions for which you use your telephoto lens and also want to make the entire composition sharp. In these cases, I often tell my students to simply focus one third of the way into the scene, and of course, set the lens to the smallest lens opening. Then, simply fire away. For example, most shooters aren't inclined to think of the wide-angle lens as a close-up lens, but if they did, their images would improve tenfold. When shooting wide and sweeping scenes, the tendency is to step back to get more stuff in the picture. From now on, try to get in the habit of stepping closer—closer to foreground flowers, closer to foreground trees, closer to foreground rocks, and so on. A poolside scene is one such opportunity to get close with your wide-angle lens. In the top example below, there's a lot of stuff in the scene, and the opportunity to exploit foreground color and shape has been missed. But by simply moving closer (bottom), the result is a much more graphic and color-filled image.

[Both photos: 20–35mm, f/16 for 1/125 sec.]

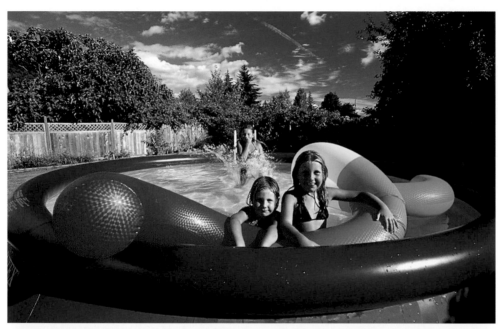

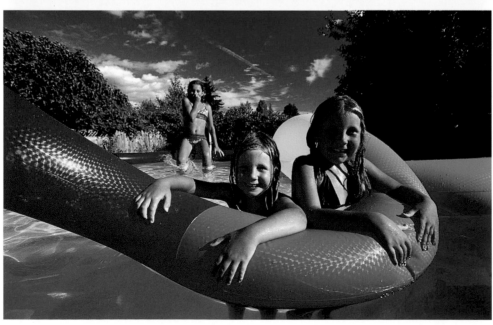

A road by its very nature acts as a powerful line that can lead the eye into a scene. After pulling onto the shoulder of this road, I set up my camera and 75–300mm lens on a tripod. I set my focal length to 130mm and my aperture to f/32, and then focused a third of the way into the scene. With my camera pointed upward to the green leaves, I adjusted the shutter speed until a -2/3 exposure was indicated—1/25 sec. instead of the recommended 1/15 sec. (See page 126 for more on this.) I then recomposed to get the scene here and fired off several frames. Presto! It's sharply in focus throughout.

[75–300mm lens at 130mm, f/32 for 1/25 sec.]

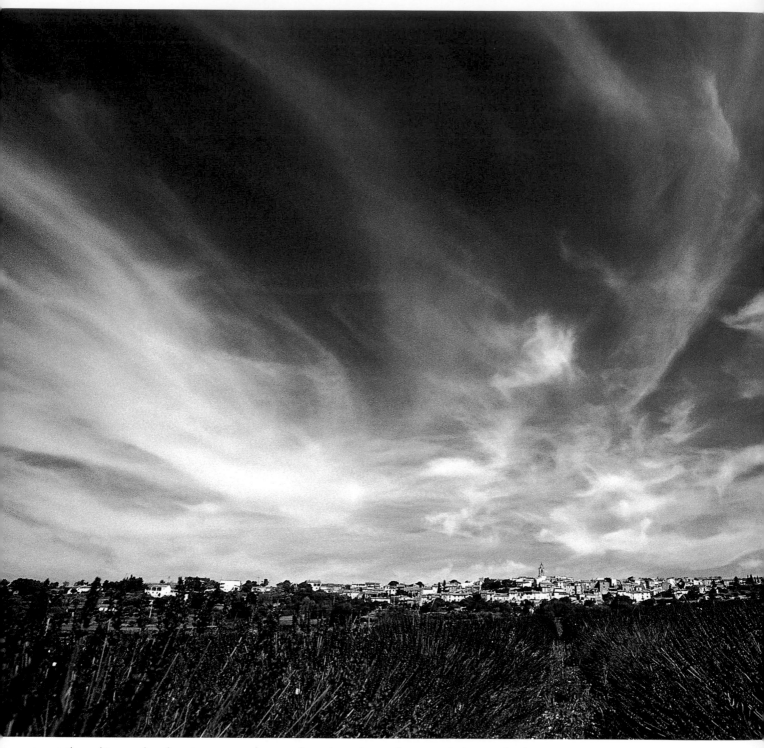

I love skies, and no lens is more capable of capturing their grandeur than the wide angle. The village of Pouimisson, surrounded by lavender fields in Provence, France, and resting peacefully under a sweeping sky offers a perfect example. If you choose a low viewpoint (above) and shoot up, make it a point to incorporate some much-needed foreground; this will create an image with great depth. Before you pick up and move on, consider laying on your back at the edge of the foreground elements (in this case, rows of lavender) and focusing your attention on a clump of foliage—combining them with the sky (opposite).

[Both photos: 20–35mm lens at 20mm, f/16 for 1/60 sec.]

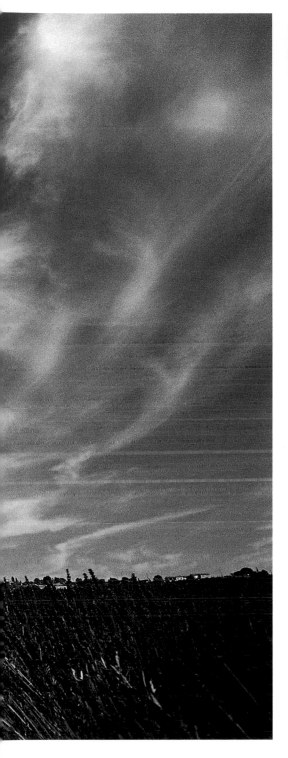

Zoom Lens Conversions for Fixed-Lens Digital Cameras

Whether you shoot with a Minolta, Olympus, Pentax, Nikon, Sony, or Canon fixed-lens digital camera, you no doubt are aware that the focal length of your zoom lens *does not* correspond to the focal-length numbers for a 35mm SLR camera. Your camera may describe the zoom lens as 7–21mm, 9–72mm, or 9.7–48.5mm.

To aid in following along in this book, when I discuss wide-angle lenses or telephoto lenses, take note of how your lens translates its angle of view into 35mm terms. The 7–21mm lens is equivalent to a 38–155mm zoom lens. The 9–72mm lens is equivalent to a 35–280mm zoom lens. And the 9.7–48.5mm lens is equivalent to a 38–190mm zoom lens.

Notice that most fixed-lens digital cameras *don't* have a focal length that offers a greater angle of view than the 62 degrees of the moderate 35mm wide-angle lens used by SLR camera owners. It's a moderate angle of view that seldom creates powerful storytelling compositions, because it's simply not a wide enough angle. So, when thinking about depth of field, keep in mind that your widest lens choice is 35mm, and that is the number you should keep in mind when presetting your lens for maximum depth of field. (See pages 38–45 for focusing for maximum depth of field.)

Fixed-Lens Digital Cameras and Depth of Field. Your fixed-lens digital camera is hopelessly plagued with an uncanny ability to render a tremendous amount of depth of field, even when you set your lens to $f/2.8$—an aperture of $f/2.8$ is equivalent to an aperture opening of $f/11$ on an SLR camera! And, when you're at $f/4$, you're able to record a depth of field equivalent to $f/16$. At $f/5.6$, you're equivalent to $f/22$. At $f/8$, you're equivalent to $f/32$, and if your lens goes to $f/11$, you're at a whopping $f/64$! Those of us who use SLRs can only dream of the vast depth of field that would result from apertures like $f/64$.

One added benefit of having apertures that render such great depth of field is in the area of exposure times. For example, if I were shooting a storytelling composition with my SLR and 35mm wide-angle lens, I would use $f/22$ for maximum depth of field. Combined with an ISO of 100 and assuming I'm shooting a sidelit scene in late-afternoon light, I'd use a shutter speed of around 1/30 sec. With this slow a shutter speed, I'd more than likely use a tripod. You, on the other hand, could choose to shoot the same scene at an aperture of $f/5.6$ (equivalent in depth of field to my $f/22$), and subsequently, you would be able to use a shutter speed that's *four* stops faster—a blazing 1/500 sec. Who needs a tripod at that speed?!

Likewise, when shooting close-ups of flowers or of dewdrops on a blade of grass (assuming you have a close-up/macro feature), you can shoot at $f/8$ or $f/11$ (equivalents of $f/32$ or $f/64$) and once again record some amazing sharpness and detail that SLR users can only dream of. And, as every SLR user knows, when photographing with a macro lens at $f/32$, we're always using our tripods since shutter speeds are often too slow to safely handhold the camera and lens. But here again, with your aperture at $f/8$ (an $f/32$ equivalent) you can photograph the same dewdrop at much faster shutter speeds—more often than not, without the need for a tripod.

So, is there a downside to these fixed-zoom-lens digital cameras, other than the absence of a true wide-angle lens? Yes, there is: You can't be nearly as successful when shooting *singular-theme/isolation* compositions (see pages 48–55) as SLR shooters can. Even with your lens set to the telephoto length, and with your aperture wide open, you'll struggle with most attempts to render a background that remains muted and out of focus. Remember, even wide open—at $f/2.8$, for example—you still have a depth of field equivalent to $f/11$ on an SLR. There are accessories coming onto the market that can help in times like this (auxillary lenses, close-up filters, and such), but by the time you add it all up, you realize that you could have spent about the same amount of money for an SLR system.

And finally, most fixed-zoom-lens digital cameras *do not* have any kind of distance markings on the lens, so you won't be able to manually set the focus for maximum depth of field as I've described for the SLR users. Instead, you'll have to rely on estimating your focused distance when shooting storytelling compositions. To make it as easy as possible, do the following: With your lens set to $f/8$ or $f/11$ and at the widest focal length (7–9mm), focus on something in the scene that's five feet from the camera. Then, adjust your shutter speed until a correct exposure is indicated and simply shoot! Even though objects in the viewfinder will appear out of focus when you do this, you'll quickly see on your camera's display screen that those same objects record in sharp focus after you press the shutter release.

Normally, a scene like this one in Old Lyon would find me reaching for my Nikon F5 or D1X and tripod, but I had chosen to travel light on this particular evening with my Nikon Coolpix 5700. Fortunately, like most digital point-and-shoot cameras, the Nikon Coolpix offers up some tremendous depth of field, *even* when I use an aperture of *f*/4 (the equivalent of *f*/16 on a 35mm camera). Since I didn't have a tripod, I was grateful for the depth of field the Coolpix affords me while still allowing me to shoot at safe handholding shutter speeds. With my lens set to 60mm (roughly 200mm in 35mm terms) and my aperture at *f*/4, I adjusted my shutter speed to 1/30 sec.

Using the Nikon Coolpix may beg the question, "Why not just use this camera all the time, especially since it seems to eliminate the need for a tripod?" There are several reasons, the most important being that the file size is much too small for my commercial clients.

[Nikon Coolpix 5700 at 60mm, *f*/4 for 1/30 sec.]

Singular-Theme Apertures

The second picture-taking situation for which your attention to aperture choice is paramount is when making what I call a *singular-theme* or *isolation* composition. Here, sharpness is deliberately limited to a single area in the frame, leaving all other objects—both in front of and behind the focused object—out-of-focus tones and shapes. This effect is a direct result of the aperture choice.

Since the telephoto lens has a narrow angle of view and an inherently shallow depth of field, it's often the lens of choice for these types of photographic situations.

When combined with large lens openings (*f*/2.8, *f*/4, or *f*/5.6), a shallow depth of field results. A portrait, either candid or posed, is a good candidate for a telephoto composition, as is a flower and any other subject you'd like to single out from an otherwise busy scene. When you deliberately seek out to selectively focus on one given subject, the blurry background and/or foreground can call further attention to the in-focus subject. This is a standard "visual law" often referred to as *visual weight*: whatever is in focus is understood by the eye and brain to be of greatest/most importance.

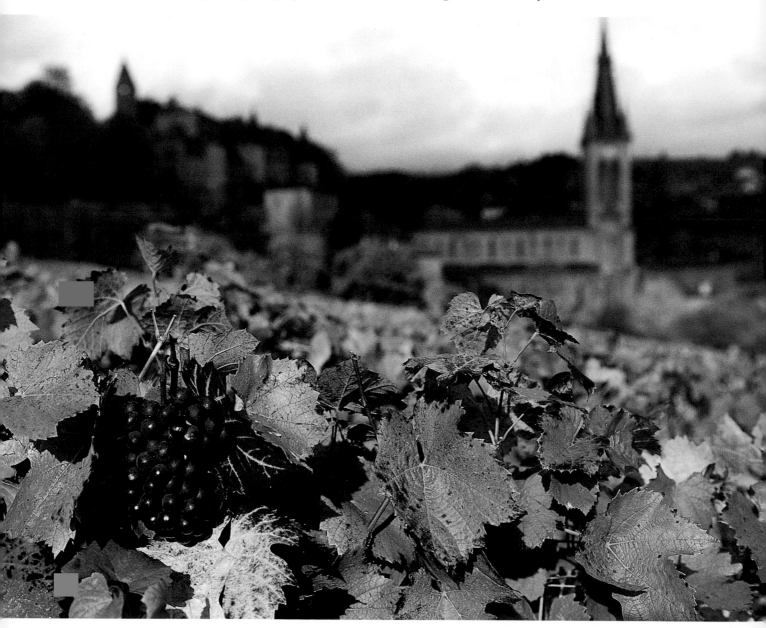

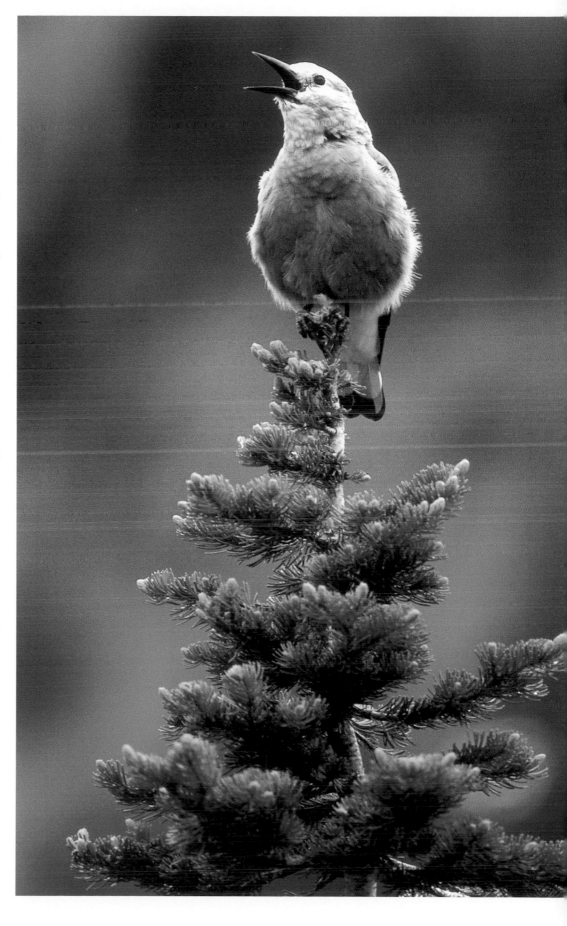

Sitting at the campfire, I was visited by a lone Clark's Nutcracker, or "Camp Robber" as some campers like to call these birds—and for good reason, too, as they're very brave and can carry off small items. Setting my focal length to 300mm, I was able to limit the composition to the top of the tree and the bird. Since my distance to the bird was relatively close and since the background trees were twenty feet or so behind this one, the bird was clearly isolated. An aperture of *f*/5.6 kept the bird isolated from the background.

[75–300mm lens at 300mm, *f*/5.6 for 1/500 sec.]

A lone grape cluster showcased against an out-of-focus village places the compositional emphasis on the grapes. Placing the visual weight on the grapes was only possible via the right aperture choice. With my camera and 35–70mm lens on a tripod, and the lens set to 35mm, I was able to encompass a moderately wide and sweeping vision of the surrounding vineyard and village in Beaujolais, France. Moving in close, I focused on the lone cluster of grapes, set the aperture to *f*/4, and then adjusted the shutter speed.

[35–70mm lens at 35mm, *f*/4 for 1/250 sec.]

The Depth-of-Field Preview Button. Is there any tool on the camera that can help determine the best aperture choice for singular-theme compositions? Yes, there is: the depth-of-field preview button. However, this button isn't found on all cameras. And unfortunately, even when it is present, it is often the most misunderstood feature on the camera.

The purpose of this button is simple: when the button is depressed, the lens stops down to whatever aperture you've selected, offering you a preview of the overall depth of field you can expect in your final image. This enables you to make any necessary aperture adjustments, thereby correcting an instance of "incorrect" or unwanted depth of field before recording the exposure.

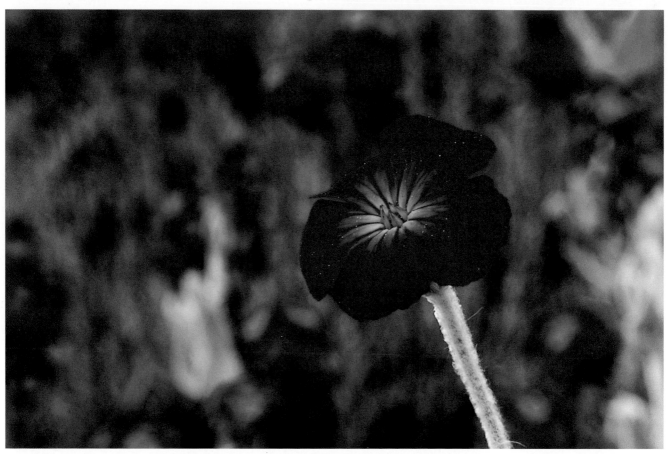

EXERCISE: Mastering the Button

As simple as the depth-of-field preview button is to use, it initially confuses many photographers. A typical comment I hear from students in my workshops is, "I press it and everything just gets dark." Overcoming this distraction isn't at all difficult; it just takes practice. If your camera does indeed have a depth-of-field preview button, try this exercise: First, set your aperture to the smallest number—$f/2.8$, $f/3.5$, or $f/4$, for example. With a 70mm or longer lens, focus on an object close to you, leaving enough room around the object that an unfocused background is visible in the composition. Then, depress the depth-of-field preview button while looking through the viewfinder.

Nothing will happen. But now change the aperture from wide open to $f/8$ and take a look, especially at the out-of-focus background. You no doubt noticed the viewfinder getting darker, but did you also notice how the background became more defined? If not, set the aperture to $f/16$ and depress the button again, paying special attention to the background. Yes, I know the viewfinder got even darker, but that once-blurry background is quite defined, isn't it?

Each time the lens opening (the aperture) gets smaller, objects in front of and behind whatever you focus on will become more defined—in other words, the area of sharpness (the depth of field) is extended.

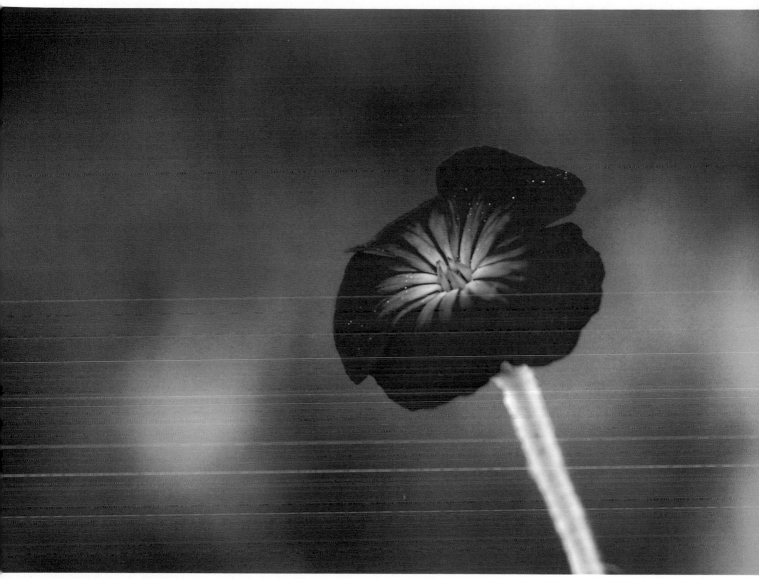

Now, head outside with a telephoto lens, say a 200mm, and set your aperture to *f*/16. Frame up a flower or a portrait. Once you focus on your subject, depress the depth-of-field preview button. Things will become quite a bit darker in your viewfinder since you've stopped down the aperture, but more importantly, take note of how much more defined the areas both in front of and behind the subject become. If you want to tone down all that busy stuff around the subject, set the aperture to *f*/5.6. The background will be less defined. Overly busy compositions that are meant to convey a singular theme can easily be fixed with the aid of the depth-of-field preview button.

In the first example at *f*/22 (opposite), note how busy the image is and how the main flower is not alone. Fortunately, I was able to see this when I depressed my depth-of-field preview button, and at that point, moved down toward the smaller aperture numbers—all the while looking through the viewfinder while keeping the depth-of-field preview button depressed. This allowed me to see the once-busy background slowly fade to blurry tones, resulting in a lone-flower composition (above) at an aperture of *f*/5.6. The soft and muted colors of the out-of-focus background serve to emphasize the importance of the single flower in the photograph. Clearly, I wanted all the attention on this lone flower, and the one sure way to achieve this is to use a large lens opening. A large lens opening, especially when combined with a telephoto lens, renders shallow depth of field.

[Both photos: 75–300mm lens at 280mm. Opposite: *f*/22 for 1/30 sec. Above: *f*/5.6 for 1/500 sec.]

The Poor Man's Depth-of-Field Preview Button

Those of you without a depth-of-field preview button may feel you're missing out on a valuable tool. Well, you are, but there are two solutions: If you insist on having a depth-of-field preview button, you can buy a new camera (hopefully the same make as your current one so that you don't have to buy all new lenses, too). Or, there's the less-expensive approach: Before shooting a singular-theme or isolation image and while still looking through the viewfinder, turn your lens one quarter of a turn or so (as if you were going to remove it from the camera body, but don't actually remove it). When you do this, you'll see the actual depth of field that the chosen aperture will render. (The viewfinder will also become darker in the same way it does when pressing an actual depth-of-field preview button.)

This is the poor man's depth-of-field preview button. At this point, take note of how much stuff comes into play behind and in front of the subject you're trying to isolate. If you're satisfied with the way the background is being rendered, click the lens back on and fire away. If not, and you want a less-defined background, open up the lens to the next *f*-stop (for example, from *f*/5.6 to *f*/4), and then execute the quarter lens turn again and take another look.

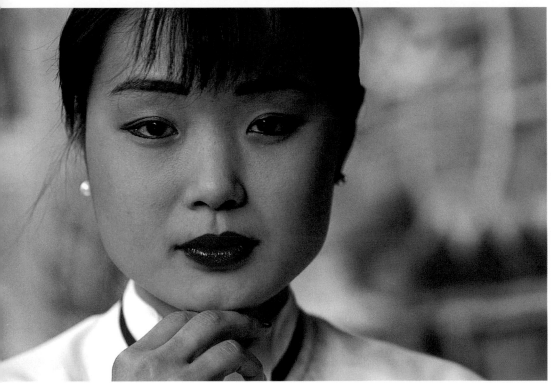

Rendering colorful backgrounds is an easy proposition, if you combine the use of a telephoto lens, a large lens opening, and a colorful background subject. Take a look at this portrait. I used a telephoto lens and shallow depth of field to render the background an area of colorful muted tones. The woman was about ten feet from the background, which was a large colorful piece of fabric that I had my assistant hold behind her. I made the shot in aperture-priority automatic mode, letting the camera's light meter set the exposure for me.

[75–300mm lens at 200mm, *f*/5.6]

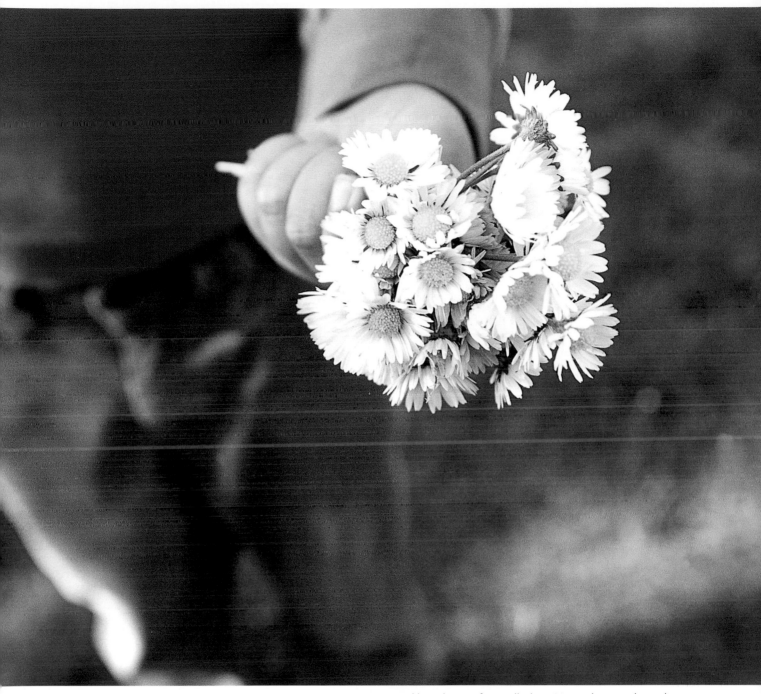

Although not often called upon to create singular-theme images, the wide-angle lens can also be a useful tool for isolating subjects—*if* you combine the close-focusing abilities of the lens with an isolating aperture, such as f/2.8 or f/4.

Here, due to a large lens opening, the depth of field is severely limited, keeping the visual weight of the image where I wanted it—on the freshly picked bouquet.

[35–70mm lens at 35mm, f/2.8 at 1/1000 sec.]

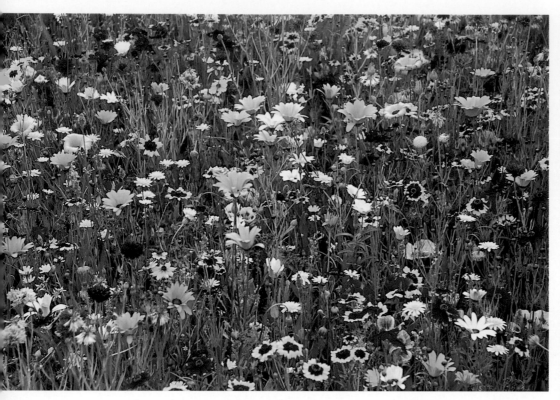

Scenes like this will make you wish for extra film, or extra batteries and flash cards in the case of digital. There's so much photographic opportunity in a field of wildflowers, not the least of which is the opportunity to isolate. After spending some time photographing the multitude of random patterns in the field with my 35–70mm lens (above), I switched to my 75–300mm lens and started seeking out the numerous lone flower opportunities. Needless to say, it was a visual feast, and the image on the facing page was just one of the many singular-theme images I got that day.

[Above: 35–70mm lens at 50mm, f/11 for 1/30 sec. Opposite: 75–300mm lens at 300mm, f/5.6 for 1/125 sec.]

"Who Cares?" Apertures

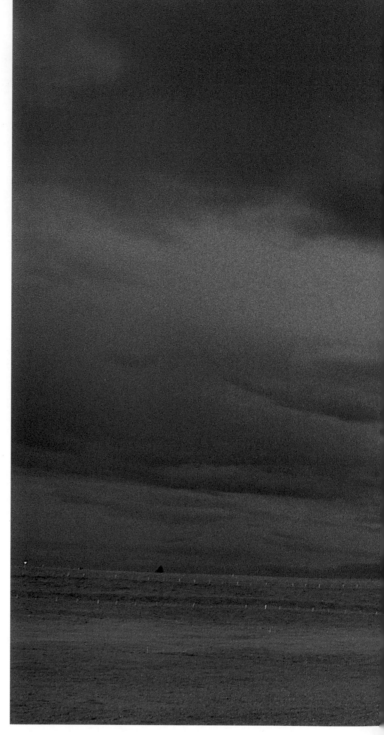

I f it's not a storytelling opportunity and it's not a singular-theme/isolation opportunity, does it really matter what aperture you use? Yes and no. Let me explain. The world is filled with *"Who cares?"* compositions: "Who cares what aperture I use when shooting a portrait against a stone wall?" "Who cares what aperture I use when shooting autumn leaves on the forest floor?" Or, put another way, "Who cares what aperture I use when everything in my frame is at the same focused distance?"

In the storytelling and singular-theme/isolation sections, not one of the images was made with an aperture of *f*/8 or *f*/11. That's certainly not because I don't ever use these apertures; I use them a lot, actually, but *only* when depth of field is not a concern. Both *f*/8 and *f*/11 are what I refer to as middle-of-the-road apertures; they rarely tell a story (rendering all the visual information within a great depth in sharp focus), and they rarely isolate (rendering only a limited, selective amount of visual information in sharp focus).

Pretend for a moment that you find yourself walking along a beach. You come upon a lone seashell washed up on the smooth sand. You then raise your camera and 28–80mm lens to your eye, set the focal length to 50mm, look straight down, and then simply set the aperture to *f*/8 or *f*/11. In this instance, both the lone seashell and the sand are at the same focused distance, so you could photograph this scene at any aperture. This approach of "not caring" about what aperture you use applies to any composition where the subjects are at the same focal distance. However, rather than randomly choose an aperture, as some shooters do, I recommend that you use *critical aperture*. This is, simply, whichever aperture yields the optimum image sharpness and contrast. Apertures from *f*/8 to *f*/11 are often the sharpest and offer the greatest contrast in exposure.

To understand why apertures between *f*/8 and *f*/11 are so sharp, you need to know a little bit about lens construction and the way light enters a lens. Most lenses are constructed of elliptically shaped glass elements. Imagine for a moment that within the central area of these elliptical elements is a magnet—which is often called the "sweet spot"—designed to gather a specific amount of light and then funnel it through to the waiting film. The approximate diameter of this sweet spot is equivalent to the diameter *f*/8–*f*/11. So, for example, when the light enters a lens through a wide open aperture, such as *f*/2.8, the amount of light exceeds the area of the sweet spot and in turn scatters across the entire elliptical range and eventually onto the film. The effect is similar to pouring milk onto an upside-down bowl: only a little milk remains on the center while most of the milk spills off to the sides. Due to the scattering of the light, a wide open aperture doesn't provide the kind of edge-to-edge sharpness that apertures of *f*/8 to *f*/11 can. When light passes through apertures of *f*/8 to *f*/11, it is confined to the sweet spot on the elliptical glass.

So, *who cares* what aperture you use when shooting compositions where depth of field concerns are minimal at best? You should! And, ironically, you should use "Who cares?" apertures (*f*/8–*f*/11), if you want critical sharpness and great contrast.

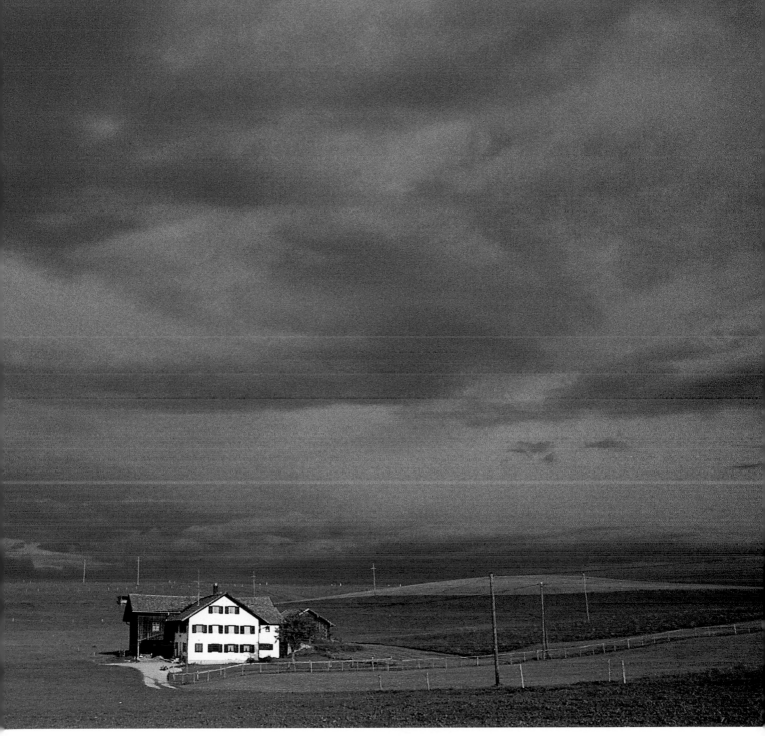

An incoming storm from the west lit by the early-morning frontlight was reason enough to stop my car and shoot this lone farmhouse. I used a critical aperture of f/8, pointed the camera down toward the green pasture, and adjusted my shutter speed until a -2/3 was indicated. (See page 126 for more on metering green.) I then recomposed and tilted the camera up toward the threatening sky before firing off several frames. "Who cares" what aperture you use when shooting landscapes such as this? After all, everything was at the same focal distance (infinity). But critical apertures matter.

[35–70mm lens at 35mm, f/8 for 1/60 sec.]

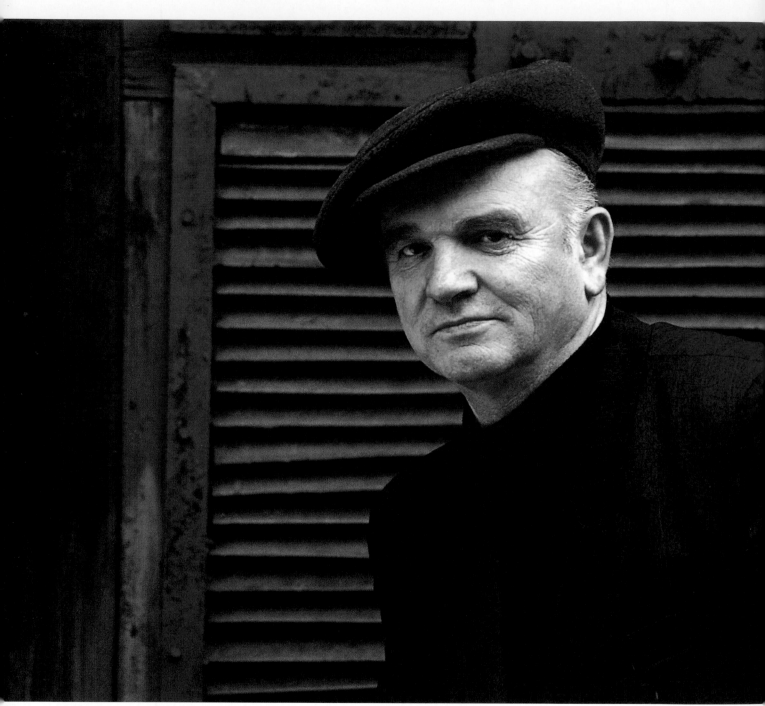

"Who cares" what aperture you use when shooting a portrait against a wall? With my camera and 80–200mm lens mounted on a tripod, and my focal length set to 135mm, I chose a critical aperture of f/8 and then adjusted my shutter speed.

[80–200mm lens at 135mm, f/8 for 1/125 sec.]

When everything in a scene is at the same focal distance from the lens, depth of field is of no great concern ("Who cares?"). However, this type of situation provides a great opportunity to use my critical apertures. When shooting this colorful wall outside a pizza shop in Aix en Provence, France, I handheld my camera and 35–70mm lens, and set the aperture to f/8. (I adjusted the shutter speed until 1/125 sec. indicated a correct exposure in the viewfinder.)

[35–70mm lens at 70mm, f/8 for 1/125 sec.]

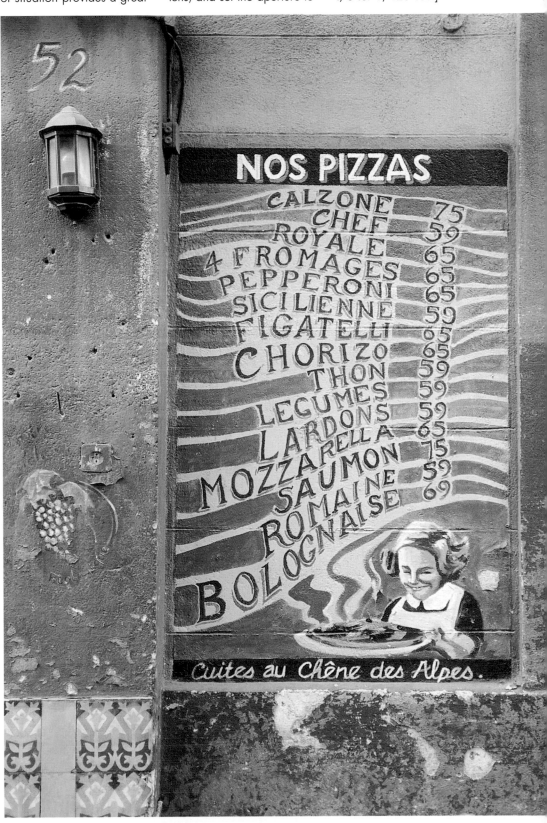

Agraphic pattern of line and color surrounds my beautiful wife. "Who cares" what aperture I use, since my point of view from above puts everything at the same focal distance? With a focal length of 35mm, I set the aperture to *f*/11 and shot in aperture-priority mode, allowing the camera to set the exposure for the mid-afternoon frontlight.

[35–70mm lens at 35mm, *f*/11 for 1/250 sec.]

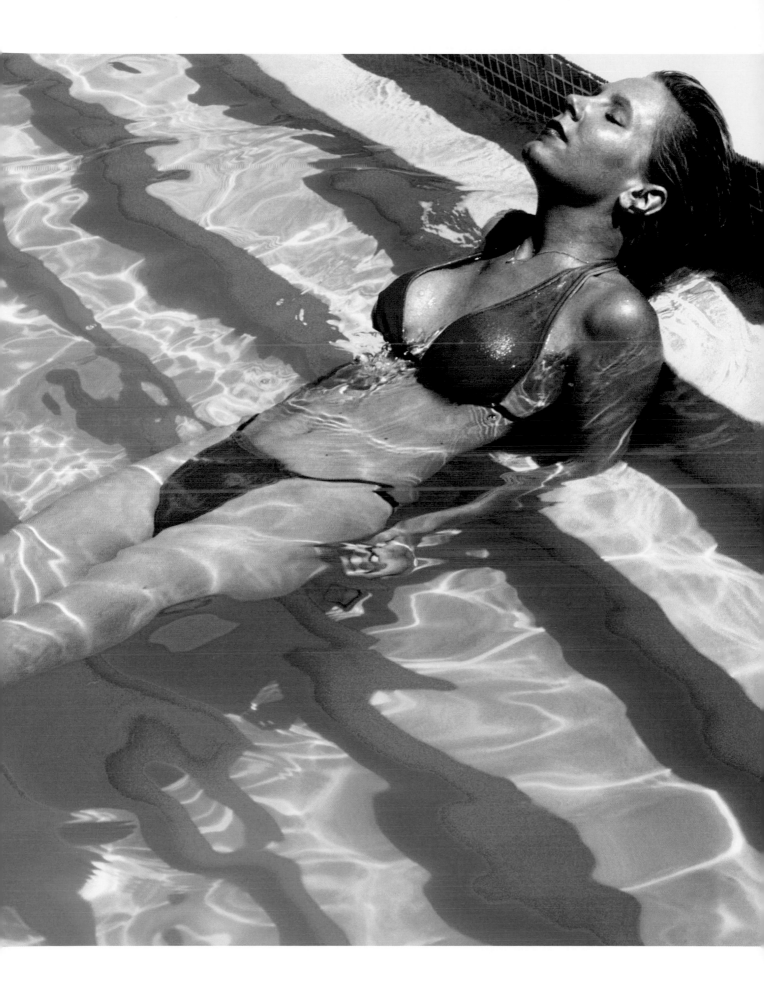

Aperture and Macro Photography

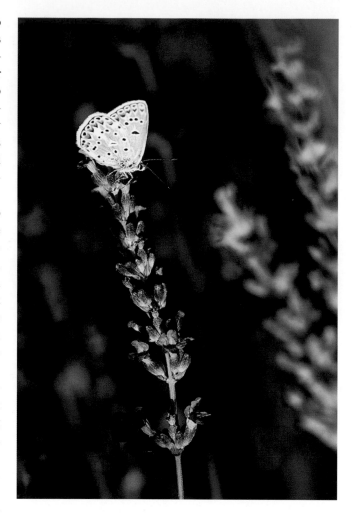

Close-up, or macro, photography continues to enjoy great popularity with both amateurs and professionals. While such obvious subjects as flowers, and butterflies and other insects are ideal for beautiful close-up images, don't overlook the many other close-up opportunities that await in junkyards and parking lots. In my courses, I've noticed more and more that my students are turning their macro gear toward the abstract and industrial world, and coming away with some truly compelling close-ups.

When it comes to working at such close proximity to your subject, you'll soon discover that many of the same principles about aperture in the "big world" apply equally to the small world of the close-up. For instance, although the world is smaller—much, much smaller in some cases—you still must decide if you want great depth of field (one to two inches of sharpness in the macro world) or limited depth of field (one quarter of an inch). Or, maybe your subject is a close-up that falls into the "Who cares?" aperture category.

There are differences between regular and macro photography, however. When you shoot close-ups, it's not at all uncommon to find yourself on your belly, supporting your camera and lens with a steady pair of elbows, a small bean bag, or a tripod with legs level to the ground. The slightest shift in point of view can change the focus point dramatically. And, since the close-up world is magnified, even the slightest breeze will test your patience—what you feel as a 5 mph breeze appears as a 50 mph gust in your viewfinder.

In addition, since depth of field *always* decreases as you focus closer and closer to your subject, the depth of field in macro photography is extremely shallow. The depth of field in close-up photography extends one-fourth in front of and one-half beyond the focused subject, while in regular photography the depth of field is distributed one-third in front of and two-thirds beyond the subject. Needless to say, critical focusing and, again, a steady pair of elbows, a bean bag, or a tripod are essential in recording exacting sharpness when shooting close-ups.

Have you ever noticed that the macro feature on your zoom lens will oftentimes just stop short of focusing really close? The solution to this dilemma is extension tubes. Normally sold in sets of three, these hollow metal tubes fit between your camera and lens, allowing the lens to focus even closer. As you can see in the first example here (opposite), my 75–300mm lens with macro falls short of offering a true close-up of the butterfly.

To get closer and attain exacting sharpness (right), I did the following: With my camera and lens mounted on tripod, I chose an aperture of f/5.6 to keep depth of field limited and adjusted my shutter speed until 1/1000 sec. indicated a correct exposure in the early-morning light. I then added a 12mm extension tube and was able to move in and focus really close, filling the frame with the butterfly and lone flower supporting it. Since depth of field diminishes the closer you focus, I was careful to choose a viewpoint that placed the side of the butterfly parallel to me. I then adjusted the shutter speed until 1/60 sec. indicated a correct exposure.

[Opposite page: 75–300mm lens at 75mm, f/5.6 for 1/100 sec. Right: 75–300mm lens at 300mm, 12mm extension tube, f/5.6 for 1/60 sec.]

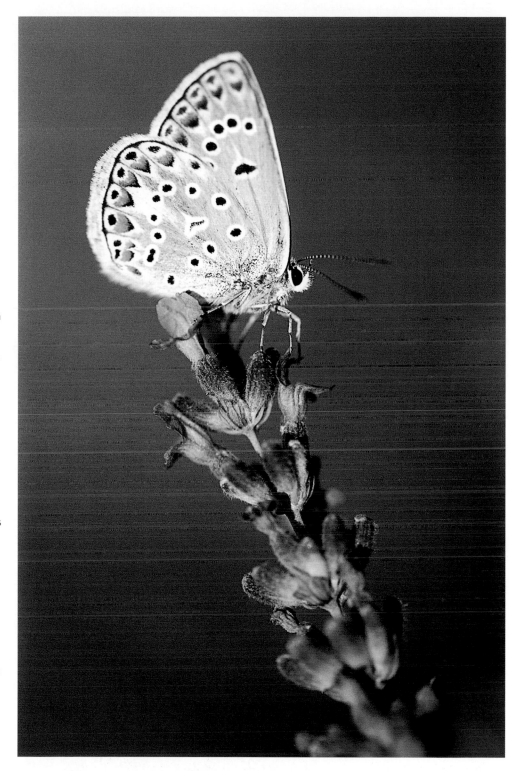

By placing this lone feather on a rock, I created a composition that offered a great excuse to break out my macro lens for some really close-up photography.

With my aperture set to f/22, I adjusted the shutter speed until 1/15 sec. indicated a correct exposure in the camera viewfinder, and with the camera's self-timer engaged, I then fired off several shots.

[Nikkor Micro 70–180mm lens at 180mm, f/22 for 1/15 sec.]

Macro Accessories and the Advantage of Fixed-Lens Digital

There are various photographic accessories available to make close-up photography possible. For all of the SLR shooters, you have macro lenses or zoom lenses with a macro or close-focus feature, as well as extension tubes, macro converters, and close-up filters, which are all designed to get you "up close and personal."

For those of you using a fixed-lens digital camera, you can also use close-up filters, or in some cases your camera manufacturer may offer a macro/close-up lens that screws into the front of your lens. For fixed-lens digital shooters, the world of close-up photography offers closeness that 35mm SLR camera users can only dream of. As explained on page 46, $f/11$ on a fixed-lens digital is equivalent to $f/64$ on a 35mm SLR. That's one heck of a lot of depth of field at your disposal! And, if truth be told, all of us 35mm SLR camera users—film or digital—are envious of you and your fixed-lens digital for this reason, if for this reason only. Sure, I have a macro lens that can go to $f/32$, but to go one stop further to $f/64$. . . oh, that would be so nice. It could make such a difference in much of my close-up work.

Granted, shutter speeds are already slow enough when I shoot at $f/32$, but even so, I would patiently wait hours if necessary for the breeze to stop just so that I could use an $f/64$. And here's another bit of good fortune for those fixed-lens digital shooters who have an $f/11$ aperture: not only do you get to record some amazing depth of field, but you can do so at relatively fast shutter speeds since your aperture remains at $f/11$ even though it renders depth of field equivalent to $f/64$! If you've ever wanted an excuse to shoot some amazing close-ups, this is certainly a good one. All that remains is to determine whether your lens offers a close-focus feature or a close-up lens attachment. I sure hope so!

Turning your attention to the industrial world can lead to some exciting discoveries. This paint-chipped, rusty door is a perfect example. With a subject like this, take your pick from the various abstract shapes, and then move in really close. It's almost an aerial view of a distant blue lake framed by the massive outcroppings of sandstone rocks. With my camera and lens mounted on tripod, I used an aperture of f/16. Since there was an overcast sky, I chose to shoot in aperture-priority mode, allowing the camera to set the exposure for me.

[Both images: Nikkor Micro 70–180mm lens, f/16 for 1/8 sec.]

Just how close can you get to your subjects? With the aid of a small extension tube on a wide-angle lens, you can get really close. This is actually a rose. I used a 35–70mm lens, a tripod, and a small 12mm extension tube, and was soon lost in a world of sensuality, curvilinear lines, and tones. Since I wanted to render the softer shapes and hues of the rose in a highly charged, sensual way, it was critical that I use a large lens opening—in this case, f/4—not a small one.

[35–70mm lens at 35mm, 12mm extension tube, f/4 for 1/60 sec.]

Do you need an excuse to wake up early? Here it is: early morning is the best time to get lost in fields and meadows covered with dew. With my 35–70mm lens in 35mm macro/close-focus mode, I came upon a blade of grass with not one but two dewdrops hanging on it. To give these dew-drops a sense of place, I set my aperture to f/22 and was able to render them in sharp detail while at the same time including the out-of-focus shape of a distant tree in the background. For a different macro look—the two drops all by them-selves—I switched to my Micro-Nikkor 70–180mm lens. With my camera resting on a small beanbag support, I was able to sharply render the two lone dewdrops *and* the upside-down fish-eye reflections (of the tree and field beyond) that where within each drop. I used a cable release to trip the shut-ter and shot a few exposures in between the very light breeze blowing through the meadow. Crawling around this field in my rain pants proved to be a good idea.

Above: 35–70mm lens at 35mm (macro/close-up mode), f/22 for 1/8 sec. Opposite: Micro-Nikkor 70–180mm lens at 180mm, f/32 for 1/4 sec.]

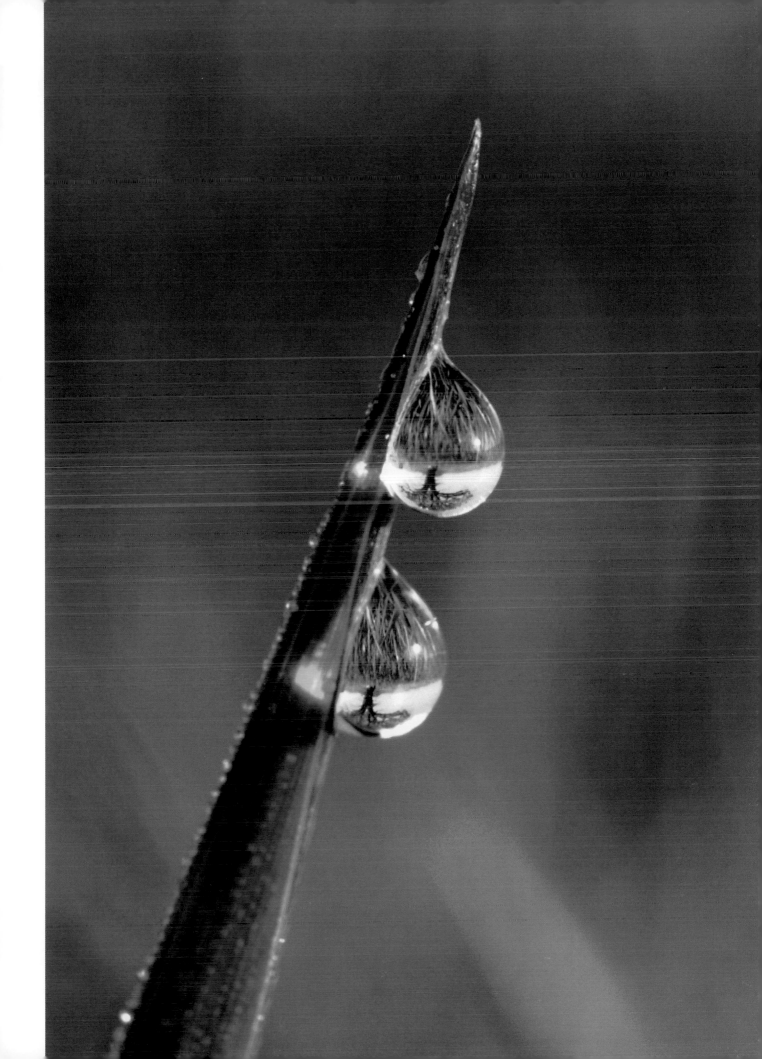

Aperture and Specular Highlights

You've undoubtedly seen your share of movies that contain night scenes shot on well-illuminated streets. Did you notice that when the camera focused in close on the characters, the background lights appear as out-of-focus circles or hexagons of color? Like the idea of visual weight, this is another optical phenomenon: in close-up photography, any out-of-focus spots of light appearing inside the viewfinder will record on film or digital media in the shape of the aperture in use. Additionally, the distance between the main subject and the background lights determines just how large and diffused the out-of-focus spots will be. The spots are also called *specular highlights*.

To produce a background of out-of-focus circles, you must use a wide-open aperture. This is the only aperture that is 100 percent circular in shape. All other apertures are hexagonal. So, whether you're using a macro lens (for which a wide-open aperture may be $f/2.5$ or $f/4$) or a telephoto zoom with the "macro" setting or extension tubes on your 35–70mm zoom (when wide open is $f/3.5$ or $f/5.6$), you must physically set the aperture to the wide-open setting if you want to record circular shapes.

If you have a fondness for hexagonal shapes, simply use any aperture *except* wide open. The sooner you put yourself in positions to explore and exploit these out-of-focus shapes, the sooner you can begin to record compositions of great graphic symbolism.

Finally, don't forget to photograph the sun. I've arrived in countless meadows at dawn or just before sunset, and focused my close-up equipment on a single of blade of grass or seed head, framing it against a large and looming out-of-focus "ball" of light. What I recorded was, of course, not the actual sun itself, but rather a circular record of its distant rays of light.

EXERCISE: Christmas Lights—Not Just for the Holidays

Grab a string of Christmas tree lights and, in a dark room, plug them in. From across the room, look at the lights through your close-up lens (either an actual macro lens, a zoom lens with a macro/close-focus setting, or a short telephoto lens with an extension tube). Now place your hand out in front of the lights and focus your camera on your hand until it's sharp. You should see a host of out-of-focus shapes of light behind your hand.

Again, to record these out-of-focus shapes as circles, you must use a wide-open aperture (the smallest aperture number). To record these shapes as hexagons, consider shooting at $f/8$ or $f/11$. If your camera has a depth-of-field preview button, press it once you've set the aperture to $f/8$ or $f/11$, and note how the shapes change from circles to hexagons.

Now that you've practiced on Christmas tree lights, consider putting this technique to work at any time of year. Theater marquees, building lights, and even car head- and taillights can be rendered as out-of-focus spots of light. Simply look at any of these subjects with your close-up equipment from a distance of ten to twenty feet and enjoy the light show. For those shooting with film cameras, these specular highlights can be great elements when shooting double exposures of city scenes at dusk or nighttime. Shoot the a version of the scene in focus, and then another out of focus.

The sun is going down and you're just wrapping up another afternoon close-up shoot, but before turning in, why not take a look at the setting sun? With my Micro-Nikkor 105mm set to wide open, f/4, I framed the lone dandelion seed head against the remnants of a setting sun. The large, out-of-focus specular highlight filled my viewfinder nicely. Titling the camera upward and metering the sky above this ball of light, I adjusted the shutter speed to 1/500 sec. and then recomposed.

[105mm micro lens, f/4 for 1/500 sec.]

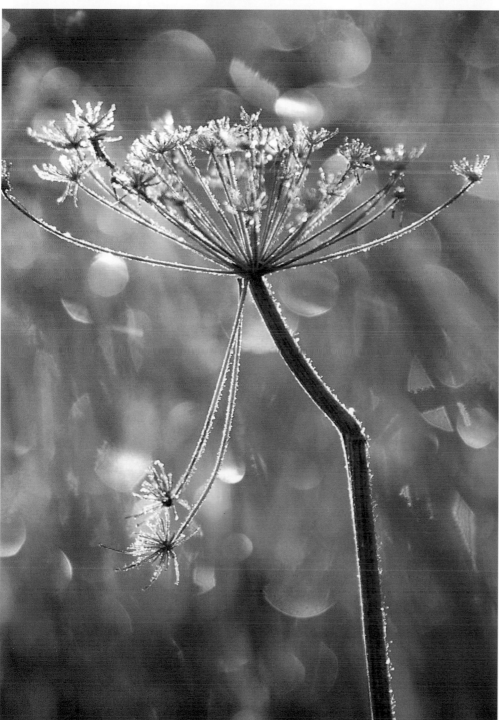

My brother Jim promised me but one day off, slave driver that he is, if I would help him build his new home this past winter in Kodiak, Alaska. When my day off arrived, I bolted out the door at dawn and into the arctic cold. I didn't have far to go before I was immersed in the world of close-ups, framing a lone seed head against a backdrop of out-of-focus and colorful specular highlights. With a wide-open aperture of f/4, I was assured of recording round shapes. Due to the strong backlight, I set my exposure for the light falling on the grass near my feet, adjusted the shutter speed to 1/125 sec., and then recomposed.

[70–180mm micro lens at 180mm, f/4 for 1/125 sec.]

Shutter Speed

The Importance of Shutter Speed

The function of the shutter mechanism is to admit light into the camera—and onto the film or digital media—for a specific length of time. All SLR cameras, film or digital, and most digital point-and-shoot cameras, offer a selection of shutter speed choices. Shutter speed controls the effects of motion in your pictures, whether that motion results from you deliberately moving the camera while making an image or from your subjects moving within your composition. Fast shutter speeds freeze action, while slow ones can record the action as a blur.

Up until now, our discussion has been about the critical role aperture plays in making a truly creative exposure. That's all about to change as shutter speed takes center stage. There are two situations in which you should make the shutter speed your first priority: when the scene offers motion or action opportunities, or when you find yourself shooting in low light without a tripod. The world is one action-packed, motion-filled opportunity, and choosing the right shutter speed first and then adjusting the aperture is the order of the day for capturing motion in your images.

Ever on the lookout for fresh points of view, you can imagine my enthusiasm when I discovered that the folks at Bogen had an array of attachments that would allow me to use my camera almost anywhere. This is especially useful when interpreting motion photographically. Their Super Clamp, Magic Arm, or Suction Cup will take you places you could only dream of before. With the Bogen Magic Arm attached to the handlebars of this scooter, I was able to capture what I call a road's-eye view of a scooter in motion. Once I attached my Nikon N90 and 20–35mm zoom lens to the other end of the Magic Arm, I looked through the viewfinder and set the focal length to 20mm. This provided the wide and sweeping view I was seeking. Since it was an overcast day, the light levels throughout the city streets were relatively consistent no matter where my wife scootered. For that reason, I set the camera to shutter-priority mode, choosing a shutter speed of 1/15 sec. In this mode, the camera would now set the correct exposure for me via the right choice in aperture. Finally, I mounted the receiver of my Nikon Infrared remote shutter release onto the camera's hot shoe (normally where one puts an electronic flash) and told my wife, "Okay, go!" Running alongside her and holding the remote shutter release, I fired at will and soon had thirty-six exposures.

This idea of attaching your camera to things that move is certainly not limited to scooters; there are bicycles, cars, skateboards, shopping carts, strollers, and lawnmowers to name just a few. With a Bogen clamp, a whole world of motion-filled opportunities awaits.

[20–35mm lens at 20mm, 1/15 sec.]

Basic Shutter Speeds

Although standard shutter speeds are indicated on the shutter speed dial or in your viewfinder as whole numbers—such as 60, 125, 250, and 500—they are actually fractions of time (i.e. fractions of 1 second): 1/60 sec., 1/125 sec., 1/250 sec., and 1/500 sec. If you bought your camera within the past five years, you've no doubt discovered that your camera offers shutter speeds that fall between those ones, for example going from 1/60 sec. to 1/80 sec. to 1/100 sec. to 1/125 sec. to 1/160 sec. to 1/200 sec. to 1/250 sec. and so on. These additional shutter speeds are useful for fine-tuning your exposure, and I discuss this idea in greater detail on the chapter on light (see pages 94–135 for more).

In addition to these numbers, most cameras offer a B setting as part of the shutter speed selection. B stands for bulb, but it has nothing to do with electronic flash. It is a remnant from the early days of picture-taking when photographers made an exposure by squeezing a rubber bulb at the end of their cable release, which was attached to the camera shutter release. Squeezing the bulb released air through the cable, thereby locking the shutter in the open position until the pressure on the bulb was released. Today, when a photographers want to record exposures that are longer than the slowest shutter speed the camera will allow, they use the B setting, along with a cable release and a tripod or very firm support.

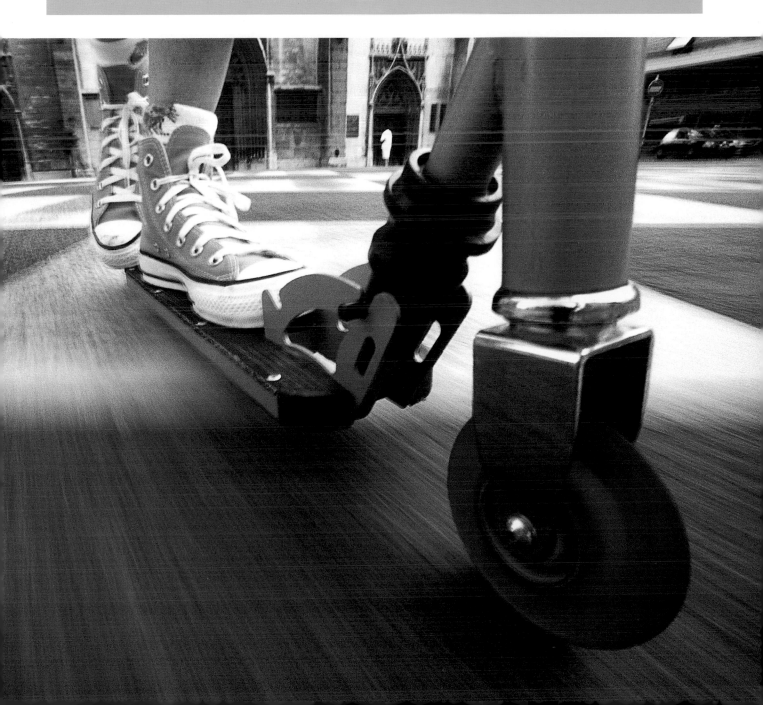

The Right Shutter Speed for the Subject

If ever there was a creative tool in exposure that could "turn up the volume" of a photograph it would have to be the shutter speed! It is *only* via the shutter speed that photographers can freeze motion, allowing the viewer's eye to study the fine and intricate details of subjects that would otherwise be moving too quickly. And *only* with the aid of the shutter speed can photographers imply motion, emphasizing existing movement in a composition by panning along with it.

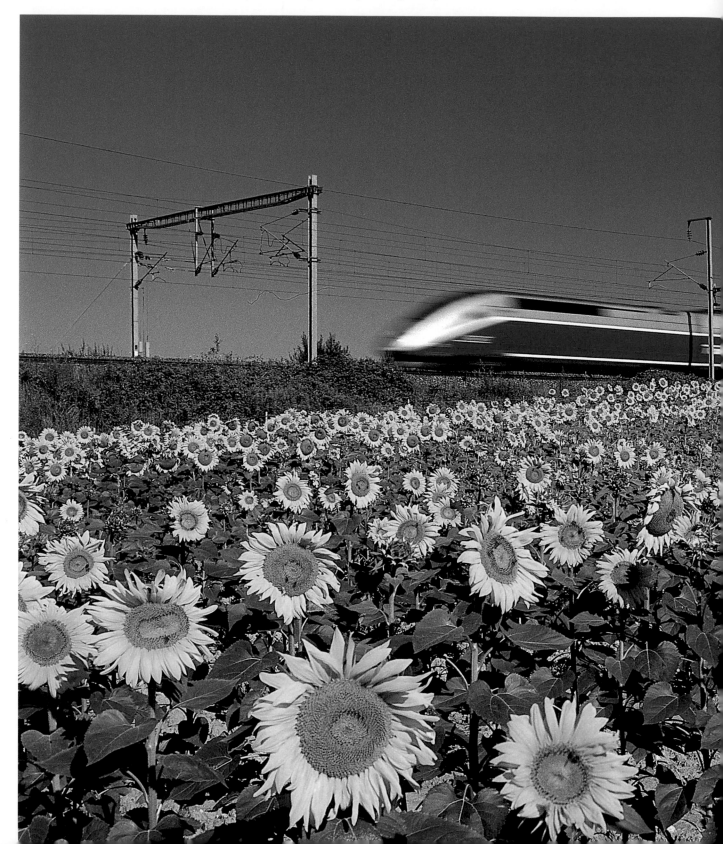

As an example, the waterfall is one of the most common motion-filled subjects. In this situation, you can creatively use the shutter speed two ways. You can either freeze the action of the water with a fast shutter speed or make the water look like cotton candy with a much slower shutter speed. Another action-filled scene might be several horses in a pasture on a beautiful autumn day. Here, you can try your hand at panning, following and focusing on the horses with your camera as you shoot at shutter speeds of 1/60 or 1/30 sec. The result will be a streaked background that clearly conveys the action with the horses rendered in focus. Freezing the action of your child's soccer game is another motion subject. Any city street scene at dusk is another. Using shutter speeds as slow as 8 or 15 seconds (with a tripod, of course), will turn the streets into a sea of red and white as the head- and taillights of moving cars pass through your composition.

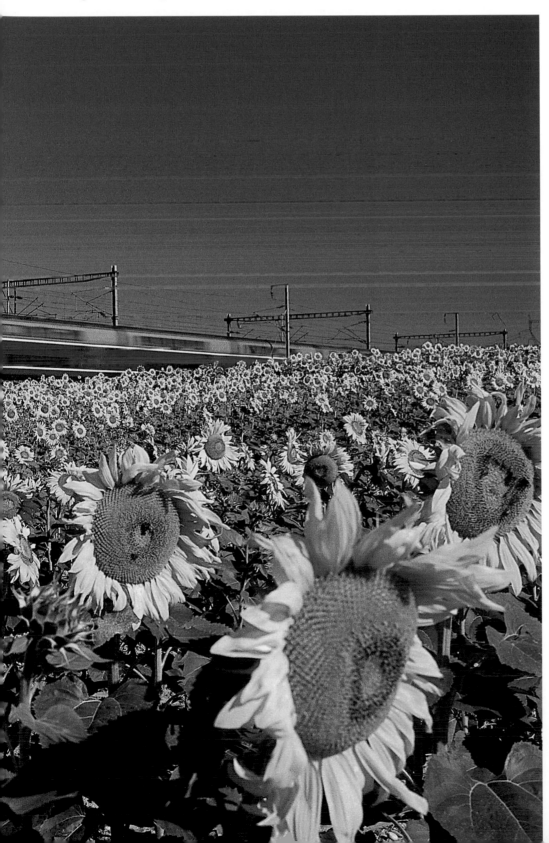

Hearing the sound of an oncoming train, I hurriedly turned my attention away from the sunflower close-up I was making and zoomed my lens from 70mm to 35mm to create a story-telling composition of a sunflower field and moving train. I quickly set my shutter speed to 1/60 sec. and adjusted the aperture until f/22 indicated a correct exposure. With the camera on a tripod, I pressed the shutter release as the train made its way across the tracks at a speed of more than 120 mph. The obvious motion that resulted conveys the idea of high speed trains in France, and the picturesque landscape that surrounds it could entice even the most diehard plane rider into trying the train.

[35–70mm lens at 35mm, 1/60 sec. at f/22]

Freezing Motion

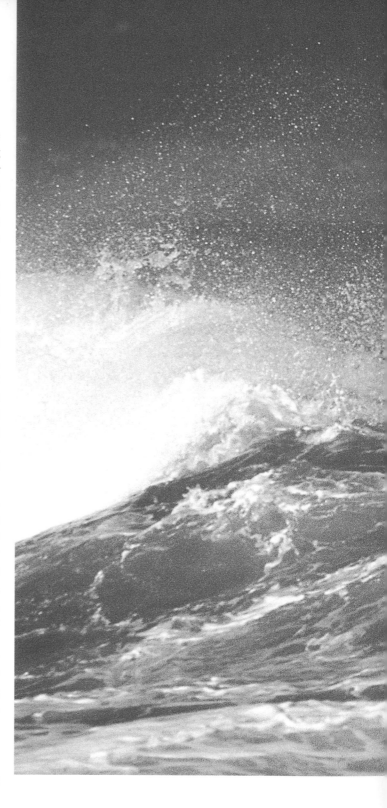

The first photograph I ever saw that used the technique of freezing action showed a young woman in a swimming pool throwing back her wet head. All the drops of water and the woman's flying hair were recorded in crisp detail. Since the fast-moving world seldom slows down enough to give us time to study it, pictures that freeze motion are often looked at with wonder and awe.

More often than not, to freeze motion effectively you must use fast shutter speeds. This is particularly critical when the subject is moving parallel to you, such as when a speeding race car zooms past the grandstand. Generally, these subjects require shutter speeds of at least 1/500 or 1/1000 sec. Besides race cars on a track, many other action-stopping opportunities exist. For example, Sea World provides an opportunity to freeze the movement of killer whales as they propel themselves out of the water from the depths below. Similarly, rodeos enable you to freeze the misfortunes of falling riders. And on the ski slopes, snowboarders soar into the crisp cold air.

When you want to freeze any moving subject, you need to consider three factors: the distance between you and the subject, the direction in which the subject is moving, and your lens choice. First, determine how far you are from the action. Ten feet? One hundred feet? The closer you are to the action, the faster the shutter speed must be. Next, determine if the action is moving toward or away from you. Then decide which lens is the most appropriate one.

For example, if you were photographing a bronco rider at a distance of ten to twenty feet with a wide-angle or normal lens, you'd have to use a shutter speed of at least 1/500 sec. to freeze the action. If you were at a distance of one hundred feet with a wide-angle or normal lens, his size and motion would diminish considerably, so a shutter speed of 1/125 sec. would be sufficient. If you were at a distance of fifty feet and using the frame-filling power of a 200mm telephoto lens, 1/500 sec. would be necessary (just as if you were ten feet from the action). Finally, you'd need a shutter speed of 1/1000 sec. if the bronco rider were moving parallel to you and filled the frame either through your lens choice or your ability to physically move in close.

On the North Shore of Maui, surfers and wind-surfers alike arrive every morning at Hookipa Beach hoping to catch the next biggest wave or ride the constant wind. When I made this image, I was hoping to freeze the action of a surfer "wiping out." Although my first few rolls were great records of fun in the sun, it seemed everyone out that day was an expert surfer. Although I was tempted to leave, I decided to be patient and was soon rewarded. The wind picked up, and with it, even larger swells began to form. My patience was soon rewarded when one surfer took a really big hit from a thundering wave that knocked him off his board and sent him fly-ing. A few minutes prior to making this image, I had set my exposure by aiming my tripod-mounted camera and lens toward the blue sky above the horizon line. With my shutter speed set to 1/500 sec., I adjusted the aperture until f/8 indicated a correct exposure. As a result, I was more than ready when the action began to unfold.

[600mm lens, 1/500 sec. at f/8]

A trip to the local waterslide park is reason enough to bring the camera and telephoto lens along. As my daughter Chloe's expression attests, this is a great way to cool off on a hot summer day. And the image is another frozen moment of time, forever depicting the joy of summer youth. To get this image, I set my lens to autofocus, and with my shutter speed at 1/500 sec., I aimed the camera at the blue sky and adjusted my aperture until the camera meter indicated that f/8 was correct. I then recomposed and shot several rolls over the course of the next fifteen minutes.

[80–400mm lens at 400mm, 1/500 sec. at f/8]

Kids and puddles go together like peanut butter and jelly. In Place Terreaux in Lyon, France, numerous small fountains dot the marbled pavement—an open invitation to kids to jump over them as if they were puddles. I chose a very low viewpoint—laying on my knees and belly in front of a fountain—and challenged several nearby children to make the jump.

Since the late-afternoon sunlight cast its warm glow on the face of the city hall and since the fountain was in open shade, I knew this would be a very graphic exposure, combining a strong silhouetted shape against a warmly lit background. In order to accomplish this, I first determined my lens choice: 17–35mm wide-angle set to the 20mm focal length. This wide and sweeping vision would let me capture not only the child in the foreground but also the surrounding plaza and distant city hall. I then chose a shutter speed of 1/500 sec., set my light meter set to spot metering, took a meter reading from the warm light falling on the building, and adjusted the aperture until f/9.5 indicated a -2/3 exposure (see page 126 for more on this metering). I was now ready and motioned to the kids to start jumping. This image was my best from the more than twenty made. Since my exposure was set for the much brighter light falling on the building, the foreground—including the child—recorded as a severe underexposure, seen here as a silhouette.

[17–35mm lens at 20mm, 1/500 sec. at f/9.5]

In my early years as a photographer, I spent many hours—from the safety of a makeshift blind that was really just a window in my garage—photographing the birds that came to my bird feeder. Obviously, a bird feeder attracts lots of birds, especially in winter when food is sometimes scarce, and I photographed my share of juncos, chickadees, and finches.

When I helped my brother build his new home in Alaska, however, we both took time out to photograph eagles! And unlike me with my backyard bird feeder of suet, millet, sunflower seeds, and peanut butter, my brother placed large pieces of salmon on several sheets of plywood. Leaving their perch in a nearby tree, the eagles swooped toward the salmon at a fast pace and, with their claws outstretched, snagged the pieces of salmon with grace and ease.

Unlike photographing birds perched in trees, photographing any birds in flight—especially big ones like eagles and especially when they are so close to you—requires the use of a fast shutter speed to freeze the action (flying speeds can reach 30 or 40 mph). With my Nikon D1X digital camera and my lens on autofocus, I first set my shutter speed to 1/500 sec. With the sun at my back and the eagles bathed in early-morning frontlight, I simply aimed the camera toward the blue sky above some distant hills and adjusted my aperture until f/9 indicated a correct exposure. I then recomposed and fired away at the many eagles flying nearby.

[80–400mm lens at 400mm, 1/500 sec. at f/9]

Motor Drives

Most cameras today come fully equipped with a built in motor drive or winder, which allows photographers to attain a higher degree of success when recording motion. Without the aid of a motor drive or winder, it's often a hit-and-miss proposition as you try to anticipate the exact right moment to fire the shutter. With the aid of a winder or motor drive, you can begin firing the shutter several seconds ahead of the peak action and continue firing through to a second or two after, and it's a very safe bet that one—if not several—of the exposures will succeed!

Although it's possible to shoot action sequences with either a film or digital camera, some film cameras are capable of recording images at up to seven frames per second while most digital cameras can only record images up to three frames per second.

Panning

Unlike photographing motion while your camera remains stationary (as described on the previous pages), panning is a technique photographers use in which they deliberately move the camera parallel to—and at the same speed as—the action. Most often, slow shutter speeds are called for when panning, i.e. from 1/60 sec. down to 1/8 sec.

Panning race cars was quite common years ago. In this situation, from your spot in the grandstand you would begin to follow a race car's movement with your camera as the car enters your frame. Next, while holding the camera, you would simply move in the same direction as the car, left to right or right to left, keeping the car in the same spot in your viewfinder as best you could and firing at will. You should make a point to follow through

with a smooth motion. (Any sudden stop or jerky movement could adversely alter the panning effect.) The resulting images should show a race car in focus against a background of a streaked colorful blur.

The importance of the background when panning cannot be overstated. Without an appropriate background, no blurring can result. I am reminded of one my first attempts at panning years ago. Two of my brothers were playing Frisbee. With my camera and 50mm lens, and a shutter speed of 1/30 sec., I shot over twenty exposures as the toy streaked across the sky. Twenty pictures of a single subject seemed almost nightmarish to me back then, but I wanted to be sure I got at least one good image. Unfortunately, not a single image turned out! With the Frisbee against only a clear and solid-blue sky, there was nothing behind it to record as a streaked background. Keep this in mind; panning is a good reason to take note of potentially exciting backgrounds.

I use a tripod frequently, but when it comes to panning, a tripod is often a hindrance, so leave it home. (I can hear the roar of thunderous applause!) Since you're panning moving subjects, you must be free to move, and using a tripod makes about as much sense as eating spaghetti with your hands tied behind your back.

I was having the time of my life shooting sunflowers out in the middle of nowhere—where the only noise that breaks the incredible silence is the occasional car passing through on the lone country road that runs through this field. It wasn't until I turned my attention away from the sunflowers that it occurred to me that panning on a car as it drove by could prove to be a good stock shot. And, as often happens in cases like this, once I *wanted* a car, I had to wait and wait and wait for one. Just when I thought about packing it in, I heard a car approaching. I put the camera to my eye and did a quick recheck of my exposure (1/60 sec. at f/16) as I metered the blue sky above the field of flowers. Once the car entered the frame, I began to shoot and pan, following the car and doing my best to keep it in the same point in the frame while moving the camera from left to right. I just kept firing the whole time the car was there (the camera's motor drive fired off five frames per second). And my hunch was right, as this one image has earned more than seven thousand dollars in combined sales with my stock agency just over the last twelve-month period.

[80–200 lens at 200mm, 1/60 sec. at f/16]

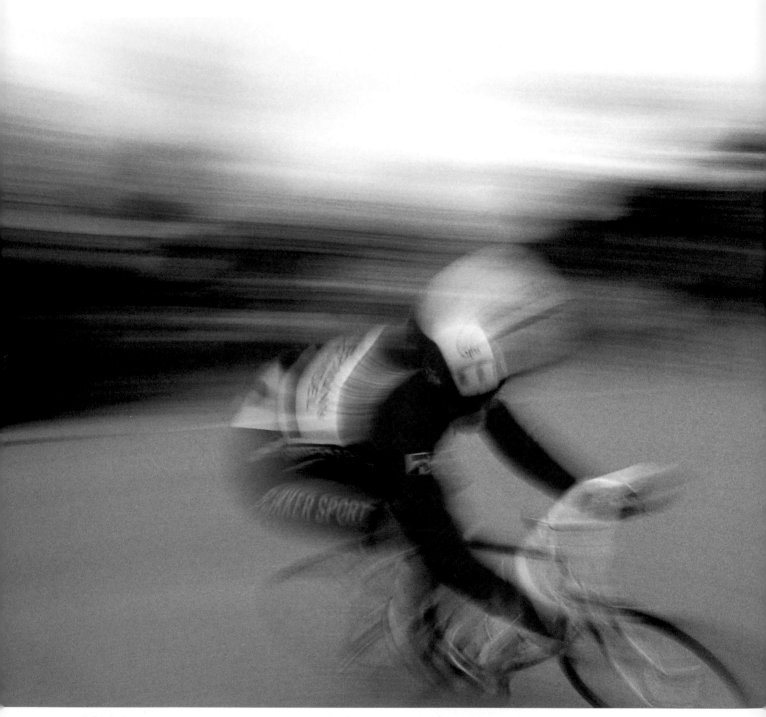

While living in Europe, I've come to regard the bicycle as a wonderful alternative to the car. Additionally, I've seen countless bicycle races all across the countryside, and in many small towns and villages. At one race in a small town in Holland, I stationed myself on a street corner where the cyclists would make one of several turns. I set the focal length of my 20–35mm zoom lens to 20mm and the shutter speed to 1/4 sec. Next, I adjusted the aperture until f/22 indicated a correct exposure for the gray road in front of me. As the cyclists came into the viewfinder, I simply moved the camera in a fluid side-to-side motion, left to right; plus, I also zoomed the lens from the 20mm focal length to the 35mm focal length. In addition to this recording the *panning* effects, it also recorded the *explosive* effects that result from zooming during a slow shutter speed exposure.

[20–35mm lens at 20mm, 1/4 sec. at f/22]

Following the end of a four-day photo workshop I taught in Alaska, I gladly accepted an invitation (from a student who was also a bush pilot) to the Katmai National Park for a day of bear viewing. Arriving near the shore on the glasslike surface of the Selikof Strait, I disembarked from the plane, stepping first on its skid and then into the clear cold water. It was slow going for the next fifteen minutes as I trudged through the waist-deep water, wearing my chest waders and carrying all my gear. As I approached the shoreline, those once small "bear dots" I'd seen from the plane became impressive in size. The bears had been feeding on salmon and berries since June and now, in these early days of autumn, their bellies seemed ready to burst. Most of them were moving slower than the second hand on a clock with a dead battery.

Of the many bear images I got that day, this one is the most memorable. As you can clearly see, it's not just a panning photograph of a bear feeding in a stream; I somehow managed to record an exposure that also captured the frightened salmon, whose heads you can see sticking out of the water. Quite honestly, I was focusing all of my attention on the bear while making these panning shots, and as you can imagine, I was absolutely thrilled to see the salmon in this shot as well when sorting through my slides on the light table.

[80–400mm lens at 400mm, 1/60 sec. at f/22]

Implying Motion

When the camera remains stationary—usually on a firm support such as a tripod—and there are moving subjects, the photographer has the opportunity to imply motion. The resulting image will show the moving subject as a blur, while stationary objects are recorded in sharp detail. Waterfalls, streams, crashing surf, airplanes, trains, automobiles, pedestrians, and joggers are but a few of the more obvious subjects that will work. Some of the not-so-obvious include a hammer striking a nail, toast popping out of the toaster, hands knitting a sweater, coffee being poured from the pot, a ceiling fan, a merry-go-round, a seesaw, a dog shaking itself dry after a dip in the lake, wind blown hair, and even wind blowing through a field of wildflowers.

Choosing the right shutter speed for many of these situations is oftentimes trial and error. It's here that, once again, the digital shooters with LCD screens have the advantage since they can instantly view the results of their shutter speed choice. Additionally, there are no film costs involved, so this trial and error costs nothing!

There are certainly some general guidelines to follow for implying motion, and if nothing else, they can provide a good starting point for many of the motion-filled situations that abound. For example, 1/2 sec. will definitely produce the cotton effect in waterfalls and streams. An 8-second exposure will definitely reduce the headlights and taillights of moving traffic to a sea of red-and-white streaks. A 1/4-sec. exposure will make hands knitting a sweater appear as if moving at a very high rate of speed. A wind of 30 mph moving through a stand of maple trees, coupled with a 1 second exposure, can render stark and sharply focused trunks and branches that contrast with wispy, windblown, overlapping leaves.

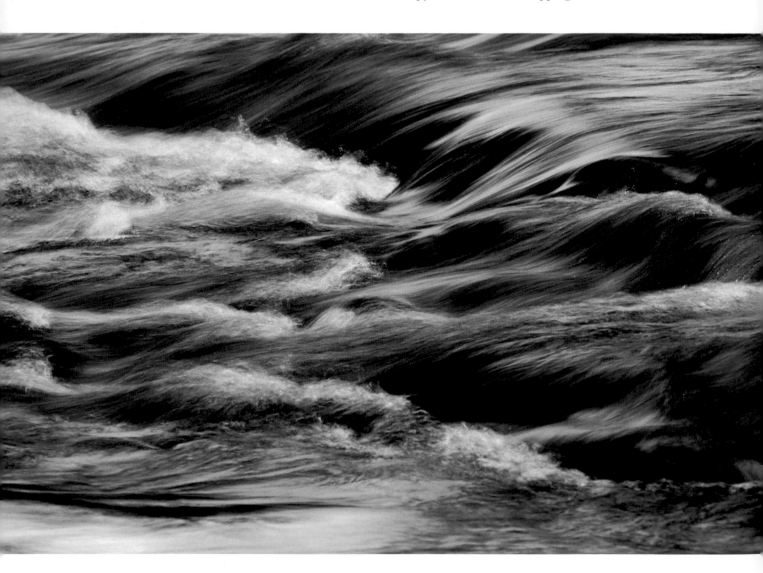

If slow shutter speeds can work for water, why not for industrial sparks? In the fall of 2002, I was offered an assignment shooting steel mills. I photographed numerous subjects over the course of five days, including a number of varied compositions of hot steel and flying sparks. At one of the five mills I photographed, thirty-foot lengths of twelve-inch steel pipe were sent down a long track where the end of each was then cut by an automated machine. It was there that I set up my tripod, about ten feet from the pipe itself. Despite this distance, I found myself sweating profusely, as the heat coming off the pipes was well above two thousand degrees.

With a focal length of 400mm, I chose a -1/2 sec. shutter speed—the same speed that has worked so well for waterfalls and streams over the years. As the pipe lay on the track, the automated cutter would slice through the steel, all within five seconds. During these five-second periods, I would look through the viewfinder and note how the camera's light meter reacted to the bright hot steel and flying sparks. Determining that the brightest point in the overall composition was the cutter itself and having shot numerous sunrises and sunsets over the years, I chose to ignore this much brighter light and set an exposure for the surrounding glowing steel of the pipe itself— much like choosing to set an exposure from the orange glowing sky to the right or left of the sun.

[80–400mm lens at 400mm, 1/2 sec. at f/27]

Whether it cascades down through rocky streams or over basalt-layered cliffs, water captured at a slow shutter speed is very soothing to look at. This example (opposite) is the Upper North Falls at Oregon's Silver Falls State Park. The early-morning light was casting its glow on the nearby trees, and subsequently, like a mirror, these vivid green colors and the blue sky overhead were reflected in the stream below. I wasted no time in turning my attention to this wonderful abstract photo opportunity. Using a tripod, I set my shutter speed to 1/8 sec., adjusted my aperture until f/19 indicated a -2/3 exposure, and fired off several frames.

[75–300mm lens at 210mm, 1/8 sec. at f/19]

EXERCISE: Motion with a Stationary Camera

Shooting movement while the camera remains stationary *relative to the subject* offers an array of possibilities. Try your hand at this exercise the next time you visit the local playground or amusement park. I promise it will help you discover many more motion-filled subjects. At a playground, find a swing set with a stand of trees in the background. As you sit in the swing with your camera and wide-angle lens, set your shutter speed to 1/30 sec., and point and focus the camera at your outstretched legs (preferably with bare feet). Then adjust the aperture until a correct exposure is indicated by the camera's meter. All set? Start swinging (keeping both arms carefully wrapped around the chains or ropes of the swing, or course). Once you reach a good swinging action, press the shutter release. Don't hesitate to take a number of exposures. The result will be sharp legs surrounded by a sea of movement—an image that says, "Jump for joy for spring has sprung!"

Next, move to the seesaw. Place the camera so that its base rests flat on the seesaw about a foot in front of where you'll be sitting. With the child or adult sitting on the other end, focus on them with your shutter speed set to 1/8 sec., and adjust your aperture. Then begin the up-and-down motion of the ride— keeping one hand on the camera, of course—and shoot a number of exposures at different intervals while continuing to seesaw. The end result is a sharply focused person against a background of streaked blurs.

At an amusement park, walk over to the merry-go-round and hop on board. Wait until the ride gets moving at a good pace, and with your shutter speed set to 1/30 sec., focus on a person or opposite you. Adjust your aperture and fire away. The end result is, once again, a sharply focused person against a background of swirling streaks. Would that make a great advertisement for Dramamine, or what?

If water looks good in nature, why not in the city? Several years ago while on a job in Barcelona, I took the night off to see some sights and came upon this huge fountain where many people had assembled to see a synchronized light show. With my tripod and 35–70mm lens, I soon found that I had shot more than twenty exposures because I liked the image before me so much. I set the focal length to 50mm, my shutter speed to 1/2 sec., and merely adjusted the aperture until f/8 indicated a correct exposure from the strong backlight. The half-second exposure did little to freeze the action of the water, but that was not my intention. I wanted to record a more ethereal water effect and 1/2 sec. accomplished this.

Since my meter reading was set for the much stronger lights on the fountain, the people gathered in front of it were rendered as severe, underexposed silhouettes.

[35–70mm lens at 50mm, 1/2 sec. at f/8]

Implying Motion While Zooming

How do you make a stationary subject "move"? You zoom it! In other words, you press the shutter release *while* zooming your lens from one focal distance to another. With the proliferation of zoom lenses on the market today, I'm surprised that the zooming-during-exposure technique hasn't been revived.

Zooming your lens while pressing the shutter release will produce the desired results *but not without practice.* Don't be disappointed if your first few attempts don't measure up. Remember my number one rule for all you film shooters out there: film is cheap when compared to the trauma of a missed shot. For those of you using a point-and-shoot digital camera, you may feel your patience being tried. Unless you can figure out a way to override the motorized zooming feature on your camera (and you'd be the first to make this discovery, by the way), you'll be unsuccessful in your attempts. The biggest reason for this is because these cameras won't let you change any settings (and this includes zooming) while the exposure is being made.

With my camera and 35–70mm lens on a tripod, I first composed this lone oak at sunset at a focal length of 35mm with the addition of a Lee sunset filter. With a shutter speed of 1/2 sec., I adjusted my aperture to f/22. As I pressed the shutter release, I zoomed from 35mm to 70mm, and this is one of only a handful of attempts that succeeded from the two rolls I shot of this tree using this effect.

[35–70mm lens at 70mm, 1/2 sec. at f/22]

Making Rain

Of all the discoveries I've made during my twenty years of shooting, my favorite is creating "rain"; it has provided me with hours of joy-filled photography. This technique has also resulted in numerous stock photo sales to greeting card and calendar companies, as well as to healthcare-related clients.

The rain effect is easy to achieve. On clear mornings, I set up an oscillating sprinkler so that the water is backlit as it cascades down. I then gather up some flowers or fruit, and arrange them in pots, small cedar boxes, bowls, or vases. To effectively produce the look of falling rain, I use a shutter speed of 1/60 sec. I move in close to the backlit subject and adjust my aperture until the light meter indicates that a correct exposure is set. I then simply back up, compose a pleasing composition, and turn on the sprinkler. I shoot only when the sweeping arc of the oscillating sprinkler begins to fall just behind and then onto the flowers. Also, I almost always choose the 200mm or 300mm focal length for rain shots, not so much because these focal lengths have an inherent shallow depth of field, but because they enable me to record pleasing compositions without getting wet.

Why should falling rain be limited to flowers? After I'd been using this technique for several years to photograph flowers, I began to place other subjects in my falling "rain", including this vivid blue bowl of fresh strawberries (below). With the bowl on a small wooden stool, I took a meter reading from the light falling on the strawberries. Then with my shutter speed set to 1/60 sec., I adjusted the aperture until the light meter indicated a correct exposure, which was at f/19. I backed up, composed the scene you see here, turned on the sprinkler, and fired off several frames each time the droplets fell on the bowl.

[80–400mm lens at 300mm, 1/60 sec. at f/19]

If you're like me, you welcome spring with great enthusiasm. The sun has returned and the rains have subsided—at least, the *real* rain has. I used an oscillating lawn sprinkler to make it "rain" on these backlit tulips, and I metered off the green grass behind them. With my shutter speed at 1/60 sec., I adjusted my aperture until f/10 indicated a -2/3 exposure and fired away. Ah, the joy of spring!

[80–200mm lens at 200mm, 20mm extension tube, 1/60 sec.]

Light

The Importance of Light: The Importance of Exposure

"What should my exposure be?" is, as I've already said, an often-heard question from my students. And, again as I stated earlier, my frequent reply—although it may at first appearing flippant—is simply, "Your exposure should be correct, *creatively correct* that is!" As I've discussed in countless workshops and on-line photo courses, achieving a creatively correct exposure is paramount to a photographer's ability to be consistent. It's always the first priority of every successful photographer to determine what kind of exposure opportunity he or she is facing: one that requires great depth of field or shallow depth of field, or one that requires freezing the action, implying motion, or panning. Once this has been determined, the real question isn't "What should my exposure be?" but *"From where do I take my meter reading?"*

However, before I answer that question, let's take a look at the foundation upon which every exposure is built: light! Over the years, well-meaning photographers

have stressed the importance of light or have even been so bold as to say that "light is everything." This kind of teaching—"See the light and shoot the light!"—has led many aspiring students astray over the years.

Am I antilight? Of course not! I couldn't agree more that the right light can bring importance and drama to a given composition. But more often than not, the stress is on *the light* instead of on the (creatively correct) exposure. Whether you've chosen to tell a story, to isolate, to freeze action, to pan, or to imply motion in your image, the light will be there regardless. I can't tell you how many times I've met students who think an exposure for

the light is somehow different than it is for a storytelling image or for a panning image, and so on. But, what is so different? What has all of the sudden changed?

Am I to believe that a completely different set of apertures and shutter speeds exists *only for the light*? Of course not! A correct exposure is *still* a combination of aperture, shutter speed, and ISO. And, a creatively correct exposure is *still* a combination of the right aperture, the right shutter speed, and the right ISO—with or without the light. As far as I'm concerned, the light is the best possible frosting you can put on the cake, but it has never been—and never will be—*the cake.*

While the light is important in any image, it was the exposure that was an integral part of making this shot. Getting a true storytelling exposure that rendered everything in sharp focus was key to conveying the humor of this scene along one of the many dikes in West Friesland, Holland.

Windmills abound in this area, and people still live in these "houses." Coming upon the clothesline of one such homeowner, I couldn't resist the obvious opportunity. With my camera on a tripod, I set my aperture to f/22. I then prefocused the scene via the distance setting and adjusted my shutter speed for the light reflecting off the blue sky until 1/60 sec. indicated a correct exposure. The scene didn't look in focus when I shot it, but due to my aperture choice, it was rendered sharp on film.

[20–35mm lens at 20mm, f/22 for 1/60 sec.]

The Best Light

Where do you find the best light for your subjects? Experienced photographers have learned that the best light often occurs at those times of day when you would rather be sleeping (early morning) or sitting down with family or friends for dinner (late afternoon/early evening, especially in summer). In other words, shooting in the best light can be disruptive to your "normal" schedule.

But, unless you're willing to take advantage of early-morning or late-afternoon light—both of which reveal textures, shadows, and depth in warm and vivid tones—your exposures will continue to be harsh and contrasty, without any real warmth. Such are the results of shooting under the often harsh and flat light of the midday sun. Additionally, one can argue that the best light occurs during a change in the weather—incoming thunderstorms and rain—that's combined with low-angled early-morning or late-afternoon light.

You should get to know the color of light, as well. Although early-morning light is golden, it's a bit cooler than the much stronger golden-orange light that begins to fall on the landscape an hour before sunset. Weather, especially inclement weather, can also affect both the quality (as mentioned above) and *color* of light. The ominous and threatening sky of an approaching thunderstorm can serve as a great showcase for a front- or sidelit landscape. Then there's the soft, almost shadowless light of a bright overcast day, which can impart a delicate tone to many pastoral scenes, as well as to flower close-ups and portraits.

Since snow and fog are monochromatic, they call attention to subjects such as a lone pedestrian with a bright red umbrella. Make it a point, also, to sense the changes in light through the seasons. The high, harsh, direct midday summer sun, differs sharply from the low-angled winter sun. During the spring, the clarity of the light in the countryside results in delicate hues and tones for buds on plants and trees. This same clear light enhances the stark beauty of the autumn landscape.

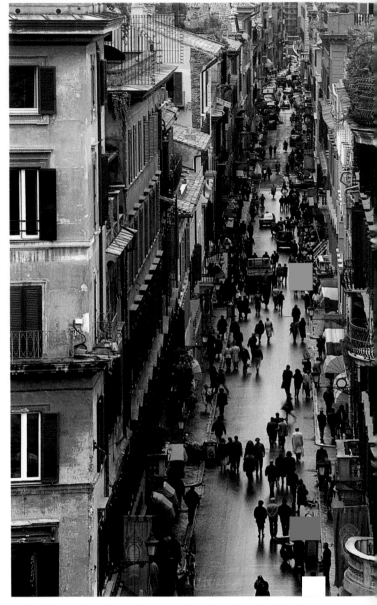

From atop the steps near Piazza di Spagna in Rome, I was afforded a view of the busy street below. With my camera and lens on a tripod, I set the aperture and adjusted the shutter speed. Even while I was shooting this scene, I commented to my assistant that it would be a far better photograph if we could just have some light. It had already been raining for the better part of three days. The next day, the skies finally cleared and we made it back to the same spot—only this time in late afternoon. As luck would have it, the street was now backlit and displayed the warmth I had previously been looking and hoping for.

[Above: 80–200mm lens at 200mm, f/22 for 1/15 sec. Opposite: 80–200mm lens at 200mm, f/22 for 1/60 sec.]

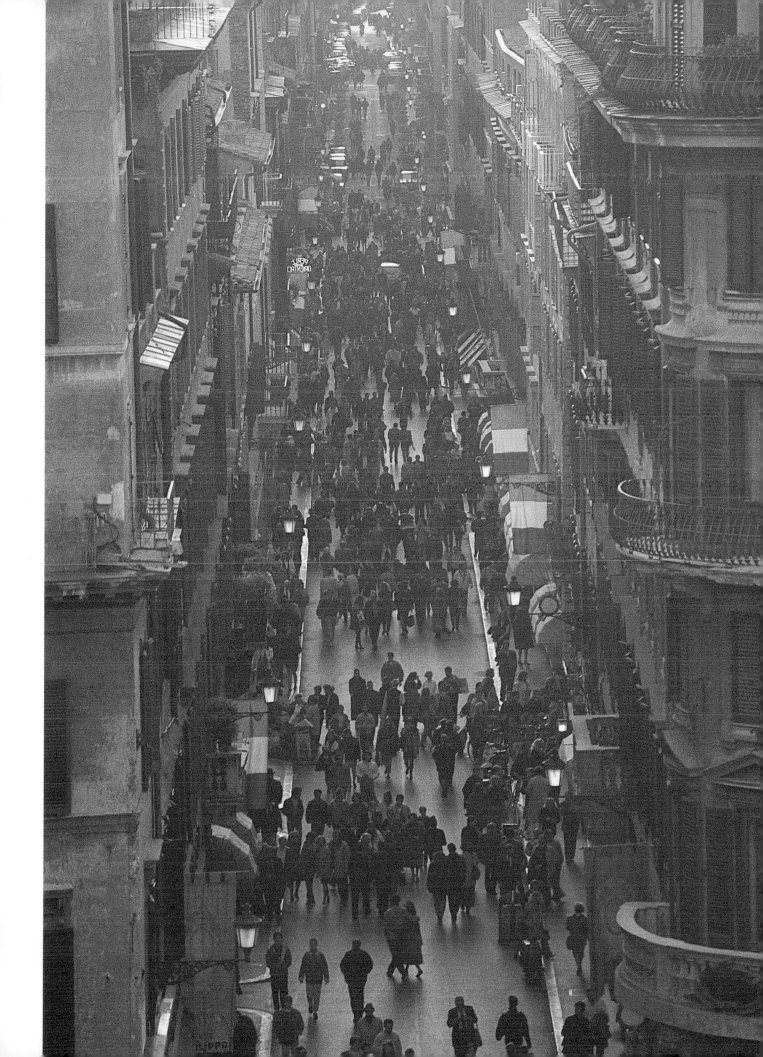

EXERCISES: Exploring Light

You can do one of the best exercises I know near your home, whether you live in the country or the city, in a house or an apartment. Select any subject, for example the houses and trees that line your street or the nearby city skyline. If you live in the country, in the mountains, or at the beach, choose a large and expansive composition. Over the course of the next twelve months, document the changing seasons and the continuously shifting angles of the light throughout the year. Take several pictures a week, shooting to the south, north, east, and west; and in early-morning, midday, and late-afternoon light. Since this is an exercise, don't concern yourself with making a compelling composition. At the end of the twelve months, with your efforts spread out before you, you'll have amassed a knowledge and insight about light that few professional photographers—and even fewer amateurs—possess.

Photographers who use and exploit light *are not* gifted! They have simply learned about light and have, thereby, become motivated to put themselves in a position to receive the gifts that the "right" light has to offer.

Another good exercise is to explore the changing light on your next vacation. On just one day, rise before dawn and photograph some subjects for one hour following sunrise. Then head out for an afternoon of shooting, beginning several hours before and lasting twenty minutes following sunset. Notice how low-angled frontlight provides even illumination, how sidelight creates a three-dimensional effect, and how strong backlight produces silhouettes. After a day or two of this, you'll soon discover why the light of the midday sun is reserved for relaxing poolside.

I felt wonderful after recording this image above of a lone Dutch elm on the banks of a small dike in Holland. The low-angled light of late afternoon had begun to cast its warm glow across the landscape, and I was there to catch it all. It was only until I happened upon this same scene again two days later—but under even more dramatic lighting conditions—that I knew the photograph could be improved. I could now capture the scene against a backdrop of a fierce and oncoming storm (opposite).

I made both images without a tripod and with the same lens settings. In both cases, I used an aperture of f/16 and preset the focus via the distance setting on the front of the lens to assure maximum depth of field front to back. And, in both cases I adjusted the shutter speed for the light falling on the tree. The difference is in the "frosting"—the light—and it is amazing. But, it was *still* necessary to decide what kind of cake I wanted to make: in this case, a cake that relied on the conscious selection of the right aperture first.

[Both photos: 20–35mm lens at 20mm, f/16 for 1/125 sec.]

Frontlight

What is meant by frontlight or frontlighting? Imagine for a moment that your camera lens is a giant spotlight. Everywhere you point the lens you would light the subject in front of you. This is frontlighting, and this is what the sun does, on sunny days, of course. Due to frontlighting's ability to, for the most part, evenly illuminate a subject, many photographers consider it to be the easiest kind of lighting to work with in terms of metering, especially when shooting landscapes with blue skies.

So, is it really safe to say that frontlight doesn't pose any great exposure challenges? Maybe it doesn't in terms of metering, but in terms of testing your endurance and devotion, it might. Do you mind getting up early or staying out late, for example? The quality and color of frontlighting are best in the first hour after sunrise and during the last few hours of daylight. The warmth of this golden-orange light will invariably elicit an equally warm response from viewers. This frontlighting can make portraits more flattering and enhance the beauty of both landscape and cityscape compositions.

In addition, frontlighting—just like overcast lighting (see pages 102–105)—provides even illumination, making it relatively easy for the photographer to set an exposure; you don't have to be an exposure "expert" to determine the spot in the scene where you should take your meter reading. Even first-time photographers can make successful exposures, whether their cameras are in manual or autoexposure mode.

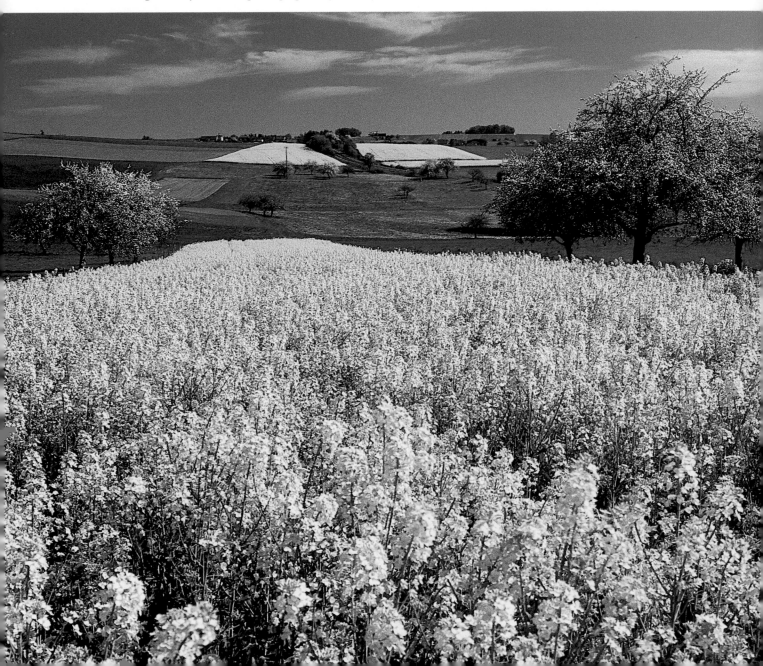

To photograph this mustard field, I handheld my camera and set my 20–35mm lens to 24mm. I then set the aperture to f/22 and preset the focus via the distance settings on the front of the lens, which assured me that everything would be sharp from two feet to infinity. With the camera in manual-exposure mode, I raised it to the sky above, adjusted my shutter speed to 1/60 sec., and then recomposed the shot.

[20–35mm lens at 24mm, f/22 for 1/60 sec.]

As the late-afternoon frontlight cast its glow across the face of this lavender farmer in Provence, I didn't hesitate. With my camera set to aperture-priority mode, I chose f/5.6 to keep the visual weight on him, and then simply fired away, allowing the camera to set the exposure for me.

[80–200mm lens at 200mm, f/5.6 for 1/500 sec.]

Overcast Frontlight

Of all the different lighting conditions that photographers face, overcast frontlighting is the one that many consider to be the safest. This is because overcast frontlight illuminates most subjects evenly, making meter reading simple. (This assumes, of course, that the subject isn't a landscape under a dull gray sky; that subject and light combination needs some extra care, which I address in the chapter on special techniques and filters on pages 138–151.)

Overcast frontlight also gets autoexposure cameras to perform well, since overall illumination is balanced. The softness of this light results in more natural-looking portraits and richer flower colors, and it also eliminates the contrast problems that a sunny day creates in wooded areas. Overcast conditions are ones in which I often shoot in autoexposure mode: either aperture-priority, if my exposure concerns are about depth of field or the absence thereof; or shutter-priority, if my concern is about motion (i.e. freezing action or panning).

Just as photographing in the woods on sunny days is problematic—yielding images that are too contrasty—shooting in outdoor markets under sunny conditions creates the same problems. Wait for overcast days; correct exposures will be much easier to record, and you can certainly shoot in aperture-priority mode without fear. In this classic "Who cares?" situation, I held my camera and stood on tiptoe to shoot down on these small spice sacks (right). Exposure was not a concern since the light levels throughout the scene were even.

[35–70mm lens at 35mm, f/11 for 1/60 sec.]

One of my students had heard about the house covered in license plates in Vermont. While on a workshop there, we were elated to find it and were not the least bit disappointed (opposite). It was a subject that lent itself perfectly to the soft and even illumination that only a cloudy day can provide. Since this house was surrounded by numbers of deciduous trees, a sunny day would have cast numerous shadows on the roof and sides of the house, resulting in a composition of sharp contrasts. With my camera on a tripod, I framed up one wall of the house with two windows and chose a "Who cares?" aperture of f/11. Due to the even illumination, I had no worries about using aperture-priority mode and letting the camera pick the exposure for me.

[80–200mm lens at 120mm, f/11 for 1/30 sec.]

Portraits are another fine subject for overcast lighting. The soft and even illumination of a cloudy day makes getting an exposure easy. Posed candids that offer direct eye contact are pleasing to viewers. Here, I first asked my subject to sit about ten feet in front of a background of blue barrels. I then placed my camera on a tripod, and because I wanted to render the background as out-of-focus shapes and tones, I set my aperture to f/5.6. Since I was using aperture-priority automatic exposure, I had only to focus on my subject's pleasant demeanor and shoot.

[80–200mm lens at 200mm, f/5.6 for 1/125 sec.]

I met this elderly German woman by accident. While driving around the country-side, I ran out of gas in front of her farm, and she gener-ously offered me several liters of gas to get me going again. But before I knew it, I'd spent more than five hours with the woman and her daughter talking about life on the farm. Of the many photographs I made that day, this is one of my favorites. Since the bench she was on was against a wall, depth of field was of no great concern. I put my lens to aperture-priority mode, set a "Who cares?" aperture of f/11, and let the camera choose the shutter speed for me.

[80–200mm lens at 100mm, f/11 for 1/60 sec.]

Sidelight

Frontlit subjects and compositions photographed under an overcast sky often appear two-dimensional, even though your eyes tell you the subject has depth. To create the illusion of three-dimensionality on film, you need highlights and shadows—in other words, you need sidelight. For several hours after sunrise and several hours before sunset, you'll find that sidelit subjects abound when you shoot toward the north or south. Make it a point to take each photograph at the indicated reading, plus take an additional exposure at -1 if you are shooting slides or digital, and an additional exposure at +1 if you are using color negative film. The shadows in any sidelit scene (whether on film or digital media) become excessively dark when the scene is underexposed, and this produces a wonderful illusion of three-dimensionality. When shooting color negative film, this +1 exposure results in a much easier and less dense negative to scan and print, thus allowing you to increase the contrast in the shadows. Textures are emphasized nicely, and the subject shows both volume and depth.

Sidelighting has proven to be the most challenging of exposures for many photographers because of the combination of light and shadow. But, it also provides the most rewarding picture-taking opportunities. As many professional photographers would agree, a sidelit subject—rather than a frontlit or backlit one—is sure to elicit a much stronger response from viewers, because it better simulates the three-dimensional world they see with their own eyes.

Since I couldn't get as close to this bee as I wanted with my 70–210mm zoom lens, I added a small extension tube, which enabled me to fill the frame with the subject without having to be within a cat's whisker of the bee. I also decided to exploit the early morning sidelight, using the background shadows to get some wonderful contrast against which to showcase the bee. With my camera and lens on a tripod, I set my aperture to f/11 and adjusted the shutter speed until 1/250 sec. indicated a correct exposure.

[70–210mm lens at 210mm, 36mm extension tube, f/11 for 1/250 sec.]

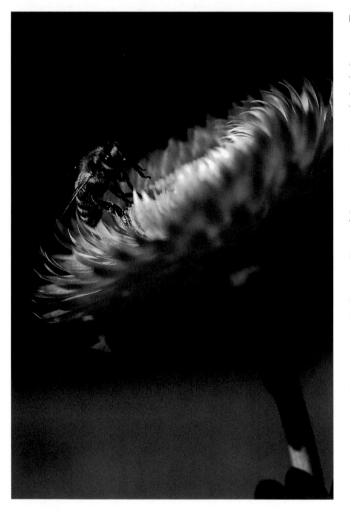

The spaces in which I work are sometimes cramped. When this occurs, I often opt for a wide-angle lens, and this is exactly what happened when I entered this teahouse in China a few years back. Since I wanted to shoot a full-length portrait of this intriguing man and found myself in a very small room, I crouched down with my camera and 35mm lens. Through the opening at the right of the frame, soft and diffused sidelight from the much brighter midday sun filled the room. With an aperture of f/8, I adjusted the shutter speed until 1/30 sec. was indicated as a correct exposure for the light reflecting off the green wall. I then recomposed the scene and made several exposures.

[35mm lens, f/8 for 1/30 sec.]

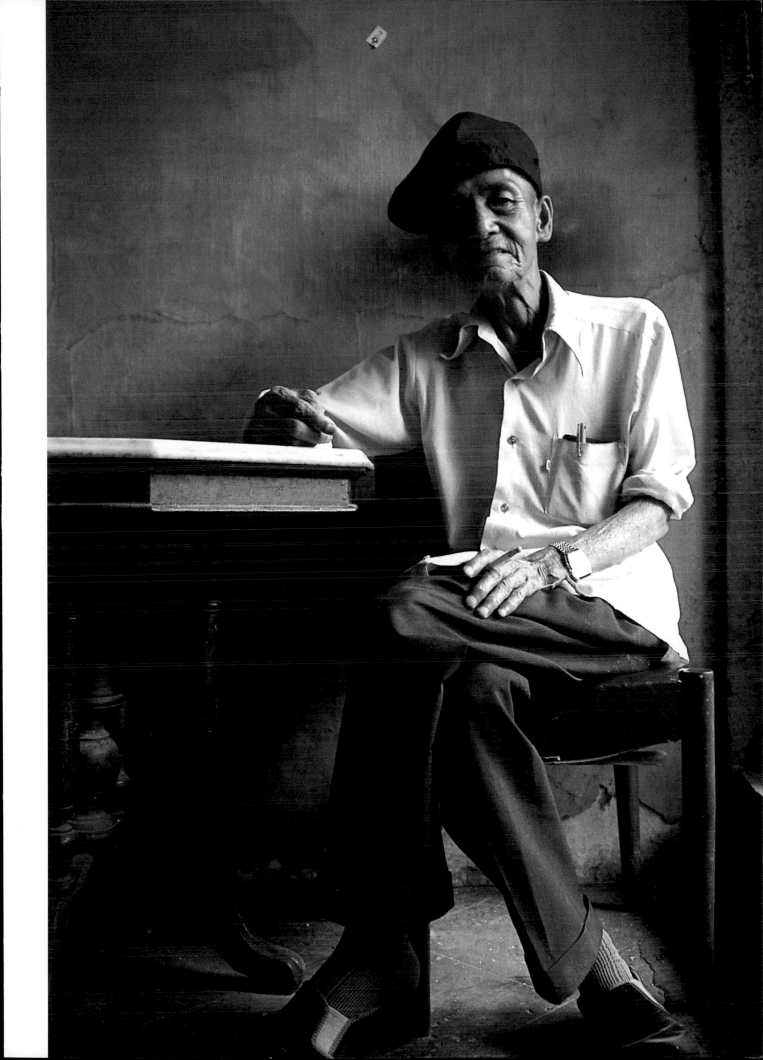

While working on a project that featured women in industry, I came upon a female welder working on the docks of the Portland, Oregon, shipyards. She was taking a brief break from making countless welds on the large anchor chain that lay before her. Bathed in the low-angled sunlight of late afternoon, I wasted no time in quickly introducing myself and setting up my camera and tripod. With my aperture set to f/22—so that I could record as much depth of field in the foreground chains as possible—I framed the scene before me and, with the camera's built-in light meter set to spot metering, metered the light falling on her face, adjusting the shutter speed accordingly until a correct exposure was indicated. Directly behind the subject, and lasting for some time, a large and looming shadow had fallen. Since the exposure was set for the much stronger side-light, the shadow areas recorded on film as severe underexposures, providing a nice contrast between light and dark, as well as imparting a feeling of three-dimensionality to the image.

[105mm lens, f/22 for 1/60 sec.]

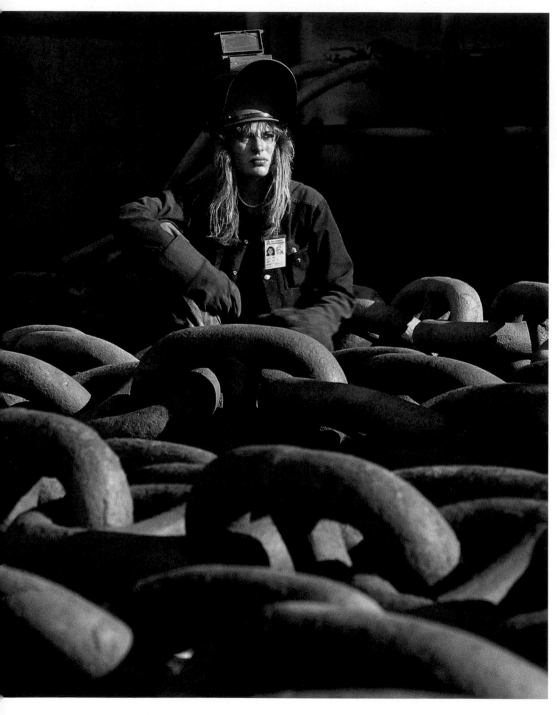

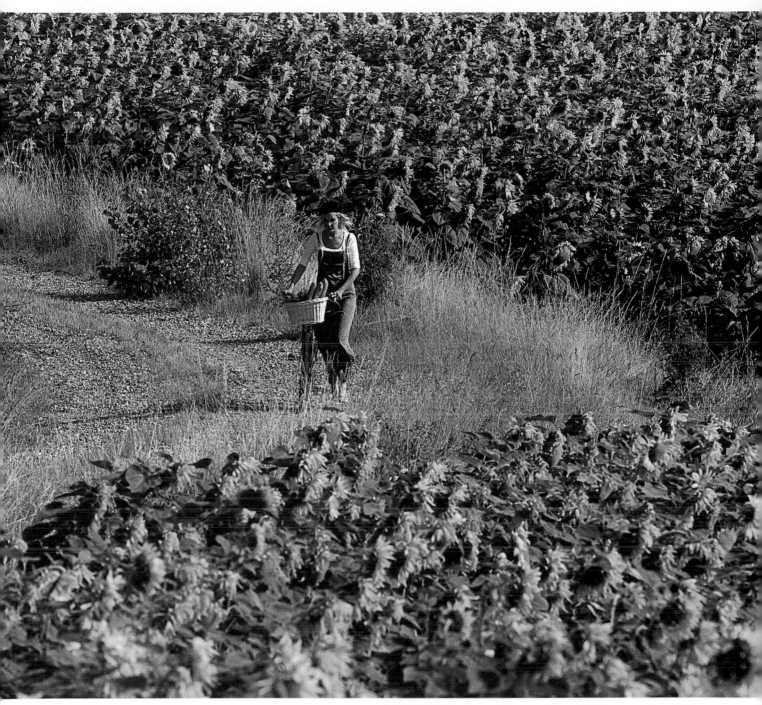

This is classic storytelling stuff—and one of those shots that "comes to you," rather than you going to it. With my camera and 300mm lens on a tripod, I framed a section of the dirt road with sunflowers from front to back. Then, with my aperture set to *f*/32, I raised the camera quickly to the blue sky above, adjusted the shutter speed, and recomposed. Getting a signed model release was easy not because I speak a little French, but because this was *my wife* returning home from the market!

[300mm lens, *f*/32 for 1/30 sec.]

Backlight

Backlight can be confusing. Some beginning photographers assume that backlighting means the light source (usually the sun if you're outdoors) is behind the photographer, hitting the front of the subject. However, the opposite is true: the light is *behind the subject*, hitting the front of the photographer and the back of the subject. Of the three primary lighting conditions—frontlighting, sidelighting, and backlighting—backlight continues to be the biggest source of both surprise and disappointment.

One of the most striking effects achieved with backlight is silhouetting. Do you remember making your first silhouette? If you're like most other photographers, you probably achieved it by accident. Although silhouettes are perhaps the most popular type of image, many photographers fail to get the exposure correct. This inconsistency is usually a result of lens choice and metering location. For example, when you use a telephoto lens, such as a 200mm lens, you must know where to take your meter reading. Since telephoto lenses increase the image magnification of very bright background sunrises and sunsets, the light meter sees this magnified brightness and suggests an exposure accordingly. If you were to shoot at that exposure, you'd end up with a picture of a dark orange or red ball of sunlight while the rest of the frame fades to dark. And, whatever subject is in front of this strong backlight may merge into this surrounding darkness. To avoid this, *always* point a telephoto lens at the bright sky to the right or left of the sun (or above or below it), and then manually set the exposure or press the exposure-hold button if you're in autoexposure mode.

When photographing a backlit subject that you don't want to silhouette, you can certainly use your electronic flash to make a correct exposure. However, because I'm

"**H**owdy partner!" is the warm and pleasant greeting this young farmer seems to be making. I had been shooting pictures of his father and uncle harvesting wheat with their large combines when I turned toward the strong afternoon backlight as I heard him call to me. I quickly turned the camera to him, shooting against the strong backlight. Since my exposure was for the much brighter backlight (not the figure), I was able to record his shape in silhouette with all of the dust surrounding him.

This is *not* a tricky exposure to make. It's actually one of those few situations in which you can record the right exposure even if you're in autoexposure mode, because the backlight is so evenly distributed throughout the entire frame.

[300mm lens, f/16 for 1/250 sec.]

Sunrise in Sonoma Valley is a welcomed experience every spring. Coming upon a grove of oak trees shortly after sunrise, I was quick to grab my camera and focus on one large tree, framing the sun in such a way that only a piece of it was visible behind the trunk (opposite). Where did I take my meter reading from? I pointed the camera in the direction of the light that was cascading down on the ground behind the oak.

[20–35mm lens at 20mm, f/16 for 1/250 sec.]

not a big fan of using artificial lighting outdoors, I've found a much easier way to get a proper exposure and a create a more pleasing effect. Let's assume your subject is sitting on a park bench in front of the setting sun. If you shoot an exposure for this strong backlight, your subject will be a silhouette; but if you want a pleasing and identifiable portrait, move in close to the subject, fill the frame with the face (it doesn't have to be in focus), and then set an exposure for the light reflecting off the face. Either manually set this exposure or, if shooting in autoexposure mode, press the exposure-hold button and return to your original shooting position to take the photo. The result will be a wonderful exposure of a radiant subject.

Backlight is favored by experienced landscape shooters, as they seek out subjects that by their very nature are somewhat transparent: leaves, seed heads, and dew covered spider webs to name but a few. Backlight always provides a few exposure options: you can either silhouette the subject against the strong backlight, or meter for the light that's usually on the opposite side of the backlight (to make a portrait), or meter for the light that's illuminating the somewhat transparent subject. Although all three choices require special care and attention to metering, the results are always rewarding. Like so many other exposure options, successful backlit scenes result from a conscious and deliberate metering decision.

Frost-covered spider webs can produce dynamic compositions when they are backlit. Crawling on my knees and belly in this meadow with my camera and 24mm lens allowed me to showcase one against the early-morning backlight. This particular web was one of the largest I'd seen that morning—almost two feet across! Choosing an aperture of f/16, I raised the camera up toward the backlit sky (so as not to include the sun in the photograph) and adjusted my shutter speed until 1/250 sec. indicated a correct exposure in the veiwfinder. I then recomposed the scene you see here, making certain to block the sun behind a piece of the frost-covered web.

[24mm lens, f/16 for 1/250 sec.]

When backlit, many solid objects (such as people, trees, and buildings) will render on film as dark silhouetted shapes. Not so with many transparent objects, such as feathers or flowers. When transparent objects are backlit, they seem to glow. Such was the case when shooting these mule's ears in a small pine forest in Eastern Oregon. I chose a low viewpoint so that I could showcase the backlit flowers against the solid, silhouetted trees. Although this may appear to be a difficult exposure, it really isn't. Holding my camera and 20–35mm lens, I set the focal length to 20mm. With an aperture of f/22, I moved in close to the flowers, adjusting my position so that one of the flowers blocked the sun. I then adjusted my shutter speed until 1/125 sec. indicated a correct exposure in the viewfinder. But before I took the shot, I moved just enough to let a small piece of the sun out from behind the flower to be part of the overall composition. With this exposure, I was able to record a dynamic backlit scene that showcases both transparent and solid objects.

[20–35mm lens at 20mm, f/22 for 1/125 sec.]

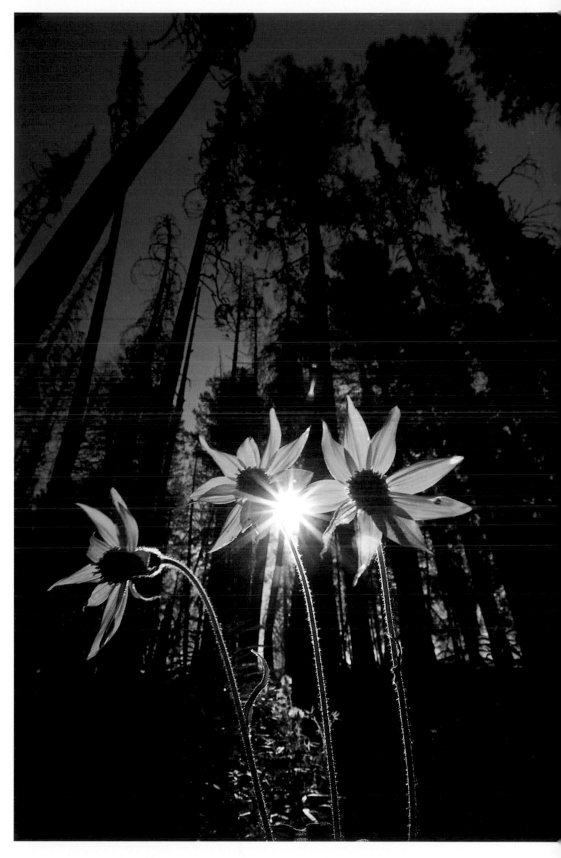

Exposure Meters

As discussed in the first chapter, at the center of the photographic triangle (aperture, shutter speed, and ISO) is the exposure meter (light meter). It's the "eye" of creative exposure. Without the vital information the exposure meter supplies, many picture-taking attempts would be akin to playing pin the tail on the donkey—hit and miss! This doesn't mean that you can't take a photograph without the aid of an exposure meter. After all, a hundred years ago photographers were able to record exposures without one, and even twenty-five years ago I was able to record exposures without one. They had a good excuse, though: there were no light meters available to use one hundred years ago. I, on the other hand, simply failed—on more than one occasion—to pack a spare battery for my Nikkormat FTN, and once the battery died, so did my light meter.

Just like the pioneers of photography, I too was then left having to rely on the same formulas for exposure offered by Kodak, the easiest being the Sunny *f*/16 Rule. This rule simply states: when shooting frontlit subjects on sunny days, set your aperture to *f*/16 and your shutter speed to the closest corresponding number of the film's ISO. (See page 117 for digital shooting and ISOs.) If I were using Kodachrome 25, I knew that at *f*/16 the shutter speed should be 1/30 sec. If I were using Kodachrome 64, the shutter speed should be 1/60 sec. Needless to say, this bit of information was valuable stuff when the battery went dead—but only when I was out shooting on sunny days! One of the great advances in photography today is the auto-everything camera; trouble is, when the batteries in these auto-everything cameras die, the *whole camera* dies, not just the light meter! Make it a point to *always* carry an extra battery or two.

Despite my feelings about this obvious shortcoming in auto-everything cameras, it cannot be ignored that the light meters of today are highly sensitive tools. It wasn't that long ago that many photographers would head for home once the sun went down, since the sensitivity of their light meters was such that they couldn't record an exposure at night. Today, photographers are able to continue shooting well past sundown with the assurance of achieving a correct exposure. If ever there was a tool most often built into the camera that eliminates any excuse for not shooting twenty-four hours a day, it would be the light meter.

Exposure meters come in two forms. They're either separate units not built in to the camera, or as with most of today's cameras, they're built into the body of the camera. Handheld light meters require you to physically point the meter at the subject or at the light falling on the subject, and to take a reading of the light. Once you do this, you set the shutter speed and aperture at an exposure based on this reading. Conversely, cameras with built-in exposure meters enable you to point the camera and lens at the subjects while continuously monitoring any changes in exposure. This metering system is called through-the-lens (TTL) metering. These light meters measure the intensity of the light that reflects off the metered subject, meaning they are *reflected-light meters*. Like lenses, reflected-light meters have a wide or very narrow angle of view.

Several less-expensive SLR cameras have *average* or *averaging reflected-light meters* built into them. This meter is useful when a scene contains areas of light and shadow, because the meter can measure both the light and shadow and give an average reading based on the two. This reading usually provides adequate data that enables you to successfully set an exposure. However, in picture-taking situations that contain much more shadow than light, or much more light than shadow, an average reflected-light meter tends to give exposure data that result in either overexposure or underexposure.

Another type of reflected-light meter is the *spot meter*. Up until recently, spot meters were only available as handheld light meters, but today it is not at all uncommon to see camera bodies that are equipped with them, as well. The spot meter measures light at an extremely narrow angle of view, usually limited to 1 to 5 degrees. As a result, the spot meter can take a meter reading from a very small area of an overall scene and get an accurate reading from that one very specific area despite how large an area of light and/or dark surrounds it in the

This simple frontlit scene in Utah's Arches National Park is an easy exposure for any camera's light meter, as is the case with most frontlit subjects. Whether your camera has averaging, center-weighted, or matrix metering, it will record a correct exposure. Since this was a classic storytelling scene, I wanted everything sharp from front to back. With my camera and 20–35mm lens on a tripod, I chose an aperture of f/22 and preset my focus via the distance scale on the front of the lens. I knew before I took the exposure that everything from two feet to infinity would be in focus. Since this was, again, a simple frontlit scene, I simply adjusted the shutter speed until 1/60 sec. indicated a correct exposure in the viewfinder.

[20–35mm lens at 20mm, f/22 for 1/60 sec.]

scene. My feelings about using spot meters haven't changed that much since I first learned of them over twenty-five years ago: they have a limited but important use in my daily picture-taking efforts.

Yet another type of light meter is the *center-weighted meter*. Unlike averaging or spot meters, center-weighted meters measure reflected light throughout the entire scene but are biased toward the center portion of the viewing area. To use a center-weighted light meter successfully, you must center the subject in the frame when you take the light reading. Once you set a manual exposure, you can then recompose the scene for the best composition. On the other hand, if you want to use your camera's autoexposure mode (assuming that your camera has one) but don't want to center the subject in the composition, you can press the exposure lock button and then recompose the scene so that the subject is now off-center; when you fire the shutter release, you'll still record a correct exposure.

And finally, there is *matrix metering*. Matrix metering came on the market about ten years ago, and has since been revised and improved. It's rare that you'll find a camera on the market today that doesn't offer a kind of metering system built on the original idea of matrix metering. This holds true for most SLRs and digital cameras. Matrix metering relies on a microchip that has been programmed to "see" thousands of picture-taking subjects, from bright white snowcapped peaks to the darkest canyons and everything in between. As you point your camera toward your subject, matrix metering recognizes the subject ('Hey, I know this scene! It's Mt. Everest on a sunny day!") and sets the exposure accordingly. Yet, as

good as matrix metering is, it still will come upon a scene it can't recognize, and when this happens, it will *hopefully* find an image in its database that comes close to matching what's in the viewfinder.

The type of camera determines which light meter or meters you have built in to the camera's body. If you're relatively new to photography and have a camera with several light meter options (matrix/evaluative, as well as center-weighted), I would strongly recommend using matrix 100 percent of the time. It has proven to be the most reliable and has fewer quirks than center-weighted metering. On countless field trips, I've witnessed some of my students switching from center-weighted metering to matrix metering repeatedly. Not surprisingly, due to each light meter's unique way of metering the light, they would often come up with slightly different readings. Also not

This image could have proved quite challenging to make if I hadn't had a spot meter. Looking down from atop a large coal storage facility, the lone yellow Caterpillar pushing around mounds of coal caught my eye. All of that black coal would have played havoc with center-weighted or even matrix/evaluative metering, which would have rendered it 18% gray (see pages 118 and 120). Trouble is, coal is black, and my client wouldn't have been thrilled with me if I turned in pictures of gray coal. So, with my camera's meter set to spot metering, and with my 80-200mm lens at 200mm, I pointed the lens at the Caterpillar. With an aperture of f/11, I adjusted the shutter speed until 1/60 sec. indicated a correct exposure. I then zoomed back out to 80mm, showing the expansive field of coal and shot several frames. Sure enough, when I did this the light meter indicated to me that I was way off! It was telling me that I should shoot the scene at f/11 for 1/15 sec. Had I shot at this exposure, I would have recorded an overexposure—or in other words, gray coal!

[80–200mm lens at 80mm, f/11 for 1/60 sec.]

surprising, they were often unsure of which exposure to believe, so they took one of each. This is analogous to having two spouses: those of us who have a spouse would certainly agree that dealing with the quirks and peculiarities of one spouse is at times too much, let alone two? Since I was raised on center-weighted metering, I'll stay with it for life. If it ain't broke, don't fix it.

Just how good are today's light meters? Both center-weighted and matrix metering prove accurate 90 percent of the time. That's an astounding, and hopefully confidence-building, number. Nine out of ten pictures will be correctly exposed, whether one uses manual-exposure mode (still my favorite) or semi-autoexposure mode (aperture-priority when shooting storytelling or isolation themes, or shutter-priority when freezing action, panning, or implying motion.) In either metering mode and when your subject is frontlit, sidelit, or under an overcast sky, you can simply choose your subject, aim, meter, compose, and shoot.

In addition, I do recommend taking another exposure at -2/3 stop with slide film, +2/3 stop with color negative film, and -2/3 stop when shooting digitally. This extra shot will allow you a comparison example so that you can decide later which of the two you prefer. Don't be surprised if you often pick the second exposure. Oftentimes, this slight change in exposure from what the meter indicates is just the right amount of contrast needed to make the picture that much more appealing. With the sophistication of today's built-in metering systems, it's often unnecessary to bracket like crazy.

Finally, there isn't a single light meter on the market today that can do any measuring, calculating, or metering until it has been "fed" one piece of data vital to the success of every exposure you take: the ISO. In the past, photographers using film had to manually set the ISO each and every time they would switch from one type of film to another. With the advances in today's cameras, the film's ISO is set automatically (via DX coding, which is a bar code on the film cassette that the camera reads). Unless you want to push or pull the film, you should never have to resort to setting film ISO manually.

Digital shooters, on the other hand and despite all the technology advances, must resort to the old way and tell the meter what the ISO is. Of course, digital shooters can also switch ISO from one scene to the next, as well as shift from shooting color images to black and white at the push of a button. So much for the old adage that you can't change horses in the middle of the stream.

The photo industry has come along way since I first started. With today's automatic cameras and their built-in exposure meters, much of what you shoot will be a correct exposure. However, keep in mind that the job of recording *creatively correct exposures* is still yours.

18% Reflectance

Now for what may be surprising news: Your camera's light meter (whether average, center-weighted, matrix, or spot) *does not* "see" the world in either living color or black and white, but rather as a *neutral gray*. In addition, your reflected-light meter is also calibrated to assume that all those neutral gray subjects will reflect back approximately 18% of the light that hits them.

This sounds simple enough, but more often than not, it's the reflectance of light off a given subject that creates a bad exposure, not the light that strikes the subject. Imagine that you came across a black cat asleep against a white wall, bathed in full sunlight. If you were to move in close and let the meter read the light reflecting off the cat, the meter would indicate a specific reading. If you were to then point the camera at only the white wall, the exposure meter would render a separate, distinct reading. This variation would occur because although the subjects are evenly illuminated, their reflective qualities radically differ. For example, the white wall would reflect approximately 36% of the light while the black cat would absorb most of the light, reflecting back only about 9%.

When presented with either white or black, the light meter freaks ("Holy smokes, sound the alarm! We've got a problem!"). White and black especially violate everything the meter was "taught" at the factory. White is no more neutral gray than black; they're both miles away from the middle of the scale. In response, the meter renders these extremes on film just like it does everything else: as a neutral gray. If you follow the light meter's reading—and fail to take charge and meter the right light source—white and black will record as dull gray versions of themselves.

To successfully meter white and black subjects, treat them as if they were neutral gray, even though their reflectance indicates otherwise. In other words, meter a white wall that reflects 36% of the light falling on it as if it reflected the normal 18%. Similarly, meter a black cat or dog that reflects only 9% of the light falling on it as if it reflected 18%.

If the light meter is confused by white and black separately, can you imagine how confused it must get when aimed at a zebra? Actually, this is one of the easiest exposures. Why? Because the light meter averages the two tones and comes back with a correct 18% gray reflectance. It's like putting equal parts white and black paint into a bucket, mixing them together, and getting medium gray. With my camera and 200mm lens set to *f*/11 ("Who cares" what aperture I use here?), I simply adjusted my shutter speed until 1/125 sec. indicated a correct exposure.

[200mm lens, *f*/11 for 1/125 sec.]

The Gray Card

When I first learned about 18% reflectance, it took me awhile to catch on. One tool that enabled me to understand it was a gray card. Sold by most camera stores, gray cards come in handy when you shoot bright and dark subjects, such as white sandy beaches, snow-covered fields, black animals, or black shiny cars. Rather than pointing your camera at the subject, simply hold a gray card in front of your lens—making sure that the light falling on the card is the same light that falls on the subject—and meter the light reflecting off the card.

If you're shooting in an autoexposure, program, shutter-priority, or aperture-priority mode, you must take one extra step before putting the gray card away. After you take the reading from the gray card, note the exposure. Let's say the meter indicated $f/16$ at 1/100 sec. for a bright snow scene in front of you. Then look at the scene in one of these modes. Chances are that in aperture-priority mode, the meter may read $f/16$ at 1/200 sec.; and in shutter-priority mode, the meter may read $f/22$ at 1/100 sec. In either case, the meter is now "off" one stop from the correct meter reading from the gray card. You need to recover that one stop by using your autoexposure overrides.

These overrides are designated as follows: +2, +1, 0, -1, and -2; or 2X, 1X, 0, 1/2X, and 1/4X. So for example, to provide an additional stop of exposure when shooting a snowy scene in the autoexposure mode, you would set the autoexposure override to +1 (or 1X, depending on your camera's make and model). Conversely, when shooting a black cat or dog, you'd set the autoexposure override to -1(1/2X).

Hot Gray Card Tip! After you've purchased your gray card, you only need it once since you've already got something on your body that works just as well—but you'll need the gray card to help you initially. If you're ever in doubt about any exposure situation, meter off the palm of your hand. I know your palm isn't gray, but you then simply use your gray card to "calibrate" your palm—and once you've done that, you can leave the gray card at home.

To calibrate your palm, take your gray card and camera into full sun, and set your aperture to $f/8$. While filling the frame with the gray card (it doesn't have to be in focus), adjust your shutter speed until a correct exposure is indicated by the camera's light meter. Now, hold the palm of your hand out in front of your lens. The camera's meter should read that you str about +2/3 to 1 stop overexposed. Make a note of this. Then, take the gray card once again into open shade with an aperture of $f/8$, and again adjust the shutter speed until a correct exposure is indicated. Again, meter your palm and you should see that the meter now reads +2/3 to 1 stop overexposed. No matter what lighting conditions you do this under, your palm will consistently read about +2/3 to 1 stop overexposed from the reading of a gray card.

So, the next time you're out shooting and you have that uneasy feeling about your meter reading, take a reading from the palm of your hand and when the meter reads +2/3 to 1 stop overexposed, you know your exposure will be correct.

(*Note*: For obvious reasons, if the palm of your hand meters a 2-, 3-, or 4-stop difference from than the scene in front of you, you're either [a] taking a reading off the palm of your hand in sunlight, having forgotten to take into account that your subject is in open shade, or [b] you forgot to take off your white gloves.)

Following a heavy snowfall in Oregon's Willamette Valley, I headed out at first light and photographed this lone oak tree. Using a 50mm lens and a tripod, I first set the aperture to f/8 and then adjusted the shutter speed until 1/30 sec. indicated a correct exposure in the viewfinder. The result (opposite, top) was that the meter turned all of my white snow gray. Why? Although white subjects reflect 36% of light, they must be metered as if they reflect the normal 18% gray. When the meter sees white, it interprets this excessive reflectance to mean that less exposure is needed and, subsequently, renders an underexposed image. One of the easiest ways to overcome this problem is with a gray card. When I held my gray card in front of the camera and lens, I noticed that the meter indicated a shutter speed of 1/15 sec. for a correct exposure. I then put the gray card down and the light meter immediately jumped back to 1/30 sec. as the indicated exposure. However, I chose to ignore it, and as you can see here, the second exposure of 1/15 sec. is the correct one.

[Both photos: 35–70mm lens at 50mm. Opposite, top: f/8 for 1/30 sec. Opposite, bottom: f/8 for 1/15 sec.]

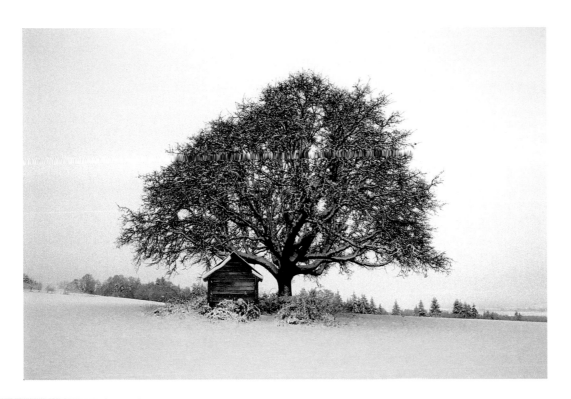

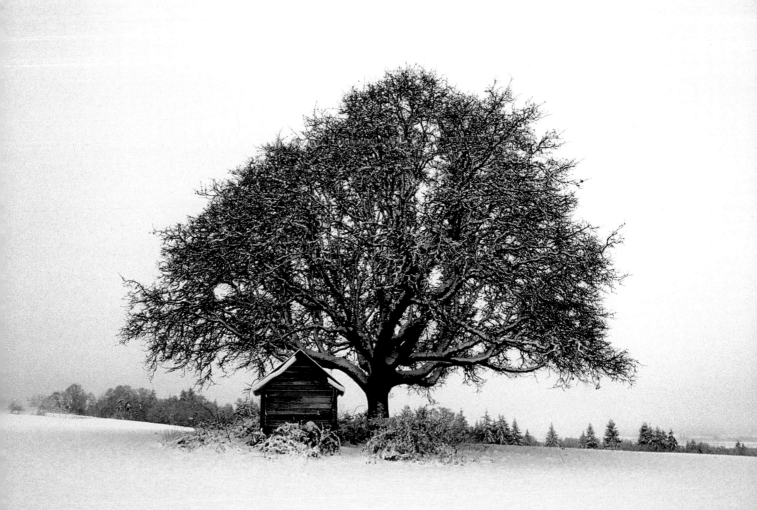

The Sky Brothers

The world is filled with color, and in fairness, the light meter does a pretty darn good job of seeing the differences in the many shades and tones that are reflected by all of this color. But, in addition to being confused by white and black, the meter can also be confused by backlight and contrast. So, are we back to the hit-and-miss, hope-and-pray formula of exposure? Not at all! There are some very effective and easy solutions for these sometimes pesky and difficult exposures: they're what I call *the Sky Brothers*.

Oftentimes when shooting under difficult lighting situations (sidelight and backlight being the two primary examples), an internal dispute may take place as you wrestle over just where exactly you should point your camera to take a meter reading. I know of "no one" more qualified to mediate these disputes between you and your light meter than the Sky Brothers. They're not biased. They want only to offer the one solution that works each and every time. So, on sunny days, *Brother Blue Sky* is the go-to guy for those winter landscapes (see page 124), black Labrador portraits, bright yellow flower

close-ups, and fields of deep purple lavender. This means you take a meter reading of the sunny blue sky and use that exposure to make your image. When shooting backlit sunrise and sunset landscapes, *Brother Backlit Sky* is your go-to guy. This means you take a meter reading to the side of the sun in these scenes and use that reading to make your image. When shooting city or country scenes at dusk, *Brother Dusky Blue Sky* gets the call, meaning you take your meter reading from the dusk sky. And, when faced with coastal scenes or lake reflections at sunrise or sunset call on *Brother Reflecting Sky*, meaning you take your meter reading from the light reflecting off the surface of the water.

Warning: Once you've called upon the Sky Brothers, your camera's light meter will let you have it. You will notice that once you have used Brother Blue Sky and set the exposure, your light meter will go into a tirade when you recompose that frontlit winter landscape ("Are you nuts?! I've got eyes of my own and I know what I'm seeing and all that white snow is nowhere near the same exposure value of Brother Blue Sky!") Trust me on this one. If you listen to your light meter's advice and, subsequently, readjust your exposure, you will end up right back where you started—a photograph with gray snow! So, once you have metered the sky using the Sky Brothers, set the exposure manually, or "lock" the exposure if you are staying in automatic before you return to the original scene. Then shoot away with the knowledge that *you are right* no matter how much the meter says you're wrong!

Chaos is perhaps the best way to describe the result of a traffic light that seems to indicate anything is possible—considering that red, yellow, and green are all lit at the same time. Over the course of an 8-second exposure—which I chose so that I could interpret the traffic as colorful streaks—I was able to record all three lights since my exposure began just several seconds before the light changed from green to yellow to red. I, of course, used a tripod for such a long exposure, and I used *Brother Dusky Blue Sky*, metering off the distant dusky blue sky.

[80–200mm lens at 135mm, f/11 for 8 seconds]

I'm a strong believer in morning light. To meter this scene, I used *Brother Reflecting Sky*, pointing my camera below the horizon line. The reason I didn't use Brother Backlit Sky is that a reflection absorbs at least a full stop of light, sometimes more. Thus, if I'd taken the meter reading off the sky, I would have ended up with an image that was at least 1 stop underexposed, if not more. If you want to show detail, color, and texture in the reflection, this would be disastrous. Granted, the sky is now 1 stop overexposed, but it's a welcome trade-off since I was able to get both detail and color in the reflection below.

[20–35mm lens at 20mm, f/22 for 1/8 sec.]

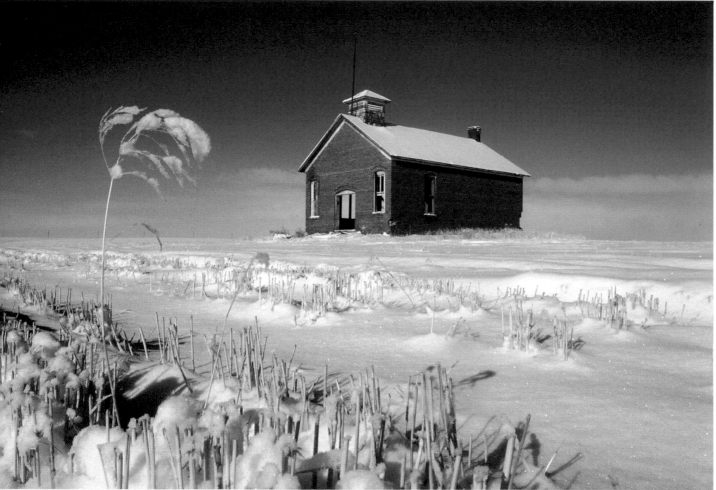

When I simply aimed my camera's light meter at this lone schoolhouse in a winter landscape and adjusted my light meter accordingly, I got gray snow (top, left). This would happen whether you're in manual- or automatic-exposure mode. And why not?

The light meter is doing exactly what it should when shooting a white subject—making it gray. But, since snow is white, you have to do an "intervention" using *Brother Blue Sky*. With my 24mm lens set to a story-telling aperture of *f*/22, I simply pointed the camera and lens to the sky above the schoolhouse (top, right) and adjusted my shutter speed until the camera's light meter indicated 1/60 sec. as the correct exposure. I then recomposed and shot the same scene at the Brother Blue Sky exposure—and presto: I got white snow (above). Of course, after I metered the sky and recomposed the scene, the light meter told me I was wrong, wrong, wrong. But just like it's a two-year-old throwing a temper tantrum, ignore it!

[24mm lens, *f*/22 for 1/60 sec.]

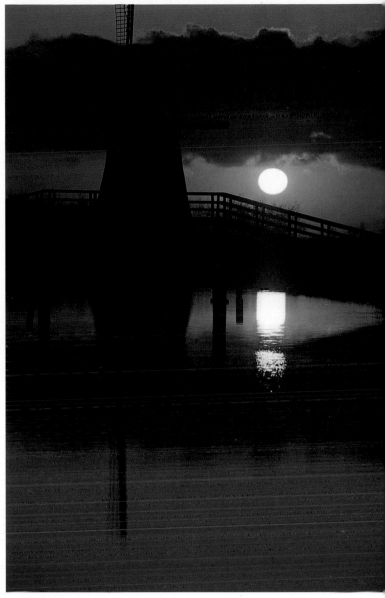

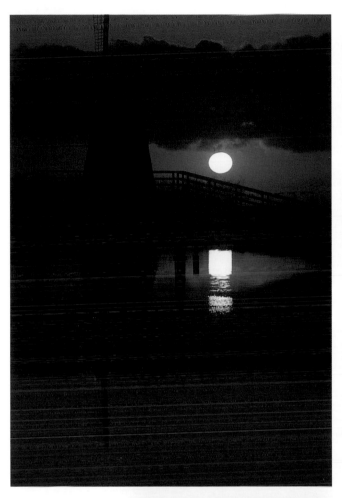

When shooting backlighting, sunrises, or sunsets—and especially with a telephoto lens—call on *Brother Backlit Sky*. In the first exposure, the windmill gets lost in a cloud and also is a bit too dark. This was the result of listening to the meter. But, when I took the exposure using Brother Backlit Sky—always to the left or right of the sun, or above or below it (left)—I was able to record a much better exposure.

[80–200mm lens at 200mm, f/22 for 1/125 sec.]

Mr. Green Jeans (The Sky Brothers' Cousin)

Mr. Green Jeans is the cousin of the Sky Brothers. He comes in handy when exposing compositions that have a lot of green in them (you take the meter reading off the green area in your composition). Mr. Green Jeans prefers to be exposed at -2/3. In other words, whether you bring the exposure to a close by choosing either the aperture or the shutter speed last, you adjust the exposure reading as "correct" when you see a -2/3 stop indication (which means you adjust the exposure to be -2/3 stops from what the meter tells you.) If there's one thing I've learned about Mr. Green Jeans, it's that he's as reliable as the Sky Brothers, but you must always remember to meter him at -2/3.

While on assignment for a large Dutch flower company, I made what has become one of my all-time favorite images. I had never before been so mesmerized by a pair of eyes as I was by those of Ijadet. She was one of several hundred employees working on the flower plantation near Burjumbura, Burundi. She was intensely camera shy, and although it took three days, I did finally manage to get her to look at me for a grand total of just one minute.

Again, the lighting challenge here is that the light meter "freaks" when presented with black or white subjects, and does everything it can to render them as gray. Due to Ijadet's dark skin color, the light meter interpreted her much lower reflected-light value to mean that the exposure time should be much longer than the "norm." So, I put *Mr. Green Jeans* to use and pointed the light meter toward the bouquet of carnations she was holding. I'd already determined this was a "Who cares?" composition, and so I chose an *f*/8 aperture. Then with my camera pointed at the flowers, I adjusted my shutter speed until a -2/3 stop exposure was indicated, and simply recomposed and took the shot.

[105mm lens, *f*/8 for 1/125 sec.]

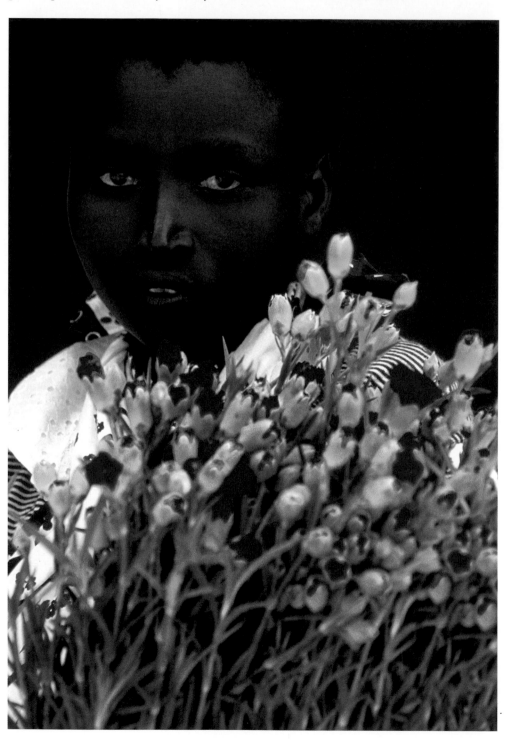

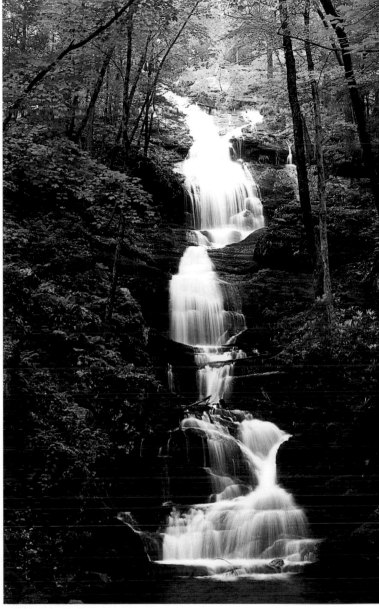

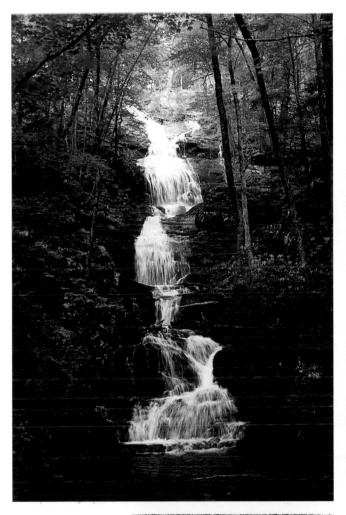

This is a classic example both of what the light meter wants to do when confronted with white (in this case the water in a waterfall) and of the need for *Mr. Green Jeans*. The first image is the result of leaving the meter to its own way of thinking: gray water. And, not only is the water underexposed, but so is the surrounding green forest. Since the skies were cloudy, taking a reading using Brother Blue Sky was out of the question. So, I swung the camera and lens to Mr. Green Jeans (the area shown at left), readjusted my aperture until *f*/19 indicated a -2/3 underexposure, and then recomposed the scene with the waterfall. Of course, my light meter immediately indicated that a different exposure was required, but I ignored it and shot the scene. Obviously, I was right and it was wrong.

[Both photos: 20–35mm lens at 20mm. Top left: *f*/32 for 1/4 sec. Above: *f*/19 for 1/4 sec.]

Night and Low-Light Photography

There seems to be this unwritten rule that it's not really possible to get any good pictures before the sun comes up or after it goes down. After all, if "there's no light," then why bother? However, nothing could be farther from the truth.

Low-light and night photography do pose special challenges though, not the least of which is the need to use a tripod (assuming, of course, that you want to record exacting sharpness). But, it's my feeling that the greatest hindrance to shooting at night or in the low light of predawn is in the area of self-discipline: "It's time for dinner" (pack a sandwich); "I want to go to a movie" (rent it when it comes out on DVD); "I'm not a morning person" (don't go to bed the night before); "I'm all alone and don't feel safe" (join a camera club and go out with a fellow photographer); "I don't have a tripod" (buy one!). If it's your goal to record compelling imagery—and it should be—then night and low-light photography are two areas where compelling imagery abounds. The rewards of night and low-light photography far outweigh the sacrifices.

Once you pick a subject, the only question remains is how to expose for it. With the sophistication of today's cameras and their highly sensitive light meters, getting a correct exposure is easy, even in the dimmest of light. And yet many photographers get confused: "Where should I take my meter reading? How long should my exposure be? Should I use any filters?" In my years of taking meter readings, I've found there's nothing better—or more consistent—than taking meter readings off the sky. This holds whether I'm shooting backlight, frontlight, sidelight, sunrise, or sunset (Sky Brothers are your go-to-guys, see pages 122–125). If I want great storytelling depth of field, I set the lens (i.e. a wide-angle lens for storytelling) to f/16 or f/22, raise my camera to the sky above the scene, adjust the shutter speed for a correct exposure, recompose, and press the shutter release.

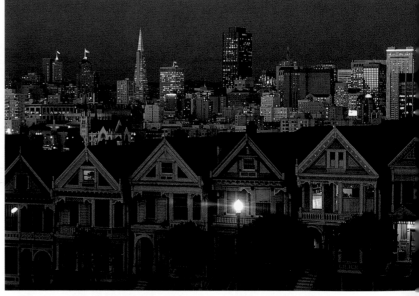

By day, Bryant Park in San Francisco is an active place, filled with people. But where do all the people go when the sun goes down? To dinner, plays, parties, and the movies! That was okay by me on this evening, since it meant that I wouldn't have to bump elbows with a host of other photo-enthusiasts while recording a more compelling low-light exposure at dusk.

For the daytime exposure, I placed my camera and lens on a tripod, and due to the need for great depth of field, I set my aperture to f/22 and then adjusted the shutter speed until 1/60 sec. indicated a correct exposure. For the dusk exposure (with the same camera and lens), I began with my aperture at f/2.8 and pointed the camera toward the sky (Brother Dusky Blue Sky). I then

adjusted my shutter speed to 1/4 sec. Since I still needed a great depth of field, I set the lens to f/22 and simply did the math to determine the new and correct exposure: Since I stopped the lens down 7 stops (f/2.8 to f/4 to f/5.6 to f/8 to f/11 to f/16 to f/22), I needed to increase the exposure time by an equal number of stops: 1/4 sec. to 1/2 sec. to 1 second to 2 seconds to

4 seconds to 8 seconds to 16 seconds to 30 seconds. Since the camera didn't have an actual shutter speed selection for 30 seconds, I had to use the B setting and, with a locking cable release, fire the shutter while keeping a close eye on my watch.

[Both photos: 80–200mm lens at 200mm. Left: f/22 for 1/60 sec. Above: f/2.8 for 30 seconds]

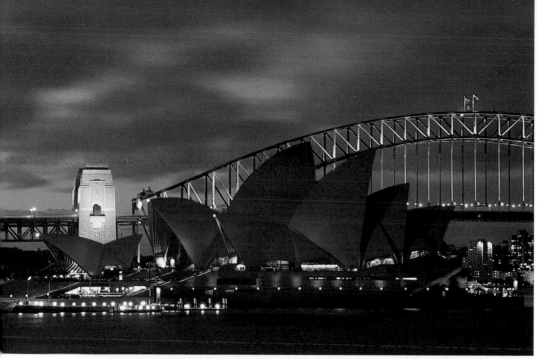

Paint the town red was the campaign for the city of Sydney during my two-week stay there about four years ago. Even the opera house was covered in red light. Not one to waste an opportunity, I set up my tripod. With my aperture set to f/8—"Who cares?" since everything is at the same focal distance of infinity—I tilted the camera up to the dusky blue, cloudy sky and adjusted my shutter speed until the meter indicated 2 seconds as a correct exposure. I then recomposed and made several exposures, tripping the shutter with the camera's self-timer.

[80–200mm lens, f/8 for 2 seconds]

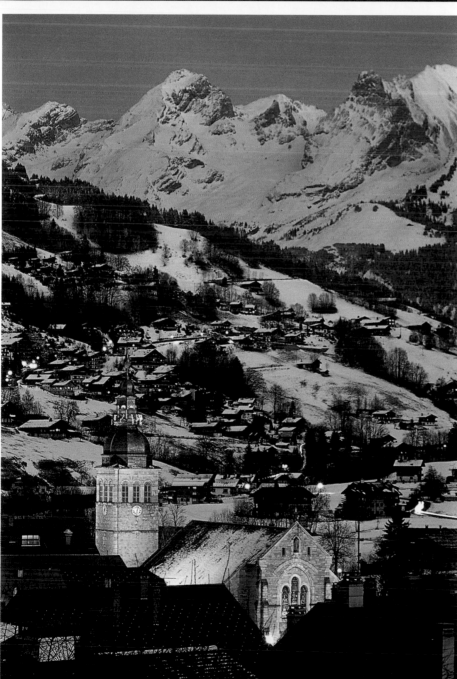

The Aravais mountain range in the Northern French Alps is a skier's paradise, and the village of Grand Bornhand sits in the valley floor of these impressive mountains. It's a town that offers wonderful low-light photo opportunities *if* you can put off eating dinner for half an hour or so!

With my camera and 35-70mm lens on a tripod, I set the focal length to 35mm and the aperture to f/2.8, and then raised the camera to the dusky blue sky above the mountain range. I adjusted the shutter speed until the meter indicated 1/8 sec. as a correct exposure. I then recomposed, stopped the lens down 5 stops to f/16, and *increased* my exposure time by five stops. With my exposure time now set for f/16 for 4 seconds, I tripped the shutter with my cameras self-timer.

[35–70mm lens at 35mm, f/16 for 4 seconds]

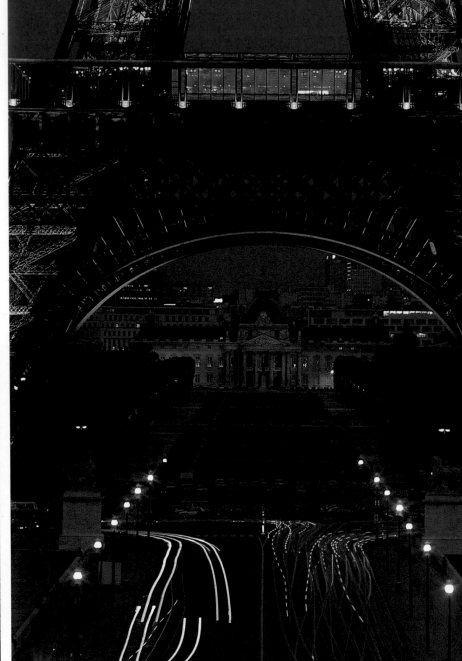

Consider whether the nighttime scene before you offers the chance to capture motion. Cityscapes often provide wonderful opportunities to show the flow of traffic. Keep in mind that the car lights will appear as streaks of red and white, so when you set up your composition, you must ask yourself if these lines will keep the eye in the scene or lead it out of it. At a minimum, a 4-second exposure will render the traffic as streaks. With your camera's shutter speed set to 4 seconds, simply aim at the sky above the scene (above, left) and adjust your aperture until you get a correct exposure. Then recompose the scene, and trigger the shutter release either via the camera's self-timer or with a locking cable release.

Since many people think the pedestrian plaza at the Place de la Concorde affords some of the best views of the Eiffel Tower, to get the image here I made it a point to arrive a bit early, scout the best spot, and lay claim to it by positioning my tripod exactly where I wanted it. For the next thirty minutes or so, I just enjoyed my baguette and cheese, and awaited the arrival of the dusky blue sky. I at first set my aperture wide open to f/2.8. I then aimed at the sky to the left of the tower and adjusted my shutter speed to 1/4 sec. However, since I was interested in getting a streaked effect from the traffic around the tower, I needed a much longer shut-

ter speed than 1/4 sec. I, therefore, stopped the lens down from f/2.8 to f/16 and—to maintain a correct exposure—chose a shutter speed of 8 seconds. Since I stopped the lens down 5 stops (f/2.8 to f/16 is 5 stops), I needed to *increase* my exposure time by an equal number of stops (1/4 sec. to 1/2 sec. to 1 second to 2 seconds to 4 seconds to 8 seconds is 5 stops).

[80–200mm lens at 200mm, f/16 for 8 seconds]

When I made this long exposure of the Vatican, I started shooting shortly after the street lights came on, yet the Vatican itself never lit up! In any event, I used a filter I can't live without (besides the polarizer and Tiffen 3 stop graduated): the FLW. It's a magenta-colored filter not to be confused with the FLD. The magenta color of the FLW is far denser and is far more effective on normally greenish city lights, giving them a much warmer cast. Additionally, this filter also imparts its magenta hue onto the sky, which is perfect for those nights when there isn't a strong dusky blue sky.

With my camera mounted on a tripod, I at first set my aperture to f/4. I pointed the camera to the gray sky and adjusted my shutter speed to 1/2 sec., but since I had already determined that I wanted the longest possible exposure time, I did the math and ended up at f/32 for 30 seconds!

[105mm lens, f/32 for 30 seconds]

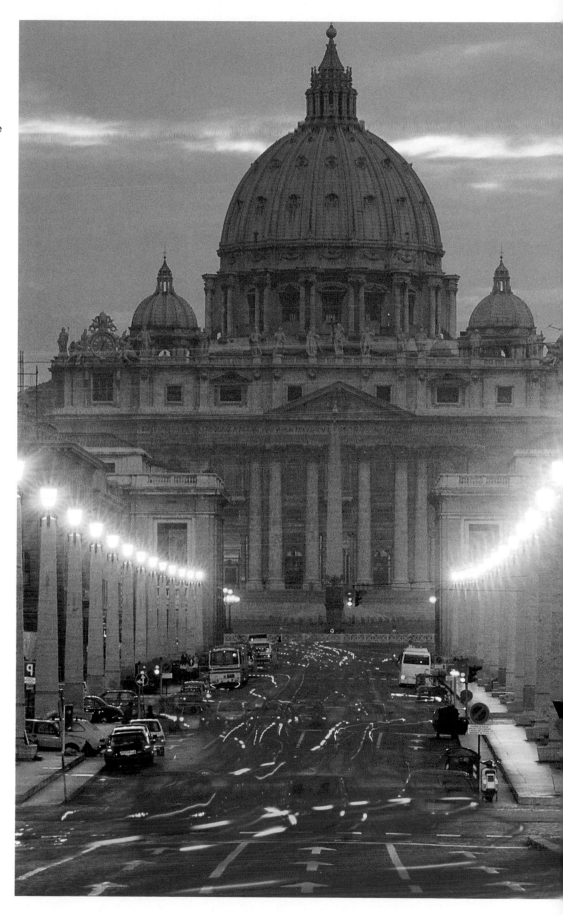

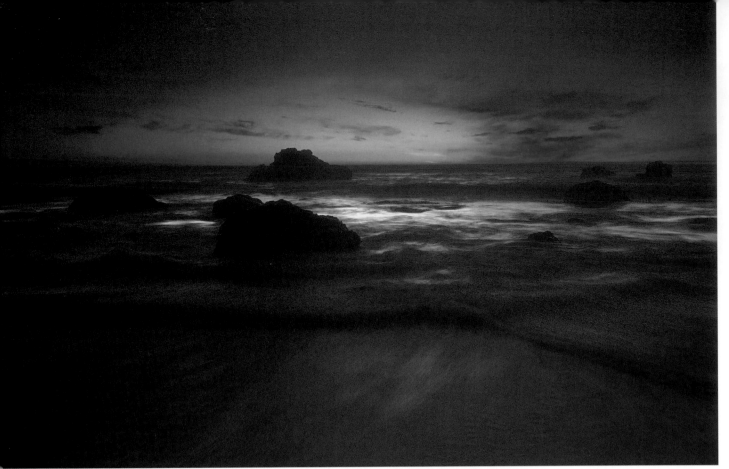

Many rocky shorelines offer opportunities to convey both tranquility and motion. This exposure, although it appears difficult, is really quite easy to make. I first placed my FLW magenta filter on my 24mm lens and then went looking for my meter reading. Using Brother Reflecting Sky and with my aperture at *f*/4, I metered off the light reflecting on the surface of the water, adjusting my shutter speed until 1 second indicated a correct exposure. I then pointed the lens above the horizon and, with the aperture still at *f*/4, took a meter reading using Brother Backlit Sky. I got a correct exposure at 1/15 sec., a difference of 4 stops (*f*/4 for 1 second vs. *f*/4 for 1/15 sec. is 4 stops—from 1 second to 1/2 sec. to 1/4 sec. to 1/8 sec. to 1/15 sec.). So, which exposure wins? Both, thanks to my trusty 3-stop graduated soft-edge neutral-density filter. The graduated neutral density had effectively slashed 3 stops of exposure from

Brother Backlit Sky, so the exposure time had to change from *f*/4 for 1/15 sec. to *f*/4 for 1/2 sec. In other words, the brothers would only be separated by 1 stop, and a 1-stop difference in backlit exposures like these is nothing.

But wait! Since I wanted to shoot a long exposure and use the first exposure I took using Brother Reflecting Sky, I had to do the math. Since *f*/4 was correct at 1 second, then *f*/5.6 for 2 seconds would also be good, as would *f*/8 for 4 seconds and *f*/11 for 8 seconds and *f*/16 for 16 seconds. Stop! That's good enough for me! After setting my depth of field via the distance setting on my lens (in this case setting five feet out ahead of the center focus mark), I was ready to shoot—and presto, here's the result (with the aid of my Lee 3-stop soft-edge neutral-density filter and my Tiffen FLW magenta filter.)

[24mm lens, *f*/16 for 16 seconds]

While many photographers watch the moon rise, few photograph it because they aren't sure how to meter the scene. Surprisingly, however, a "moonrise" is easy to expose. It's actually just a frontlit scene—just like the frontlit scenes found in daylight— but now, of course, it's a *low-light* frontlit scene.

Since depth of field was not a concern here, I set the aperture on my lens to *f*/8, metered the sky above the tree, adjusted my shutter speed to 1/8 sec., recomposed the scene, and—using the camera's self-timer—fired the shutter release button.

Note: In this instance, as well as for other full-moon landscapes, it's best to take the photograph on *the day before* the calendar indicates a full moon. Why? Because the day before a full moon (when the moon is almost full), the eastern sky and the landscape below are darn near at the same exposure value. (And, truth be told, I could have also taken my meter reading from the wheat field in this scene and it would have been within a cat's whisker of the meter reading for the sky.)

[300mm lens, *f*/8 for 1/8 sec.]

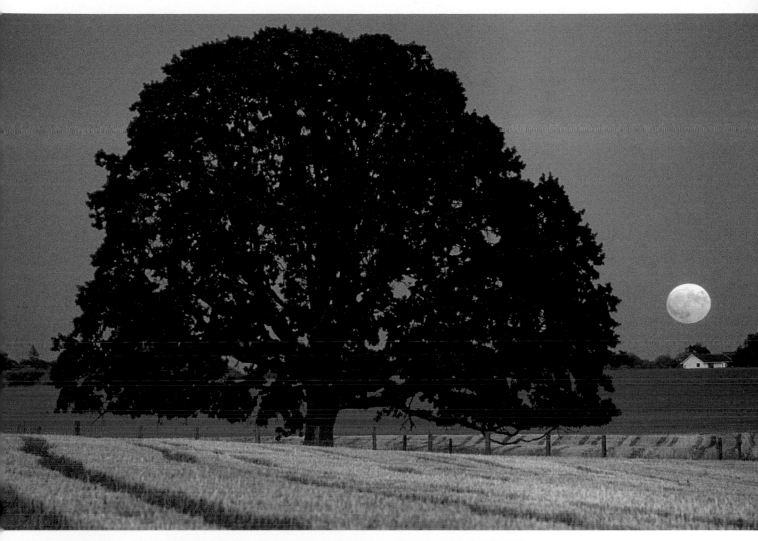

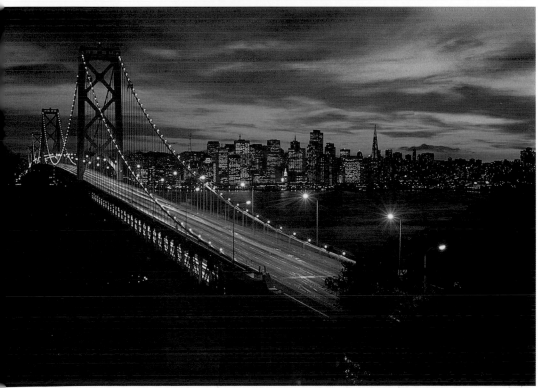

A firm and steady tripod enabled me to shoot this classic scene of the San Francisco skyline. With my camera and 35–70mm lens on a tripod, I set the focal length to 50mm and set my aperture wide open at f/2.8. I then pointed the camera to the sky above and adjusted the shutter speed to 1/2 sec. Since I wanted an exposure of at least 8 seconds to capture the flow of traffic on the bridge, I knew that by stopping the lens down 4 stops to f/11 would require me to increase my exposure time by these same 4 stops to 8 seconds. With an 8-second exposure, I tripped the shutter with my cable release.

[35–70mm lens at 50mm, f/11 for 8 seconds]

The Importance of the Tripod

When should you use a tripod? When I want exacting sharpness and/or when I'm shooting long exposures and want to convey motion in a scene, I always call upon my tripod.

The following features are a must on any tripod. First, the *tripod head*: This is the most important because it supports the bulk of the camera and lens weight. When looking at the many different styles of tripod heads, make it a point to mount your heaviest combination of camera and lens on each head as a test. Once you secure the camera and lens, check to see if it tends to flop or sag a bit. If so, you need a much sturdier head. Next, see if the tripod head offers, by a simple turn of the handle, the ability to shift from a horizontal to a vertical format. Also check whether you can lock the tripod head at angles in between horizontal and vertical. Finally, does the tripod head offer a quick release? Some tripods require you to mount the camera and lens directly onto the tripod head by way of a threaded screw. A quick release, on the other hand, is a metal or plastic plate that you attach to the camera body; you then secure the camera and plate to the head via a simple locking mechanism. When you want to remove the camera and lens, you slimily flick the locking mechanism and lift the camera and lens off the tripod.

Second, the *base stability*: Before buying any tripod, you should also spread out its legs as wide as possible. The wider the base, the greater the stability. Each leg of the tripod is composed of three individual lengths of aluminum, metal, or graphite. You can lengthen or shorten the legs, and then tighten them by a simple twist of hard plastic knobs, metal clamps, or a threaded metal sleeve. The height of a tripod at full extension is another important consideration: obviously, if you are 6'2", you don't want a tripod with a maximum height of only 5'2"—unless you won't be bothered by stooping over your tripod all the time. All tripods have a center column designed to provide additional height; this can vary from six inches to several feet. Some center columns extend via a cranking mechanism while others require you to pull them up manually. Keep in mind that you should raise the center column only when it's absolutely necessary, because the higher the center column is raised, the greater the risk of wobble—which defeats the purpose of using a tripod.

Finally, when shooting any subject with your tripod, make it a point to use either the camera's self-timer or a cable release to trip the shutter.

If there's light in the sky and I've got the time, I'm going to shoot the scene before me and somehow try to work in the landscape. This was the case as I was driving through the winding roads in Arches National Park in Utah several years ago. I kept searching to the left and right for some silhou-etted rocks and sky, but I was having trouble finding anything that looked com-pelling. At that point it hit me: the shot was right in front of me! I set up my cam-era on a tripod in front of my car. With my headlights on, I framed the winding road and distant rock out-croppings against the predawn sky. "This will work," I said to myself, then pointed the camera to the sky above the rocks, and with my aperture set to f/4, adjusted my shutter speed to 1/2 sec. I wanted an expo-sure time long enough to record passing car taillights as streaks of color. So, stop-ping the lens down from f/4 to f/16 would accomplish both of my goals for this photograph: great depth of field from foreground to background and long expo-sure time. If f/4 is good at 1/2 sec., then f/16 is good at 8 seconds.

[17–35mm lens at 24mm, f/16 for 8 seconds]

Special Techniques and Filters

Deliberate Overexposure

Up until now, I've shared a lot of solid and basic information—information that will get you where want to go and back again. But now I want to show you how you can add some extras to your understanding of exposure. These extras include techniques such as deliberate overexposure, double exposure, and multiple exposure, as well as the use of filters such as the neutral-density, graduated neutral-density, graduated color, and of course, the often misunderstood polarizing filter. Let's start with overexposures.

When was the last time you deliberately shot a composition as overexposed? I don't mean overexposed by a stop or two, but rather by three or four stops. Like any experiment, the results of shooting exposures three or four stops overexposed won't always be compelling; but since more often than not, a compelling image will result, you may want to try this simple trick. Lighting plays the biggest role in deliberate overexposures. The light should be even, and for that reason, frontlit subjects or subjects that are under the soft and even illumination of an overcast day are best.

The image of my wife above is a standard exposure. The one to the right is a deliberate overexposure, resulting in what is called a *high-key* effect. A deliberate overexposure of three to four stops (in this case it was three stops) intensifies the sensual qualities of an image, transforming normally vivid colors into delicate pastel tones.

In addition, I made both these images at ISO 1600. I chose this high-speed film not because of the setup's low-light level, but becuse of the film's inherent graininess. (This graininess serves to heighten the sensuality of this type of "boudoir" image and is a "secret" of many fashion and glamour photographers.). Note that the lighting here is all natural, diffused window light; I'm very anti-flash, especially when there's plenty of daylight around.

[Both photos: 80–200mm lens at 100mm. Above: f/8 for 1/500 sec. Right: f/8 for 1/60 sec. (+3 overexposed)]

With my camera and lens secured to my tripod, I was able to compose some graphic images of the flamingos in the small lake below me at Singapore's Jurong Bird Park. In my first exposure, I set the aperture to f/8 and simply adjusted the shutter speed until 1/500 sec. indicated a correct exposure, resulting in a pleasing pattern that was just what I'd expected. But, I wanted to try my luck at "art," so I simply adjusted my shutter speed until a 4-stop overexposure was indicated (1/500 sec. to 1/250 sec. (+1 stop) to 1/125 sec. (+2 stops) to 1/60 sec. (+3 stops) to 1/30 sec. (+4 stops). With the aperture still set to f/8 and my shutter speed now set to 1/30 sec., I achieve a very different look.

[Both photos: 70–300mm lens at 300mm. Top: f/8 for 1/500 sec. Above: f/8 for 1/30 sec.]

Double Exposure and Sandwiching

Shooting double exposures can be twice the fun of shooting single exposures. Check your camera right now to see if it has double-exposure capabilities. Unfortunately, not all cameras do, and that's particularly true of many digital cameras. The purpose of the double-exposure feature is to enable you to shoot two (or more) exposures on the same piece of film (or on the same digital exposure, if your digital camera allows it). It's important to remember that when you shoot a double exposure, you must pay attention to how the images will overlap. Many compositions are ruined by the misalignment of the two exposures. But, other than the need to be careful and precise with your alignment, the actual creation of the exposure is easy. You simply shoot both of your exposures at a 1-stop underexposure whether you're shooting prints, slides, or digital.

If you don't have the double exposure feature on your camera, you can still enjoy double exposures. In fact, you can even have greater control over making your double exposures because you'll be using a technique called *sandwiching*. This is nothing more than placing two slides or negatives together (just like exposing two images on the same piece of film) and then making a print. The trick to making the right exposure when sandwiching, however, is just the opposite of making an in-camera double exposure: you want to choose slides or negatives that are each 1 stop overexposed so that when they are sandwiched together, they combine to make a "correct" exposure. (If you sandwich together two slides or negatives that are each 1 stop underexposed, you'll end up with a dark, 2-stop underexposure sandwich.)

One of my favorite techniques is to combine some overexposed skies with some of my "earth" work. The results are often surprising. Some photographers love to sandwich several flower compositions, while others combine several overexposed portraits. The next time you're out shooting film, make it a point to shoot an additional one or two frames deliberately at 1 stop overexposure in anticipation of sandwiching them later.

When I first arrived at this location (opposite, left), my intent was simply to record a basic sunset image, and that's what I did. After taking several exposures and getting ready to head home, I turned around and saw the moon rising in the eastern sky. It was too late to trek around trying to find an actual landscape composition that incorporated the moon, so I did the next best thing: I made a double exposure that included the moon (opposite, right). I returned to the scene before me, fired off another exposure of the tree and sky, and then—using my camera's double-exposure feature—advanced the shutter without advancing the film. I then changed lenses (replacing my 35–70mm lens with my 200mm lens), and pointed the camera at the moon and composed a shot in which the moon appeared in the upper third of the frame. I used an aperture of f/8 ("Who cares?" since the moon is at infinity) and a shutter speed of 1/250 sec. to then make the exposure of the moon on top of the exposure I had just made of the tree.

[Opposite page, left: 35–70mm lens at 50mm, f/16 for 4 seconds. Opposite page, right: 35–70mm lens at 50mm, f/16 for 4 seconds (for the tree); 200mm lens, f/8 for 1/250 sec. (for the moon)]

La Defense in Paris offers up some wonderful modern-day photographic opportunities. One morning, I was photographing from an elevated pedestrian walkway when I caught sight of this lone woman climbing the stairway below me. Although at the time I made this image, I was thinking of its use as a business shot for my stock photo library, I made a point of shooting several frames overexposed by 1 stop, just in case I wanted to use them for sandwiching. Several years later, I pulled this image out and combined it with some cloudscapes I had recently shot from an airplane window seat. Sure enough, they made a great, "gates of heaven" combo.

[Cloud photo: 35–70mm lens at 35mm, f/16 for 1/125 sec. La Defense photo: 300mm lens, f/8 for 1/125 sec.]

Multiple Exposure

If taking two exposures on the same piece of film (or exposure on a digital card) doesn't quite do it for you, how about taking three, five, eight, sixteen, or even thirty-two exposures? As long as you engage the double exposure feature on your camera, you can keep placing exposure on top of one another. I am continually surprised by the result.

To make a deliberate multiple exposure, you photograph the same subject over and over while you move the camera ever so slightly between each shot. For example, you find a composition of fruits and vegetables at a country produce stand on an overcast day. The sky subjects are evenly illuminated, and because you're shooting looking down on the subject, you choose a "Who cares?" aperture of *f*/8 and then adjust the shutter speed to 1/60 sec. If you want to shoot sixteen exposures of the composition before you, the math is really simple: If one exposure at *f*/8 for 1/60 sec. is correct, then two exposures at *f*/8 for 1/125 sec. are also correct, and four exposures at *f*/8 for 1/250 sec. are also correct, as are eight exposures at *f*/8 for 1/500 sec. and sixteen exposures at *f*/8 for 1/1000 sec. So, taking sixteen shots at *f*/8 for 1/1000 sec. is exactly the same quantitative value as taking a single exposure at *f*/8 for 1/60 sec.

Most any subject can benefit from the multiple exposure technique—even cities—and especially when they are composed as a pattern. One of the most important things to keep in mind, however, is to avoid compositions with lots of sky. With these scenes, there isn't much visual difference between single and multiple exposures. Additionally, pay special attention to the light—overcast days and frontlit scenes are best when you are photographing multiple exposures.

I shot this simple flower composition four times. With my camera and 70–300mm lens on a tripod, I set my aperture to f/8 and adjusted my shutter speed until 1/30 sec. indicated a correct exposure. Since I wanted to shoot four exposures on the same piece of film, I needed to shoot four exposures at f/8 for 1/125 sec. Rather than move the camera just slightly after I made each exposure, I chose to zoom my lens with each exposure, changing the focal length from 70mm to 80mm to 90mm to 100mm. As a result, I recorded a very "explosive" effect.

[70–300mm lens, f/8 for 1/125 sec.]

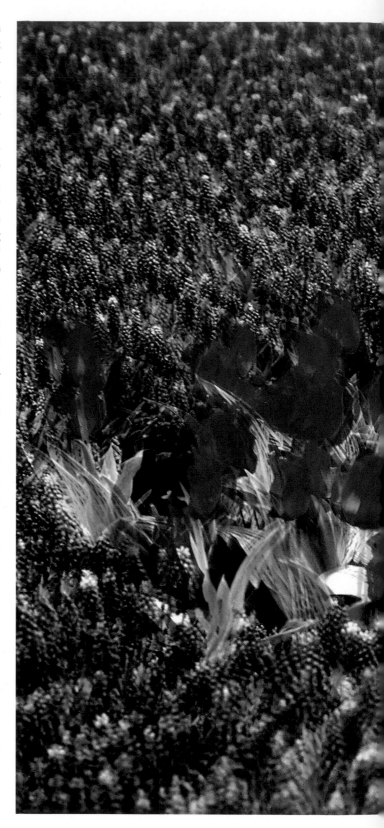

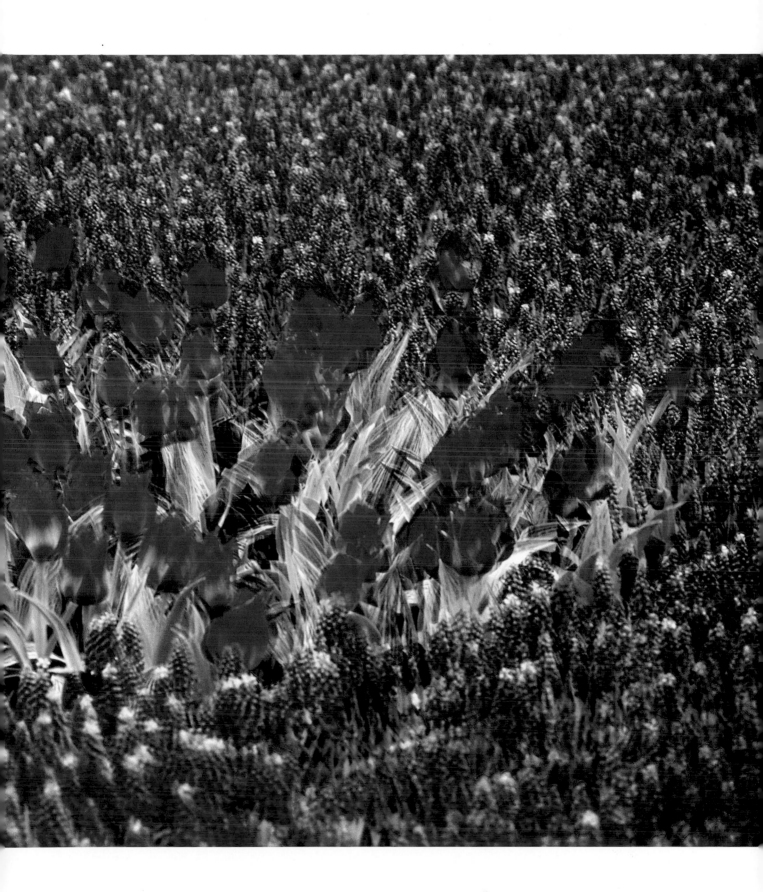

Polarizing Filters

Of the many filters on the market today, a polarizing filter is one that every photographer should have. Its primary purpose is to reduce glare from reflective surfaces, such as glass, metal, and water. On sunny days, a polarizer is most effective when you are shooting at a ninety-degree angle to the sun. For this reason, sidelighting (when the sun is hitting your left or right shoulder) is a popular lighting situation for using a polarizing filter. Maximum polarization can only be achieved when you are at a ninety-degree angle to the sun; if the sun is at your back or right in front of you, the polarizer will do you no good at all.

Working in bright sunlight at midday isn't a favorite activity for many experienced shooters since the light is so harsh, but if you need to make images at this time of day, a polarizer will help somewhat. This is because the sun is directly overhead—at a ninety-degree angle to you, whether you are facing north, south, east, or west.

If you're working in morning or late-afternoon light, you'll want to use the polarizing filter every time you shoot facing to the north or south. In this situation, you're

at a ninety-degree angle to the sun, and as you rotate the polarizing filter on your lens, you'll clearly see the transformation: blue sky and puffy white clouds will "pop" with much deeper color and contrast.

Why is this? Light waves move around in all sorts of directions—up, down, sideways, and all angles in between. The greatest glare comes from vertical light waves, and the glare is most intense when the sun itself is at a ninety-degree angle to you. The polarizing filter is designed to remove this vertical glare and block out vertical light, allowing only the more pleasing and saturated colors created by horizontal light to record on film or digital card.

Note that if you shift your location so that you're at a thirty- or forty-five degree angle to the sun, the polarizing effect of the filter will be seen on only one half or one third of the composition, so one half or one third of the blue sky is much more saturated in color than the rest of it. Perhaps you've already seen this effect in some of your landscapes. Now you know why.

Although there's vertical light around when you are working with frontlit or backlit subjects, there's no need to use the polarizing filter at these times, since the sun is not longer at a ninety-degree anlge to you.

Is the use of polarizing filters limited to sunny days? Definitely not! In fact, on cloudy or rainy days, there's just as much vertical light and glare as on sunny days. All this vertical light casts dull reflective glare on wet streets, wet metal and glass surfaces (such as cars and windows), wet foliage, and surfaces of bodies of water (such as streams and rivers). The polarizing filter gets rid of all this dull gray glare.

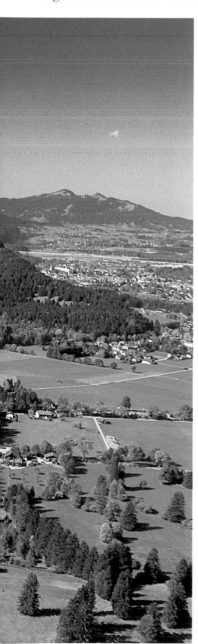

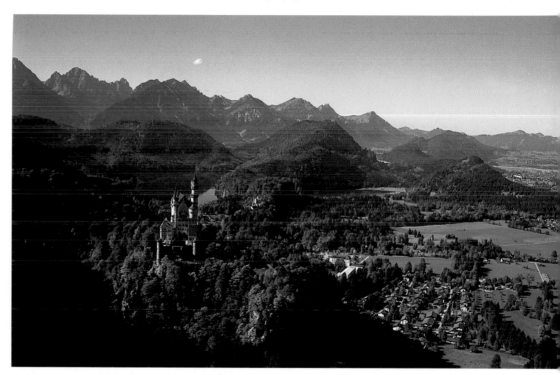

Since my point of view was at a ninety-degree angle to the early-morning light coming in from my left, this scene of Neuschwanstein castle in the German Alps offered an obvious opportunity to use my polarizing filter. In the first example (above), I didn't use the filter, and you can see the overall haze, the lack of vivid blue sky and of detail in the distant mountains, and the somewhat flat greens of the valley floor. In the second example (opposite), after placing the polarizing filter on my lens and rotating the outer ring to achieve maximum polarization, the difference is clear. Even the once lone and indistinct cloud is now more vivid and has company!

[Both photos: 35–70mm lens at 35mm. Above: f/8 for 1/250 sec. Opposite: f/8 for 1/60 sec.]

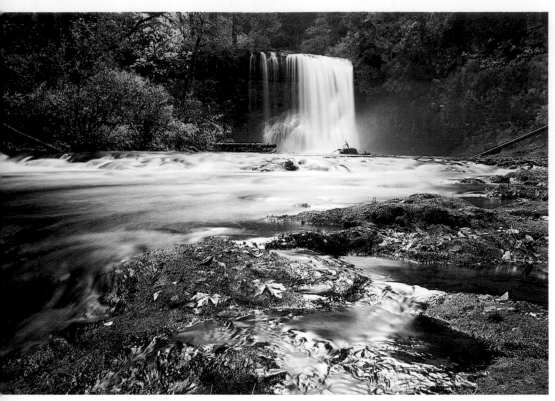

I can't live without my polarizing filter, more for the rain than for the sunshine. It's the one tool that will save you each and every time when shooting in the woods on rainy days. It alone can remove all the glare from your rainy-day compositions—no amount of Photoshop ever will! Take a look for yourself. In the first example, above, without the polarizing filter, note all the glare. The stream, rocks, and leaves are all reflecting the dull gray rainy sky overhead. But as you can see in the second example, right, made with the filter, you discover a colorful world that only seconds ago was awash in glare.

Note that because a polarizing filter cuts the light down by 2 stops, I had to increase my shutter speed by 2 stops (from 1/4 sec. to 1 second) to accommodate this. Since that brought the shutter speed to 1 second, a tripod was a must and I then used the camera's self-timer to fire the shutter release.

[Both photos: 24mm lens. Above: f/22 for 1/4 sec. Right: f/22 for 1 second]

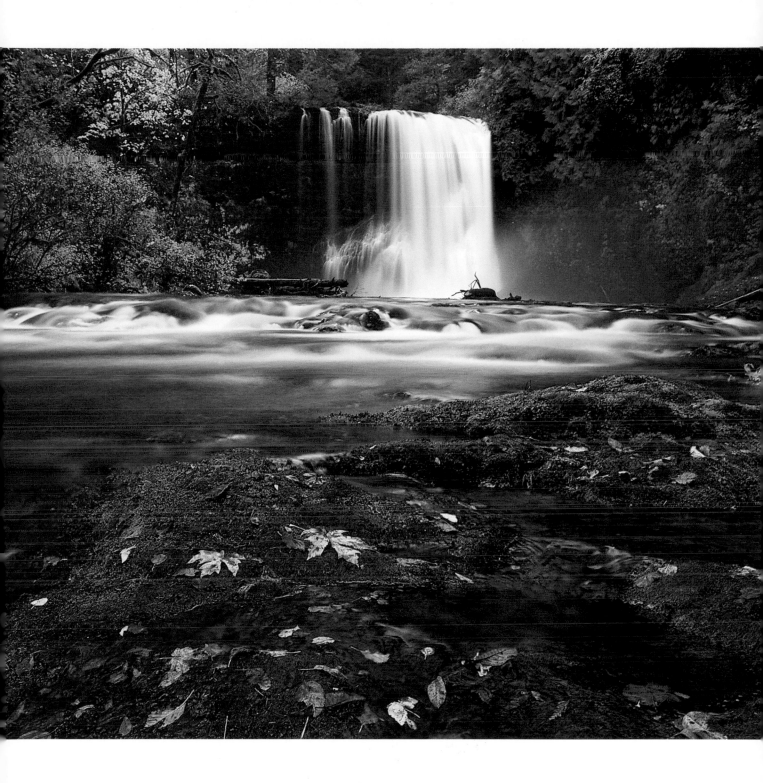

Neutral-Density Filters

Is there a filter than can reduce your depth of field? Is there a filter than can imply motion (panning) or turn that fast-moving waterfall into a sea of white frothy foam? You bet there is, and it's called a neutral-density filter.

The *sole* purpose of the neutral-density (or ND) filter is to reduce the intensity of the light in any givien scene It acts in much the same way as a pair of sunglesses, knocking down the overall brightness of a scene without interfering with the overall color. Just as sunglass lenses come in varying degrees of darkness, neutral-density filters come in stop increments. So for example, a 3-stop neutral-density filter knocks down the brightness of the light by 3 stops.

This reduction of light intensity allows you to use larger lens openings (resulting in shallower depth of field) or slower shutter speeds. If, for example, I were using ISO 400 film and wanted to create a cotton candy effect in a waterfall, I would first stop the lens down to the smallest lens opening. For argument's sake here, let's say that is *f*/22. I would then adjust my shutter speed until I got a correct exposure, let's say at 1/15 sec. At

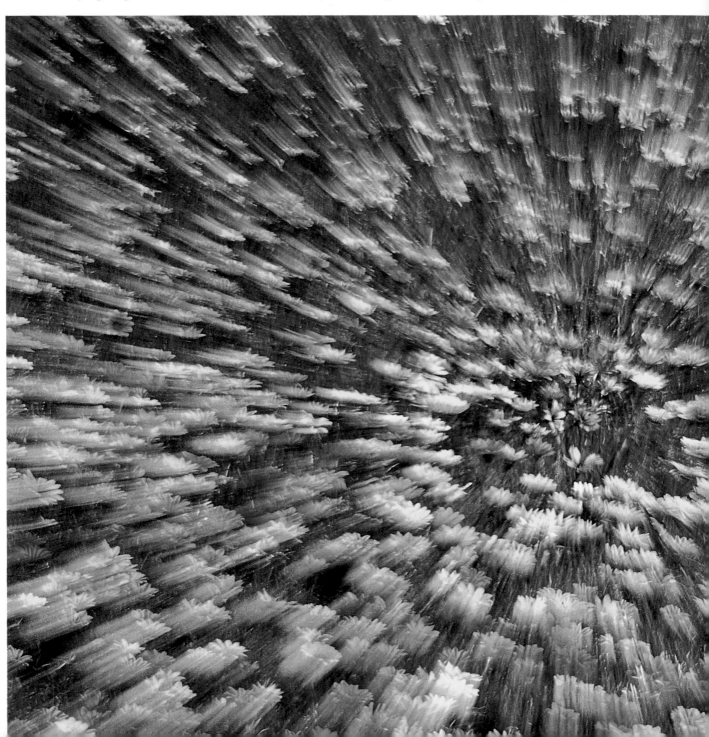

1/15 sec., I couldn't record the cotten candy effect, because the shutter speed is too fast. I would need at least 1/4 sec. to record this effect. If I were to use a 3-stop neutral-density filter, I'd knock the intensity of the light down by 3 stops. My meter would tell me that f/22 for 1/15 sec. is 3 stops underexposed, so I would readjust my shutter speed to 1/2 sec. (1/15 sec. to 1/8 sec. to 1/4 sec. to 1/2 sec. is 3 stops), which is slow enough to record the cotton candy effect I was going for.

And there are other "problems" for which the ND filter is a good solution. Let's say you find yourself shooting a portrait of a vendor at an outdoor flower market. You position your subject about ten feet in front of a "wall" of flower stands. You want all the visual weight on the vendor, with a background of only out-of-focus flower tones and shapes. So you choose, rightly so, a short telephoto lens (say 135mm) and a large aperture (say f/4) to limit the depth of field to the vendor. As you adjust your shutter speed and notice that you reach the end of the shutter speed dial (say 1/2000 sec.), your light meter still indicates a 2-stop overexposure. You could stop the lens down to f/8, but this would increase the depth of field, revealing too much background detail. By adding a 3-stop ND filter to your lens, f/4 for 1/1000 sec. yields a correct exposure—and gives the depth of field you want.

Although you can buy ND filters that reduce the intensity of light from 1 to 4 stops, my personal preference is the 3-stop filter. As you'll see over time, this is all you need when you want to use slower shutter speeds or larger lens openings *without* the worry of overexposure.

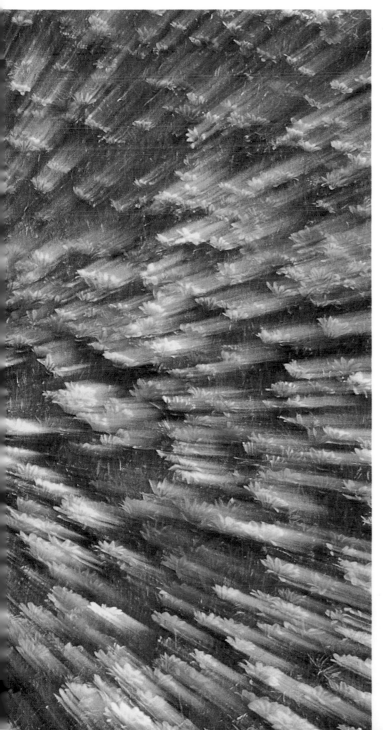

With my camera and 80–200mm lens on a tripod, I set my aperture to f/22, knowing full well that a lens opening this small would necessitate the slowest possible shutter speed; in order to "explode" this meadow of flowers with my zoom lens, I would need a slow shutter speed. How slow? Normally, at least 1/4 sec., if not 1/2 sec. As I adjusted my shutter speed, I noticed that my light meter was indicating 1/30 sec. as a correct exposure. Good thing I had my 3-stop Tiffen neutral-density filter with me. I threaded it onto the lens, and just like that, I had a correct exposure indication of f/22 for 1/4 sec. As I fired off several exposures, I was quick to zoom the lens from 80mm to 200mm during the 1/4 sec. period. Some of my attempts fell a bit short, but this and a few others turned out beautifully.

[80–200mm lens, f/22 for 1/4 sec.]

Graduated Neutral-Density Filters

Unlike a neutral-density filter, a graduated neutral-density filter contains an area of density that merges with an area of no density. In effect, it is like a pair of sunglasses with lenses that are only tinted in certain areas and not others. Rather than reducing the light transmission throughout the entire scene, as an ND filter does, a graduated ND filter reduces light only in certain areas of the scene.

Suppose you were at the beach just after sunset and want to use your wide-angle lens to get a composition that included the bright color-filled postsunset sky, several small foreground boulders surrounded by wet sand, and the incoming waves. Since this would be a story-telling image, you would choose the right aperture first, in this case *f*/22 for maximum depth of field. Then, you would point your camera at the sky to get the correct shutter speed, in this case 1/30 sec. But if you took a meter reading from the wet sand, 1/2 sec would be the correct shutter speed. That's a 4-stop difference in exposure. If you were to go with *f*/22 for 1/30 sec., you'd record a wonderful color-filled sky, but the foreground sand and rocks would be so underexposed they would hardly appear. If you were to go expose for the sand and rocks, on the other hand, the sky would be way overexposed and all its wonderful color would disappear.

One of the quickest ways to "change" the exposure time for the sky so that it gets close to matching that of sand and rocks is to use a drop-in graduated neutral-density filter. Unlike a "normal" graduated ND filter, which threads onto the front of your lens, a drop-in filter is square or rectangular in shape and drops into a filter holder that you secure to the front of your lens. This allows you to slide the filter up or down, or to turn the outer ring of the filter holder so that you can place the filter at an angle. This, in turn, allows for perfect placement of the filter in most of your scenes.

Aligning the Filter

If you have a camera with a depth-of-field preview button, use it as you position the graduated ND filter. As you slide the filter up or down, you can clearly see exactly what portions of the composition will be covered by the density of the filter. Using the preview button will guarantee perfect alignment every time.

In the situation described above, a 4-stop graduated ND filter positioned so that only the sky was covered by the ND area would be the solution. You wouldn't want the filter covering anything other than the bright sky. Once the filter was in place, aligned so that the ND section stops right at the horizon line, the correct sky exposure would be reduced by 4 stops, and you could shoot the entire scene at *f*/22 for 1/2 sec.

Just like ND filters, graduated ND filters come in 1- to 4-stop variations. In addition, they come in hard-edge and soft-edge types, meaning that clear section of the filter meets the ND section with either an abrupt change or a gradual transition. My personal preference is the soft edge.

The tricky part of this scene was the 4-stop difference between the wheat field and the sky. With my camera and lens on a tripod, I chose an aperture of *f*/16 and set my exposure for the green field. I recorded a correct exposure of the field, but at the expense of the cloud and colorful sky (opposite). In the second try (right), I was able to record a correct exposure of the green field as well as the cloud and sky, but only after placing my Lee 3-stop graduated neutral-density filter on my lens. My exposure time for both of these images was the same: *f*/16 for 1/4 sec.

If you don't have a graduated neutral-density filter you could take two separate, correct exposures—one of the field and the other of the cloud and sky—and then use Layers in Photoshop on your computer to blend the two exposures into one, and end up with the same thing. But, whew! I don't know about you, but I get exhausted just thinking about this. A word of advice: If you've got Photoshop, then your budget can easily absorb the cost of a Lee graduated neutral-density filter. Buy it now, and the next time, *get the right exposure in-camera*! You'll have more time to spend with your family and friends.

[Both photos: 35–70mm lens, *f*/16 for 1/4 sec.]

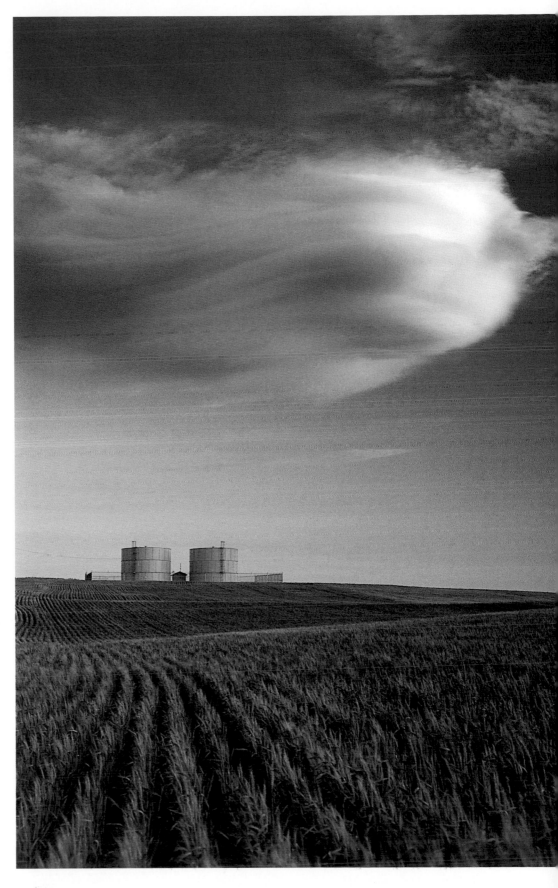

Film vs. Digital

ISO

Film cameras offer many combinations of film choice and different ISO (ISO 25, 50, 64, 100, 160, 200, 400, and so on). Digital cameras give you at least three choices in ISO settings—125, 200, or 400—and if it's a more sophisticated digital camera, you may find that it offers ISO 800 and ISO 1600, as well. ISOs of 400, 800, and up are referred to as *fast speed*; ISOs of 100, 125, 160, or 200 are referred to as *medium speed*; and ISOs of 25, 50, and 64 are referred to as *slow speed*.

So why all the ISO choices? Why not just select one and stay with it? A lot of shooters do just that, myself included. I use ISO 100 a good 99 percent of the time when using my film camera, and when shooting with my Nikon D1X, I use ISO 125 (Nikon doesn't offer ISO 100 on their D1X). There's an array of subject matter that can successfully be rendered with a medium ISO like ISO 100—from family outings, to outdoor sports at school, to flowers in the backyard, to mountaintop wildflowers, to your pet cat, to wild lions in the Kalahari Desert.

Although this book has explored night and low-light photography, it does so on the assumption that you'll be shooting with ISO 100 to ISO 200. However, if you're shooting at night or in low light and you don't want to use a tripod, you can certainly opt for loading up a high-speed ISO 800 or ISO 1600 film, or simply switch the ISO setting on your digital camera. The purpose of these high-speed ISOs is twofold: to freeze action and to shoot in low light.

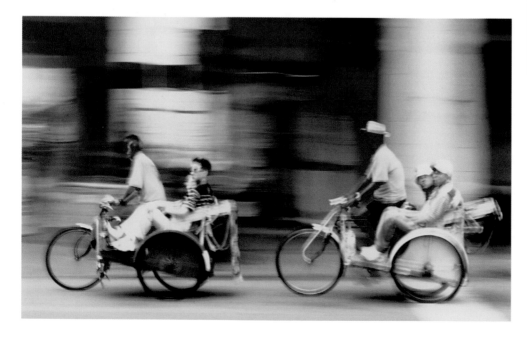

I was in Singapore doing a shoot for Northwest Airlines' in-flight travel magazine when I fell in love with Little India, as have many others who've visited Singapore. It's a colorful place with the friendliest of people. Standing on a street corner with my Nikon D1X set to ISO 125 and my 35–70mm lens at 35mm, I was anxious to "pan" many of the tourists as they sped by in their pedal-driven taxis. With my aperture set to f/22, I adjusted the shutter speed to 1/30 sec.

Shortly after, I went inside a small grocery store where, after several minutes of conversation, the shopkeeper agreed to have his picture taken. Due to the low light levels in the store, I needed to switch to ISO 800, and even though the overhead lighting was from fluorescent bulbs, it wasn't necessary to use a color-correction filter since my auto-white balance feature made the necessary corrections for me. If I had been using a film camera, I would have had to either (a) use a flash, (b) change my film to something like Kodak Max 800 and then leave it up to the lab to color correct, or (c) stay with the ISO 100 film I normally shoot, add an FLD filter to correct for the fluorescent lighting, and use my tripod. If you're looking for an argument in favor of digital, this would certainly be a good one.

[Opposite: 35–70mm at 35mm, f/22 for 1/30 sec. Above: 17–35mm lens at 24mm, f/8 for 1/60 sec.]

Color

Unlike digital shooters, film shooters have an array of options when it comes to choosing the *right* color film. The film counter at any camera store, or giant drug store for that matter, clearly shows numerous yellow, green, and orange boxes. In addition, you must decide between color print/negative film or color slide film. You can quickly identify either, regardless of brand, because *all* color print films end in the word "color"—i.e. Kodacolor, Fujicolor, Agfacolor—while *all* color slide films end in the word "chrome"—i.e. Ektachrome, Fujichrome, Agfachrome.

One of the most common questions I get in my workshops is, "Which brand is best?" For many photographers, film is a personal choice, and much of what you choose is based on several variables. If you want to share your results with friends and family soon after taking your roll of film, you'll be more inclined to shoot color print film. Passing around 4x6 color prints at the office makes a lot more sense than passing around individual color slides. If, on the other hand, you're the type who

likes to give slide shows, then obviously, color slide film will be your choice. Additionally, if you want to save money on film processing costs, color slides would be the logical choice. Normally, the cost of processing a roll of thirty-six exposure slide film is about half of what it is for a roll of thirty-six exposure color print film.

You can also make any number of prints from color slides, but it's an extra step in the process. You must first take a look at all of your efforts and then decide which ones are worthy of making into prints. That's an argument in itself for shooting slides when you realize most of the thirty-six exposures are often similar shots, while perhaps only two or three are really, really good! With a roll of color print film, you would spend twice as much to keep the same three shots as you would have had you shot slides.

When it comes to overall color saturation and contrast, color slide film has a long history of "winning" over color print film. However, color print (or negative) film is a lot more forgiving in the area of exposure, so if you mess up and shoot some of your pictures a bit overexposed or a bit underexposed, the lab will make all of the necessary cor-

Being able to switch from color to black and white with the push of button is certainly a big advantage to shooting with a digital camera, assuming of course that you do indeed like to shoot the same subject in black and white as well as in color. When this Ukranian security guard finally smiled, revealing a gold tooth (opposite), I had already switched the camera to black and white, so unfortunately, that gold tooth is forever recorded only in black and white.

A possible lesson to take away from this is this: if you're shooting digitally and are not absolutely sure you only need a black-and-white image, shoot in color mode. You can always convert a color file to black and white, but you can't change black and white into color, and you may miss a good color opportunity, as I did here.

[Both photos: Nikon D1X at ISO 200, 20–35mm lens at 28mm, f/5.6 for 1/160 sec.]

rections for you, within reason of course. Slides on the other hand, require a bit more attention to exposure simply because there's no process in the lab to make corrections once the film has been processed. I'm fully aware of the home computer and its ability, via photo-imaging software, to make corrections in your exposures (whether color slides or color prints), but I look at these tools as a last resort—helpful, but a last resort.

Regarding any color film's particular characteristics, trial and error over time will enable you to discover which films work best for your photography and your tastes, whether you're shooting the vivid greens of a spring forest or the pure whites of a wedding dress. Over the last twenty-five years, I have certainly had my share of film love affairs: During my first fifteen years, I was *always* shooting Kodachrome 25 or 64. I then discovered Fujichrome and shot both 50 and 100. And in the mid-nineties, I was introduced to Kodak's Ektachrome 100 and began using it religiously, and for the past four years, I've almost exclusively shot Ektachrome E100VS (the VS signifying "very saturated"). As it is a highly saturated color slide film, I use it for all of my subjects *except* people; it's far too saturated for most skin tones, making everyone appear sunburned. When photographing people, I opt for the Kodak E100S.

One of the drawbacks for digital shooters is that there's no film choice; there are no options in choosing color print/negative film or color slide film, and subsequently, no options in how saturated your exposures will be without first loading the digital image into the computer and then applying the necessary steps to achieve the desired effect. It's all about time when shooting digitally: it takes only a second or two to see your image on the camera's LCD screen, but there's much more time ahead once you've downloaded the images onto the computer. If you're like most digital shooters, spending time on the computer has become commonplace.

However, digital shooters have the upper hand in other areas. As discussed on the previous page, they can switch ISOs from one exposure to the next. Additionally, digital shooters can switch from color to black and white at the touch of a button. Digital shooters can set their "white balance" for most building interiors so that even when the office lights overhead are fluorescent, the normal greenish cast that film shooters record (assuming they didn't use the FLD filter) is never seen by the digital shooter; subjects look "normal." And finally, digital shooters can immediately see their results via the LCD screen, enabling them to correct any errors or make any adjustments they want before saving the image.

Pushing and Pulling

Digital shooters don't have to worry about pushing and pulling, since they're not using film. If you're using a film camera, however, take note. Film can be *pushed* (purposely set to a faster ISO speed) or *pulled* (purposely set to a slower ISO speed). *Pushing film* is often done when you realize that your film doesn't offer enough ISO to get the job done. For example, let's say you arrive at your son's soccer game and discover that you don't have ISO 200 film as you thought, but rather only ISO 100. You were hoping to freeze action, and you may feel all is lost, but that doesn't have to be the case. You just have to manually set your film speed to ISO 200 and shoot as you would with that ISO. The camera now thinks that ISO 200 film has been loaded into the camera and will give you exposure readings based on this information. Once you've shot that roll, mark the film cassette (with a Sharpie felt-tip marker) as +1 or 200, and when you then go to the lab, indicate to the lab that the roll needs to be "pushed" to 200.

Drawbacks to pushing film are that it's more expensive, and that it results in more graininess and also a build up in some unwanted contrast. The pictures are, for the most part, good, but more often than not, it would make better sense to have the right film speed on hand for all of your anticipated needs.

Pulling film is seldom done. It's usually done to salvage film that was accidentally exposed at an ISO less than its true value. With today's DX coding, it's next to impossible to find yourself needing to pull film. The only time you might need to is when you're using a camera where film speeds are set manually, and you set the ISO incorrectly. As with pushing, pulling film is expensive.

While on assignment at Busch Gardens in Tampa Bay, Florida, for *Popular Photography* magazine, I came upon "the joker" and he gladly played for the camera. Since he was walking on stilts, I stood atop a nearby bench so that I could be a little bit closer to his eye level. Handholding my camera, I set the aperture to f/8 ("Who cares?") and simply adjusted my shutter speed until the camera's light meter indicated 1/250 sec. as the correct exposure for the low-angled frontlight that was falling on his face.

[75–300mm lens, f/8 for 1/250 sec.]

Index